MODE series directed by Maria Luisa Frisa

1 Alessandra Vaccari
 WIG-WAG. THE FLAGS OF FASHION

2 Antonio Mancinelli
 ANTONIO MARRAS

3 Claudio Marenco Mores
 FROM FIORUCCI TO THE GUERRILLA STORES

4 Vittoria Caterina Caratozzolo
 IRENE BRIN. Italian style in fashion

5 James Sherwood
 THE LONDON CUT. SAVILE ROW. BESPOKE TAILORING

6 Paola Colaiacomo
 FACTIOUS ELEGANCE. PASOLINI AND MALE FASHION

7 Vittoria Caterina Caratozzolo - Judith Clark - Maria Luisa Frisa
 SIMONETTA. The First Lady of Italian Fashion

8 Elda Danese
 THE HOUSE DRESS. A Story of Eroticism and Fashion

WORKWEAR

WORKFASHIONSEDUCTION

Marsilio MODE FONDAZIONE PITTI DISCOVERY

This volume has been published to coincide with the exhibition
WORKWEAR
WORK FASHION SEDUCTION
a project of the Fondazione Pitti Discovery
curated by Oliviero Toscani with La Sterpaia, Bottega dell'Arte della Comunicazione
and Olivier Saillard

Stazione Leopolda, Florence
January 13 / February 8 2009

The catalogue and the exhibition WORKWEAR have been made possible by the generous backing of the Ente Cassa di Risparmio di Firenze, which has always given its support to the cultural projects of the Fondazione Pitti Discovery

THE WORKWEAR PROJECT IS PROMOTED BY THE
CENTRO DI FIRENZE PER LA MODA ITALIANA AND PITTI IMMAGINE

Creative and Artistic Director
Oliviero Toscani

Graphic Project
La Sterpaia

Design
Roberto Carra
Emanuele Catena
Jelena Novoselski
Sara Venturini

Editorial Coordination
Roberta Maccioni
Lola Toscani

Picture Research
Stephane Dubreil
Valentina Meneghello
La Sterpaia

Translations
Huw Evans

Image provider
Corbis s.r.l.

We would like to thank
Profile + for its research efforts

The Fondazione Pitti Discovery and the authors also wish to express their gratitude to the following
Allegri, Giorgio Armani, Adeline André, Agnés B., Pietro Bartolini, Walter Van Beirendonck, Giacomo Borselli, Bullard, Comme des Garçons, C.P. Company, Francesco Caracciolo, J.-C. de Castelbajac, Lorenzo Cellini, Antonio Colombo, Condor, DSquared², Diadora Utility, Christian Dior, Dupont, Alessandro Durante, Christian Lacroix, Custom Leathercraft, Fondazione Meyer, Fraizzoli, Samy Gattegno, Jean-Paul Gaultier, Giordani Giancarlo, Marithé e François Girbaud, Grainger, Hermès, Jim & Jules, Jolly Scarpe, Krizia, Lee, Lotto Works, Millenia Sport, Martin Margiela, Isidoro Marino, Marni, Antonio Marras, Marco Masi, Max Mara, Nicholas McGuire, Moldex, Montebove, Moschino, MSA, Thierry Mugler, Prada/Miu Miu, North Safety, Pro.te.co. Sub, Raitex, Safety, Salisbury, SCBA, Scott Italia, Siggi Group, Streamlight, Paul Smith, Sperian, Tecnologie Monaldo Monaldi, TimberlandPRO, Uvex, Versace, Vgard, Louis Vuitton, Wells Lamont, Westward, Yohji Yamamoto, 3M.

The Fondazione Pitti Discovery regrets any photographic credits
that have been unintentionally omitted

FONDAZIONE PITTI DISCOVERY

discovery@pittimmagine.com
www.pittimmagine.com

first edition January 2009
isbn 88-317-9690

Printed by Grafiche Nardin, Ca' Savio - Cavallino - Treporti (Venezia)
for Marsilio Editori® in Venezia

Contents

7 Introduction - *Alfredo Canessa*

9 Clothes Make the Monk - *Oliviero Toscani*

11 Workwear - *Olivier Saillard*

17 Workwear - Iconographic atlas

Introduction

Workwear. Work, Fashion, Seduction focuses on a subject that never ceases to be topical and to exercise a great influence at every level of our daily lives as well as fashion. Always changing to reflect shifts in taste and fashion, workwear is uniform, basic clothing, protective garment.

Characteristics that at first sight might seem remote from the concerns of fashion, and closer if anything to the fundamental needs of clothing and industry.

And yet these simple qualities continue to fascinate the most refined fashion designers. Was it not Yves Saint Laurent who regretted not having invented blue jeans himself instead of the gold prospectors of California? And their attraction grows even greater in periods of profound change like the one we are living in now, when the stylistic research of fashion feels a strong need to draw on the basic necessities of clothing. To draw inspiration from them, to reinterpret, destructure and distort them. But also because something is expressed in workwear that is solid and inescapable even for the most lively forms of creativity.

But that is not all. Today fashion companies and designers find incorporated in work clothes a very high level of technological research that in many ways converges with their own: efficient materials and lines that go along with the desire for a more athletic and active life, the need for people to feel at their ease in every situation, for them never to be too far away from their own digital prostheses and, at the same time, to have a more direct contact with a nature that today, alas, could also turn out to be something more threatening and less romantic than an occasional shower of rain from which to protect yourself.

With the exhibition and book *Workwear. Work, Fashion, Seduction*, the Fondazione Pitti Discovery is drawing attention to this elementary dimension of dress. Something that, like work – the work that produces goods and services, the engine of the real economy – has never ceased to be in fashion.

Alfredo Canessa
PRESIDENT OF THE CENTRO DI FIRENZE PER LA MODA ITALIANA

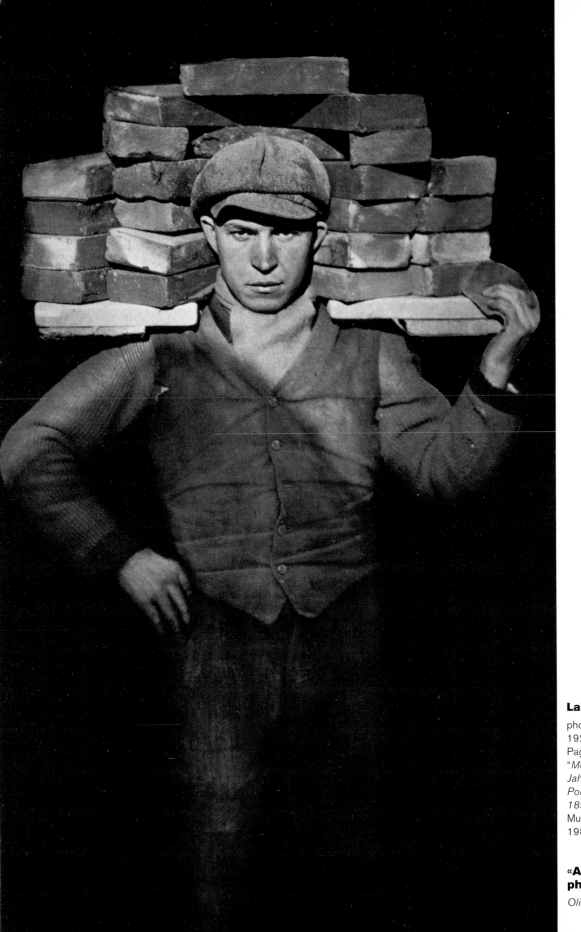

Laborer

photo August Sander, Köln, 1929.
Page from August Sander "*Menschen des 20. Jahrhunderts: Portraitphotographien 1892-1952*".
Munich: Schirmer/Mosel, 1980.

«Always my favorite photograph of all»

Oliviero Toscani

Clothes Make the Monk

Clothes make the monk, the steelworker, the lawyer, the rapper, the banker, the fashionable woman, the jockey, the musician, the cook, the sailor, the prostitute, the policeman, the doctor, the doorman, the judge, the miner... Our clothes are the image and the guarantee of what we are and what we do.

The naked man has never created culture. When he started to become aware of the good and bad points of his own condition, the first garment he put on was the fig leaf. Sex, perhaps, was the first problem from which he wished to defend himself; the most obvious problem and still the one that has not been solved.
The first shelter that we sought as human beings was not a physical one, but that of modesty, of privacy, a defense against the complex of being frail.

In our dressing we are conditioned by our fears, by our certainties and uncertainties. Clothing is the armor of our physical, social, moral and cultural condition. It is the hope, more or less well-founded, that each of us cherishes for his or herself, and at the same time it is the measure, the image and the value of our interpersonal relationships.

Clothing protects us from danger, psychological and practical. It relieves us of the risk of not having sufficient authority. It preserves our physical safety, any charisma we may have and our social standing.
Evening dress is reliable if it makes the body attractive, working clothes if they protect us. Both act as shields.

"Clothes make the man," said Mark Twain.
If we want to maintain our security, we must have the intelligence never to forget that we are vulnerable. Physically and mentally.

Oliviero Toscani

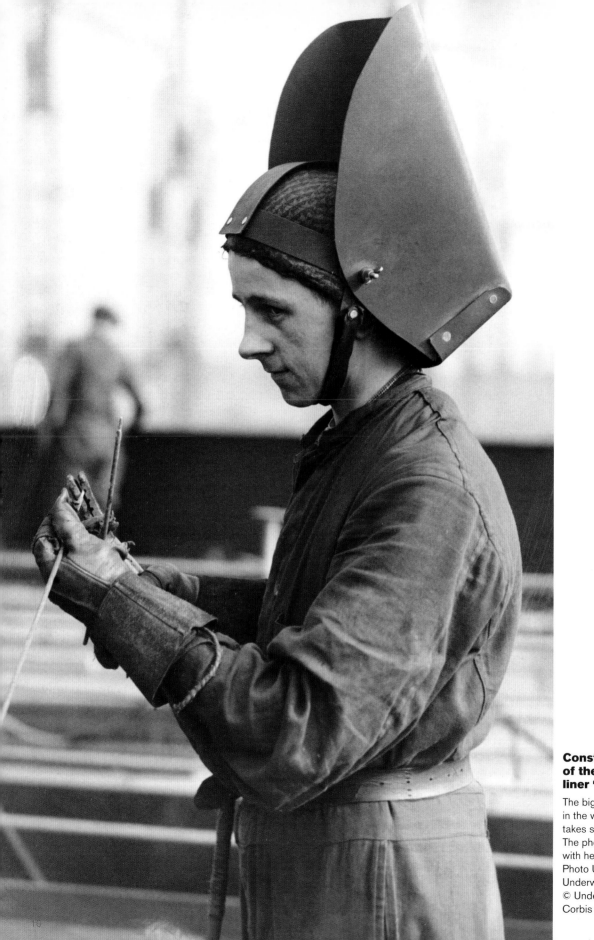

**Construction
of the transatlantic
liner "Queen Mary"**

The biggest transatlantic liner
in the world, the *Queen Mary*,
takes shape at Clydebank.
The photo shows a worker
with her kit.
Photo Underwood &
Underwood.
© Underwood & Underwood/
Corbis

Workwear

Essential Clothing:
An Essay on the Overall, Utopian Garment in Art and Eccentricity in Fashion

Historians of dress have been fascinated by fluctuations in fashion, studying the evolution of styles, their unexpected, seasonal and recurrent shifts. Ethnologists have compiled registers of the geographical variations that can be found in a regional headdress or in the ornamentation of a typical coat. In the extensive and yet long despised catalogue of clothing terms over the course of the centuries, ceremonial dress or the haute-couture garment has found all the favor, to the detriment of everyday rural or urban dress.

Its absence from museums and collections of costume and the gaps in its representation provide additional evidence of this inequality. Because ordinary, used and worn, it also disappears spontaneously from private wardrobes, while an evening dress or an item of "Sunday best" holds the attention and often ends its days on the solemn coat hanger of a collection of heirlooms.

Born out of a specialization of everyday clothing, the so-called "working" garment is the product of a diversification of ordinary dress in recent times, contemporary with the industrial revolution and urbanization. In fact it was over the course of the 19th century that the complete outfits of clothing for many trades were constituted and fixed. In aprons, overalls, functional pants and jackets, smocks and clogs, generations of pastry cooks, mechanics, cooks or painters have recognized their uniform of protection and distinction. From 1850 onward, the clothing industry brought new and cheap outfits within the reach of all. Its beginnings had "primarily entailed the mass production of working clothes like overalls, smocks and blouses. Out of these developed the occupational outfits of grocers, confectioners and butchers, especially in the 19th century, as well as those of a large number of other tradesmen and merchants." They survived in part up until the 1950s, before disappearing with the standardization of some trades or their eclipse by blue jeans, an item of workwear that to begin with was as widely used on building sites as in the city. They came back into use again in the form of a technical and functional solution dictated by today's rules of safety and vigilance.

Workwear refuses to bow to the whims of fashion. Steeped in functionality, apparently exempt from any ornamentation, it explicitly rejects the concentrated frivolity and aesthetic constraints of couturiers and designers. The fashionable garment, ephemeral and melancholic, dies each season. The working one is made to last. The wear of the former hastens its downfall; it ennobles the latter. Yet some designers, especially from the sixties onward, when the ready-to-wear sector developed rapidly, took their inspiration directly from functional clothing and drew from its fixity a poetic argument that was supposed to win over a society dominated by consumption.

Among the models of simplicity and usage that were revived, the overall can be taken as a recurrent symptom. An item of protective clothing, for use in an emergency, minimalist as well as futurist, always essential, the overall made its reappearance throughout the 20th century with radicalism.

The utopian garment of modernist artists, it has also been a symbol of distinction and originality for many fashion designers of acknowledged talent. It allows us to follow the logic of the appearance and disappearance of workwear in art and in fashion.

In the book *Europe 1910-1939. Quand l'art habillait le vêtement*, Valérie Guillaume looked back at the overall, the garment that was worn by American workmen at the beginning of the 20th century and taken up by certain artists at the same moment.

"That Thayaht was also the first artist to launch the *tuta* (one-piece garment) is no co-incidence. His design was similar to another item of clothing that covered the whole of the body, the American 'overall.' The overall [often called a coverall or coveralls in American and a boiler suit in Britain, *translator's note*] is a generic term that designates the different outfits available to workers: dungarees, multi-pocket jackets, overalls and pants [...]. The same year, the Viennese architect Adolf Loos predicted a universal destiny for the 'man in overalls': 'the American worker, with his practical spirit, does not see why he should wear clothing made of two pieces. He uses working clothes that have a close resemblance to the rompers worn by our children. The pants cover the chest as well and are held up by straps over the shoulders. This is the outfit known as *overalls*. It will become that of European workers. Half a million Americans worked in French factories during the war, another half million behind the front. This huge number of workers has popularized this kind of workwear in France. In thirty years it will be introduced in Austria too. And then the politician, as his American colleague has been saying for thirty years, will pompously declare: 'the man in overalls.'"

In her essay divided into extensively documented sections, organized by geographical zone, the author Valérie Guillaume goes on to comment on the "functionally imaginative" uniforms characteristic of the Italian futurists and the Russian avant-gardes. Whether we are talking of Thayaht's *tuta*, Rodchenko's production clothing, Tatlin's proposal for men's clothing or the workers' outfits designed by Varvara Stepanova and Lyubov Popova, all have very close ties with the "overall" referred to above.

The utopia of the one-piece garment, as it was expressed by each of these artists, closely followed in some of its details the design of the mechanic's overalls.

The *tuta* that Thayaht launched in Florence was a practical item of clothing, new in its aesthetics and cheap. In fact you could make it yourself. Buttoned at the front, it could easily be slipped on and off, worn without a shirt, with a simple belt around the waist and sandals. It was fitted with four applied pockets, without any decorative accessory. Conceived in 1918, the *tuta* was launched two years later by a campaign in the press and the publication of three leaflets. A detailed cutting layout of the man's and woman's models was printed on one of them. Over 1000 patterns were sold in a few days at 50 centimes each.

Unlike the very similar models created by Rodchenko and Garcia Lorca, the *tuta* was neither a working garment, nor one linked ideologically to a particular social class. The elegance of its sobriety and simplicity was intended to make it suitable for all occasions and circumstances.

If the clothing design of futurist artists recommended the use of color and pattern, absent from male and middle-class dress since the 19th century, that of the Russian constructivists placed more emphasis on the aesthetics of economy and functionality. "For Tatlin, for example, the garment was a constructed and not a designed object. Various pieces were put together to make the clothing, assembled in the same way as a machine is out of separate parts. And the criteria of efficiency that govern machines ought to be applied to clothing."

The garments created by Tatlin in the twenties were supposed to be prototypes for industry, for standardization. The function of the clothing was strictly utilitarian.

Alexander Rodchenko and Varvara Stepanova also designed functional items of work-wear that they called "production clothing." Rodchenko designed for himself a pair of overalls with many pockets that were to be used to hold instruments like a ruler and compasses, red, blue and black pencils, scissors, a pipe, a watch, etc. Stepanova sewed Rodchenko's overalls together out of woolen cloth and leather. She delighted in the sight of stitching made on the machine. "What gives the garment its shape are the seams indispensable to the cut. I would go even further, the stitches, the fasteners should be visible [...] laid bare like in a machine. No more invisible hand-stitching, but the line of machine stitches..."

Rodchenko would make the new outfit his uniform and wear until it was worn out.

The productivists set out to design practical garments, adapted to the different movements of the body (at work or play) by various alterations made with the help of pockets, flaps and hooked elements, whose claims to ornamentation offered a new poetic vision. The interest in the mechanical beauty of clothing was linked to the zipper that everyone displayed proudly. Invented in the United States in 1893, it was imported into Europe during the First World War. The development of plastic fasteners dates from the thirties.

Introducing a new gesture into clothing and the act of dressing, it was soon applied to all types of garment, profoundly modifying their conception.

Laying claim to rationality, the clothing designed by artists took on the outline of the overalls, whose timeless character was supposed to abolish the very idea of fashion, to which they were firmly opposed.

Yet as Radu Stern reminds us in his essay on Tatlin's clothes, "far from breaking out of their time, they strongly evoke the spirit of the twenties and the fact that they never went beyond the stage of prototype [...] is a constant reminder of the failure of utopia."

<p style="text-align:center">***</p>

While the mechanic's overalls in all their variants and new versions disappeared from the disciplinary field of the arts in which they had performed a symbolic function, they were retained by those categories of workers of which they became the permanent uniform (engineers, garage mechanics, cleaners, painters...) and brought back into the world of fashion by avant-garde couturiers and designers, a sign that they intrinsically possessed a distinctive character and originality that still differentiated them from more short-lived garments.

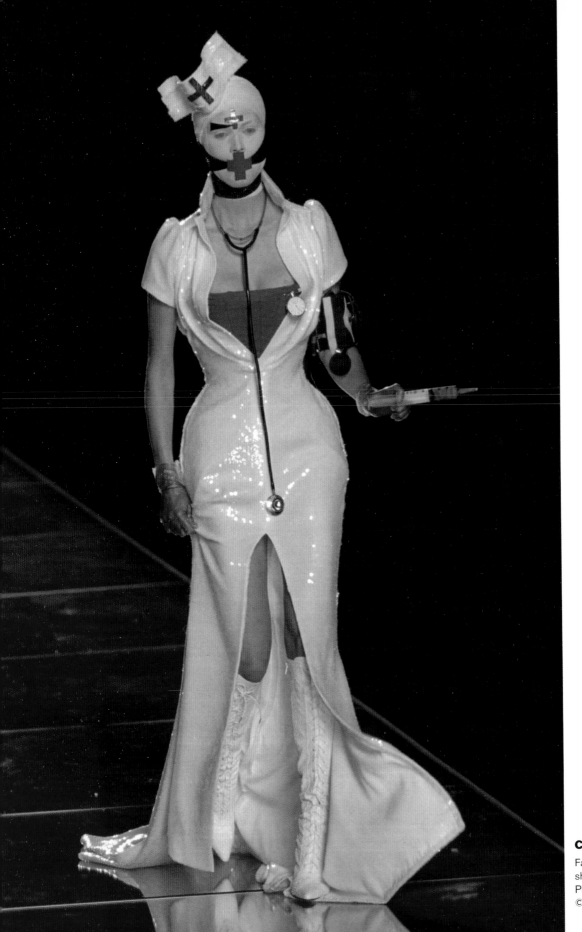

In 1939, Elsa Schiaparelli, a couturière who specialized in scandal and had close links with the surrealists, invented a garment whose form was reminiscent of the overall that Rodchenko wore.

In midnight blue wool, Schiaparelli's *tenue d'abri* (as she called it) proudly displayed the zip fastening that divided it in two and ran from bottom to top, along with four large gusset pockets in which the woman who wore the overall could hide precious jewelry and other essential objects. As its name suggests, the *tenue d'abri* or "shelter suit" had been conceived as a rapidly donned and yet elegant mode of dress for the woman who had to take refuge in the cellar or air-raid shelter as soon as she heard the sirens go off (this was in the Second World War).

In the sixties another woman made the overall a daily uniform, emphasizing its originality as well as its comfort. Sonia Rykiel, nicknamed "the sock woman" in an article in *L'Express* in 1968, designed and wore an overall of skintight jersey that left her movements free and made them even more suggestive. In 1967, in Paris, Michel Schreiber and Patrick Hollington formed a partnership and created a series of garments that renewed the vocabulary of men's fashion. In keeping with a period that had discovered secondhand clothing, army surplus stores and workwear as a means of making a statement or an expression of protest, Schreiber & Hollington invented the garment with no lining or inside pockets, a sort of uniform that was quickly adopted by artists and intellectuals and that made explicit reference to working clothes.

At the same time magazines did not hesitate to use this item of workwear for fashion features in which it appeared on an equal footing with designer clothing. This is what *Dépêche mode* did in September 1973 when it devoted twenty pages to the virtues of the polyester fiber Tergal, deliberately presenting the creations of designers alongside work outfits produced by French brands like Adolphe Laffont or HobbyCoat Kidur.

Agnès B's first collection in 1975 included work overalls and painter's jackets and pants in cotton. A number of models, such as the mechanic's overall or dungarees, were renewed from season to season owing to their classic character. Some of them were in sky blue cotton, while others were in white with *trompe l'oeil* motifs stitched onto them and yet others were given a refined look by being produced in black satin or tuxedo versions.

The designer Thierry Mugler drew attention to himself by wearing his own famous overalls with padded shoulders that were soon to become the emblem of the whole of the eighties. The man who invented a uniform for the sexy secretary created a series of overalls whose radical, simple and ergonomic design had no equals except the Russian prototypes which had been their direct inspiration.

But it was in the creations of the Japanese designer Yohji Yamamoto that workwear rediscovered all the poetry of which it is capable. Enchanted by the farmers and workers photographed by August Sanders and fascinated by the traces of wear on the shiny cotton of their clothing, Yohji Yamamoto has always insisted on the refinement of working garments, which touch us because they bear the indelible mark of those who have worn them. It is not just their form but also the way that time leaves its impression on them which inspires him, as in this ready-to-wear collection for the spring-summer of 2003 which includes a series of six overalls in typical blue, each more elegant than the last, and more rudimentary too: an ode to the essential of which he is a master.

Other designers have developed a very close relationship with work clothing, whose timeless and modernist character never ceases to find a place in their collections.

Among them, Jean-Charles de Castelbajac knows how to appreciate its functionality, which he makes use of as a radical form of ornament. The profusion of pockets or the sturdy fastenings that underline the architecture of his clothes reflect an unchanging fascination with this kind of garment.

For the spring-summer of 2003 he went so far as to have men who were chosen for their function parade in his boutique, undergoing alterations at the time, in overalls or in foreman or architect's garb, pointing out their utilitarian appeal.

Marithé & François Girbaud have also made workwear a permanent source of inspiration in the same way as denim, which they have made use of ever since their début. The declinations are multiple and varied. The two designers emphasize the simplicity or the complexity of a work jacket without ever growing weary of the old or modern charms suggested by these garments.
It is surprising, finally, to find in each of Walter van Beirendonck's collections the overalls of gardeners or mechanics, which he combines with colorful high-tech fabrics, offering them a second youth.

For the spring-summer of 1995 Comme des Garçons devoted an entire collection of menswear to the work aesthetic. Under and over loose pants, the atypical models wore blouses and overalls as proudly as a three-piece suit, with the same care and attention for their attire, magnifying just a little bit more the durable charm of workwear.

Of course dungarees and overalls find their primary place alongside a technical and sportswear vocabulary that is best suited to identifying the contemporary fashion of the street. Whether it is the overall of the futurists and the constructivists, regarded as a symbol of the art of dress, or the fashionable overalls that designers have used to renew the genre and that still springs surprises on the catwalks, workwear is everywhere.

We come across it everyday, in its strictly utilitarian form, or in the detail of a fastener, a pocket, a reflective material or an adapted fabric. An essential not to say minimalist garment, the overall is the never vanished symptom of a clothing industry that some would like to be more constant and less frivolous, and serves in the end to confirm the ambition of the artists of the twenties.

Olivier Saillard

1 Sylvie Legrand. *La vêture* in *1000 ans de costumes français 950-1950*, Thionville: Gérard Klopp, 1993, page 80.
2 Valérie Guillaume, *Europe 1910-1939. Quand l'art habillait le vêtement / Musée de la Mode et du Costume.* Paris: Editions des Musées de la Ville de Paris, 1997.
3 Adolf Loos, *Ins Leere gesprochen. Gesammelte Schriften* 1897-1900. Vienna: Prachner, 1997. English ed.: *Spoken into the Void: Collected Essays*, 1897-1900. Cambridge, Mass.: MIT Press, 1982. The passage has been translated from the French ed., *Paroles dans le vide - Malgré tout* (1900-30). Paris: Ivrea, 1979.
4 Guillaume, cit., p. 67.
5 In *LEF*, no. 2, 1923, quoted by S. Khan-Magomedov, Le Vkhutemas, Paris: Editions du Regard, 1990, vol 2, p. 703.
6 Radu Stern, *Tatlin et le problème du vêtement.* In *Quand l'art...* cit.

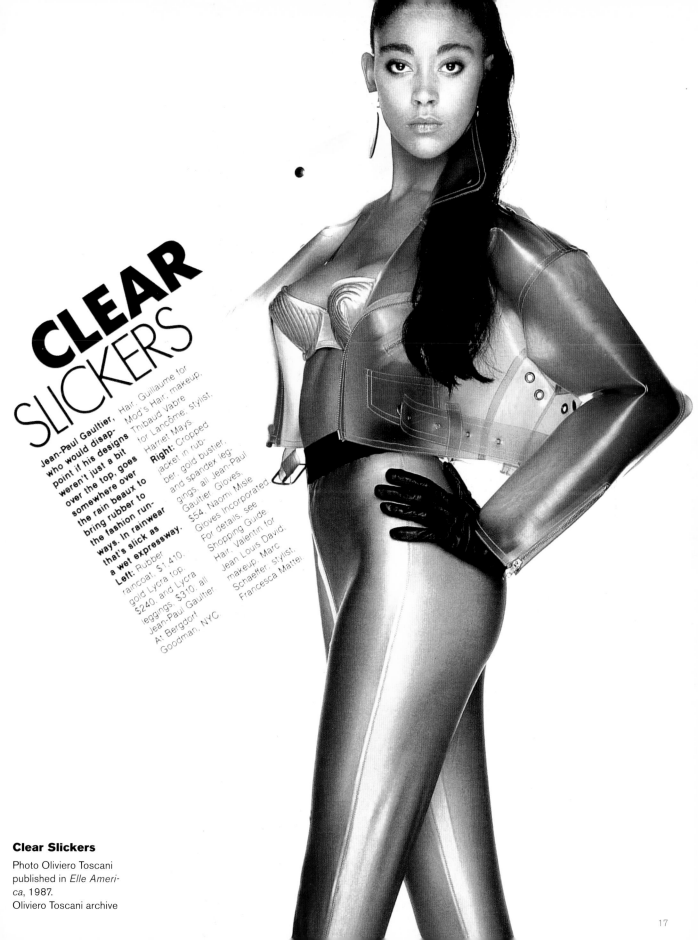

CLEAR SLICKERS

Jean-Paul Gaultier, who would disappoint if his designs weren't just a bit over the top, goes somewhere over the rain beaux to bring rubber to the fashion runways. In rainwear that's slick as a wet expressway. **Left:** Rubber raincoat, $1,410; gold Lycra top, $240, and Lycra leggings, $310, all Jean-Paul Gaultier At Bergdorf Goodman, NYC. Hair, Guillaume for Mod's Hair, makeup, Thibaud Vabre for Lancôme, stylist, Harriet Mays. **Right:** Cropped jacket in rubber, gold bustier, and spandex leggings, all Jean-Paul Gaultier, Gloves, $54, Naomi Misle Gloves Incorporated For details, see Shopping Guide Hair, Valentin for Jean Louis David, makeup, Marc Schaefer, stylist, Francesca Mattei.

Clear Slickers

Photo Oliviero Toscani published in *Elle America*, 1987.
Oliviero Toscani archive

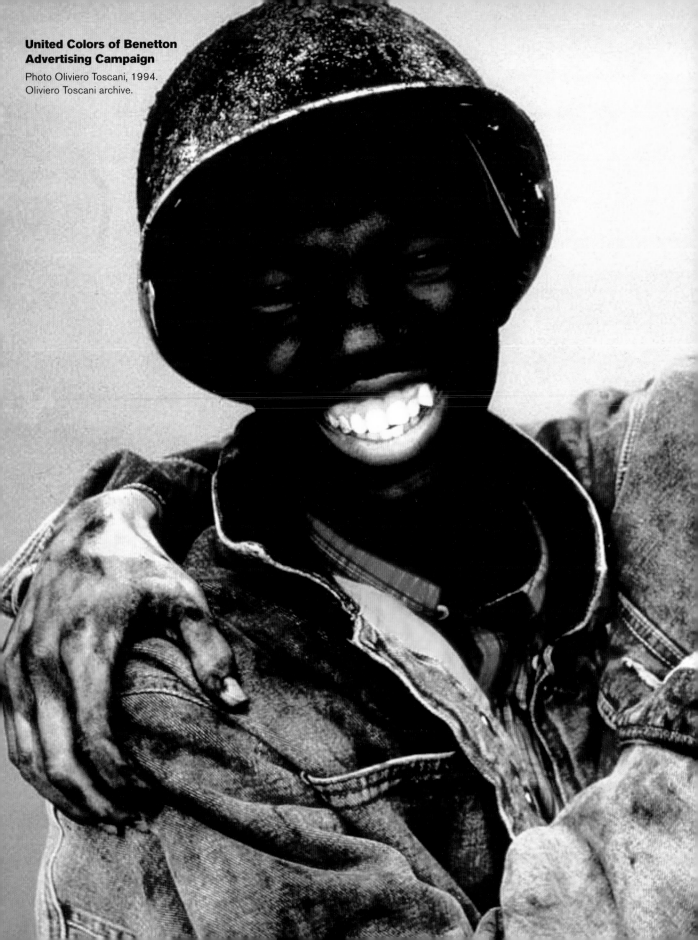

**United Colors of Benetton
Advertising Campaign**

Photo Oliviero Toscani, 1994.
Oliviero Toscani archive.

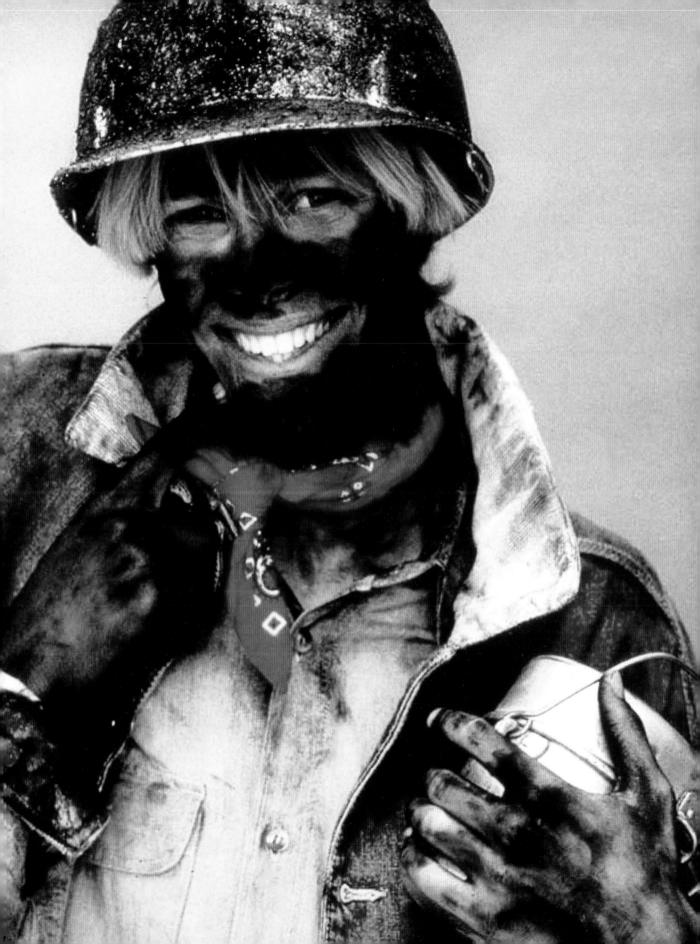

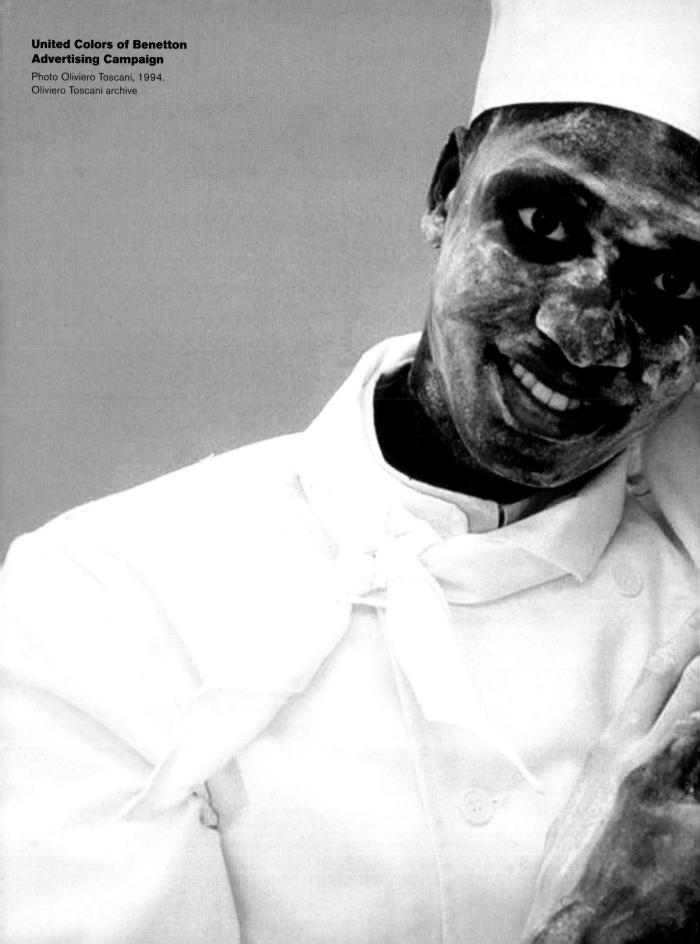

**United Colors of Benetton
Advertising Campaign**

Photo Oliviero Toscani, 1994.
Oliviero Toscani archive

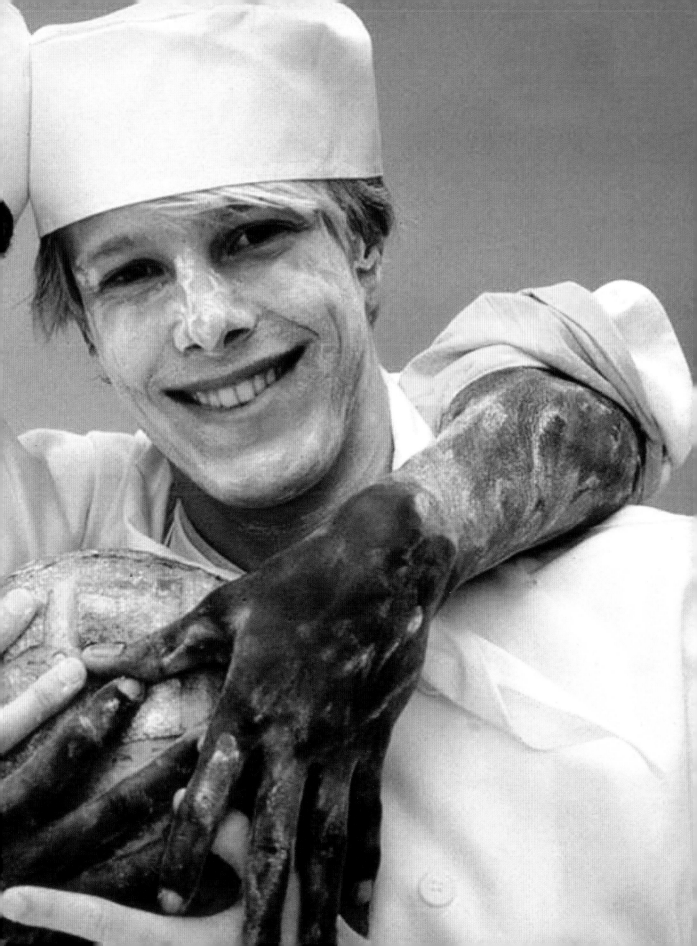

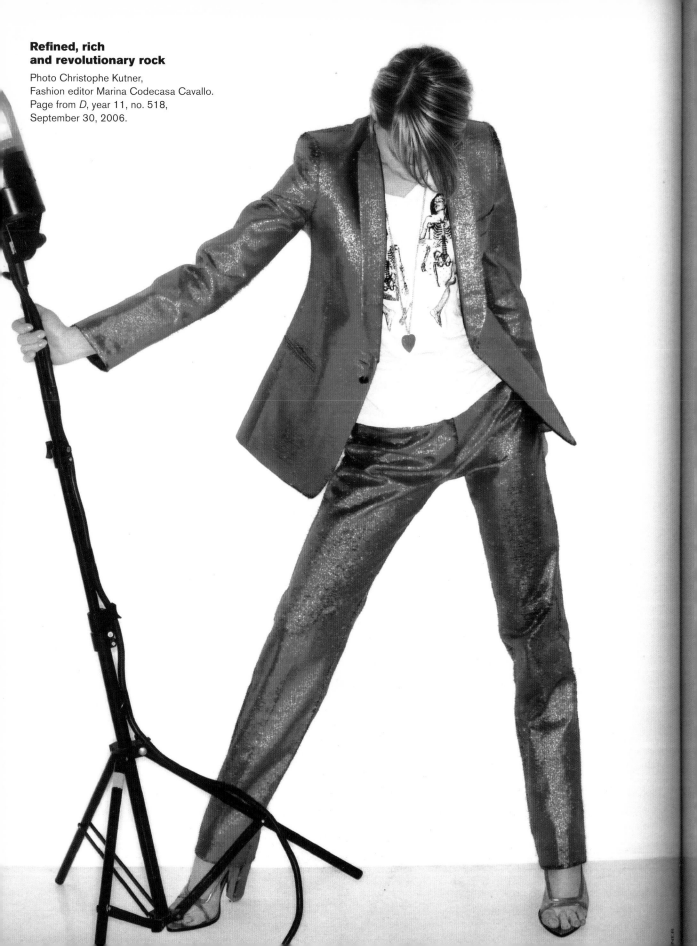

**Refined, rich
and revolutionary rock**

Photo Christophe Kutner,
Fashion editor Marina Codecasa Cavallo.
Page from *D*, year 11, no. 518,
September 30, 2006.

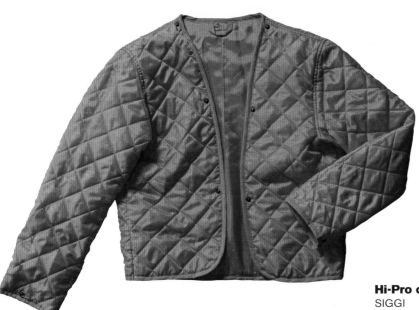

Hi-Pro outfit internal padding
SIGGI

Jacket and pants in thermal polyester used as padding for the high-visibility outfit made out of fabric in conformity with ISO 16603/04. Class 2.

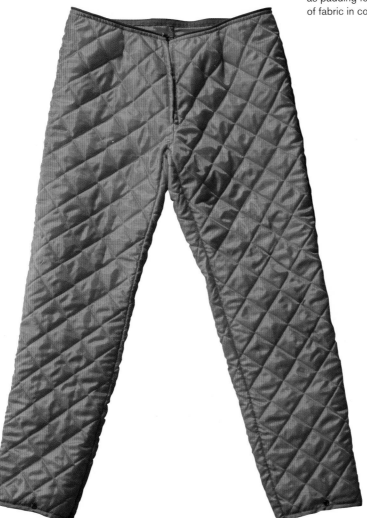

GENERAL REGULATIONS FOR THE PREVENTION OF ACCIDENTS

WORKERS' OBLIGATIONS

1. Each worker must take care of his or her own safety and health and that of other people present in the workplace, who may be affected by his or her actions or emissions, in conformity with his or her training and the instructions and means provided by the employer.

2. In particular workers should:

a) follow the directions and instructions given by the employer, managers and other people in charge, for the purposes of collective and individual protection;

b) make correct use of machinery, equipment, tools, dangerous substances and preparations, means of transport and work facilities, as well as safety devices;

c) utilize the systems of protection placed at their disposal in an appropriate manner;

d) immediately report to the employer, manager or other person in charge any inadequacies of the means and devices referred to under letters b and c, as well as any dangerous conditions that come to their notice, taking direct measures, in case of urgency, within the limits of their competence and ability to eliminate or reduce such inadequacies or dangers, while informing the person responsible for safety at the works;

e) not remove or modify safety, warning or control devices without authorization;

f) not carry out operations or actions of their own initiative that are not within their competence or that might compromise the safety of themselves or other workers;

g) undergo the health checks provided for them;

h) contribute, along with the employer, managers and other people in charge, to the fulfillment of all the obligations placed on them by the competent authority or that are otherwise necessary to ensure the safety and health of workers at work.

3. The failure to respect the aforesaid obligations will be punished in conformity with the provisions of art. 93 D.L. no. 626 of Sep 19, 1994 and subsequent modifications.

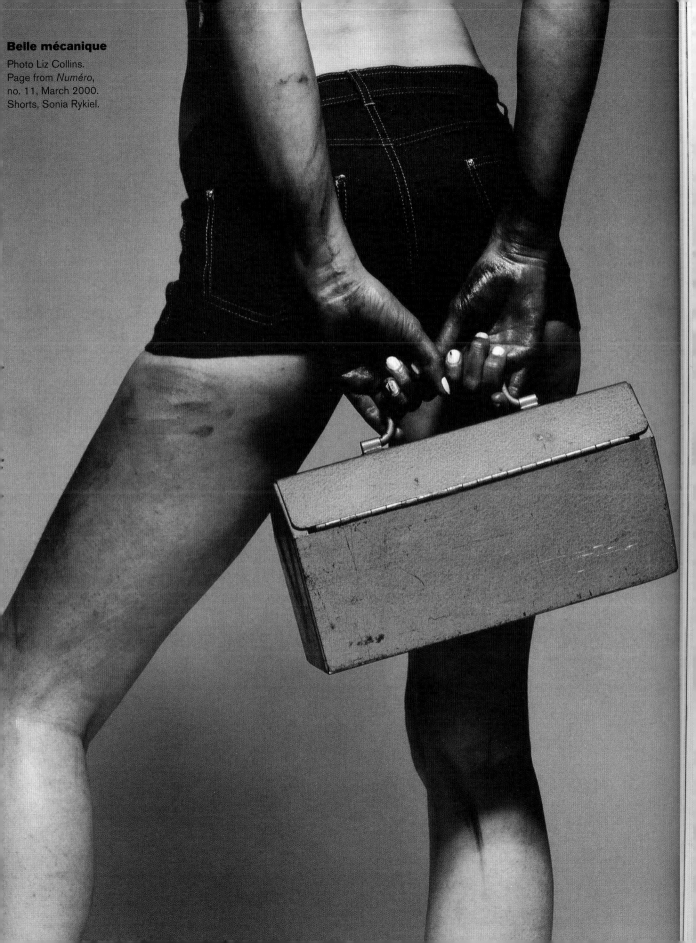

Belle mécanique

Photo Liz Collins.
Page from *Numéro*,
no. 11, March 2000.
Shorts, Sonia Rykiel.

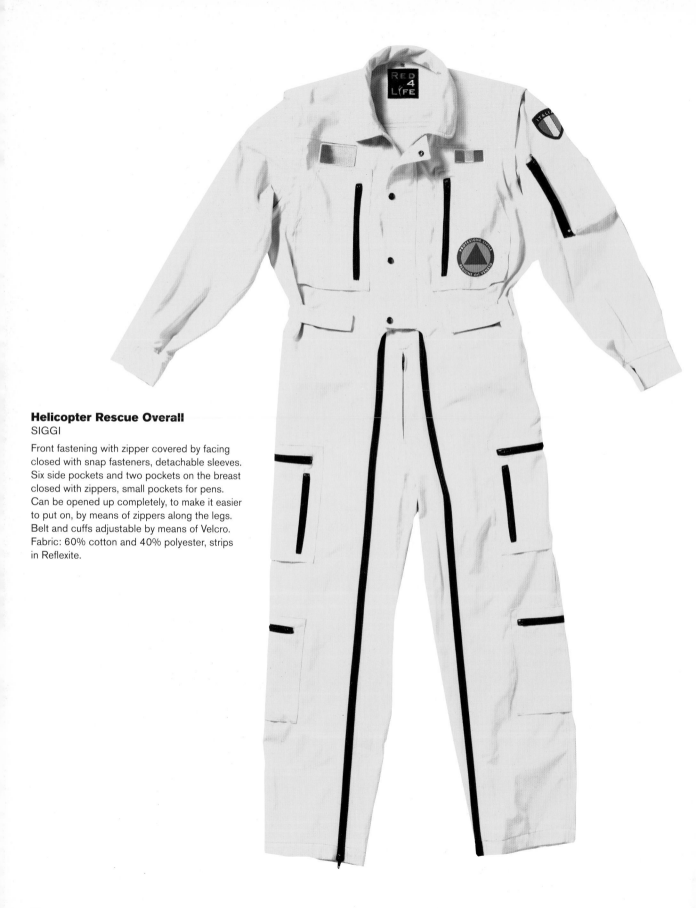

Helicopter Rescue Overall
SIGGI

Front fastening with zipper covered by facing
closed with snap fasteners, detachable sleeves.
Six side pockets and two pockets on the breast
closed with zippers, small pockets for pens.
Can be opened up completely, to make it easier
to put on, by means of zippers along the legs.
Belt and cuffs adjustable by means of Velcro.
Fabric: 60% cotton and 40% polyester, strips
in Reflexite.

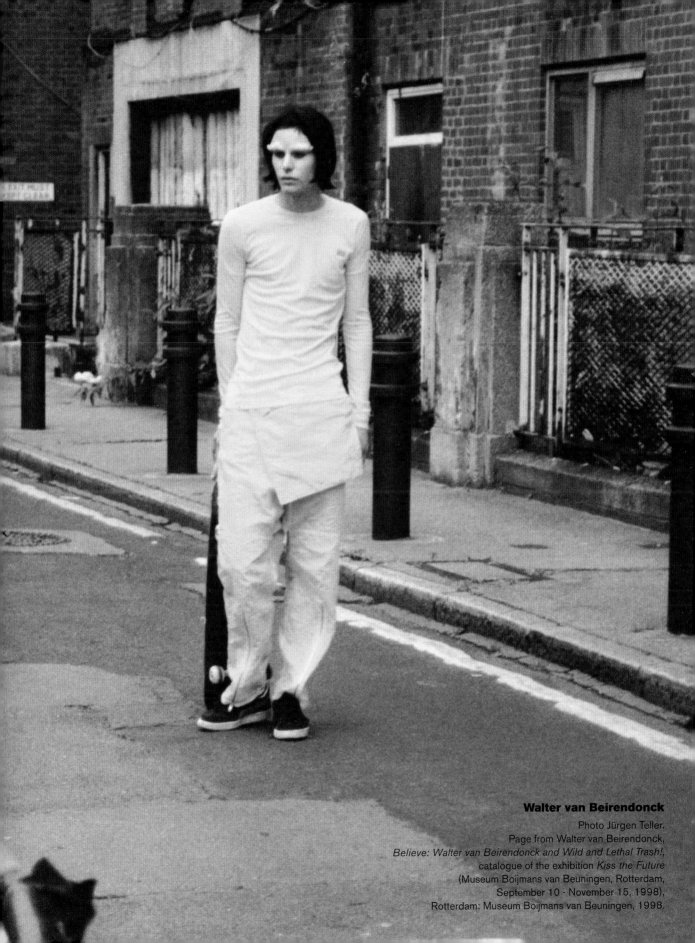

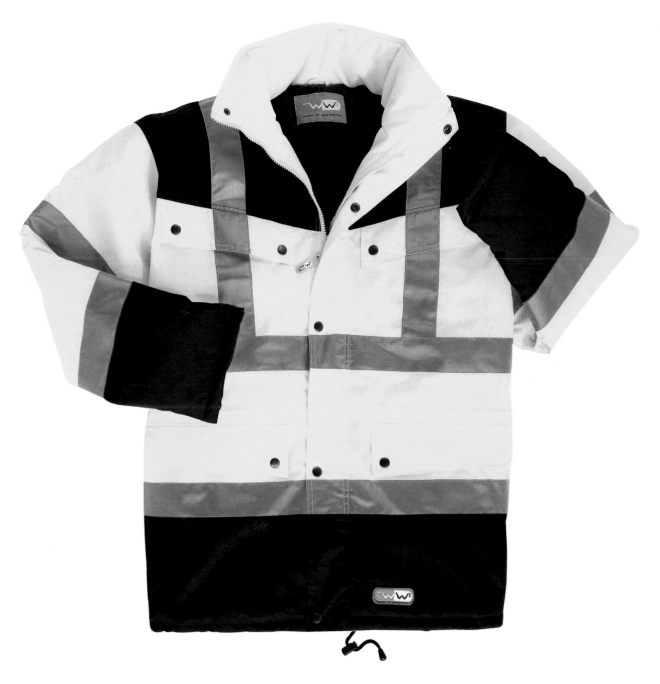

High-visibility parka
SPERIAN

Outshell: 100% Oxford polyester with PU coating and waterproofed seams.
3M reflective strips and quilted padding.
Adjustable attached hood stored in the collar, four external pockets plus
one internal one. Drawcord on waist and garment base and cuffs elasticized
on the inside.

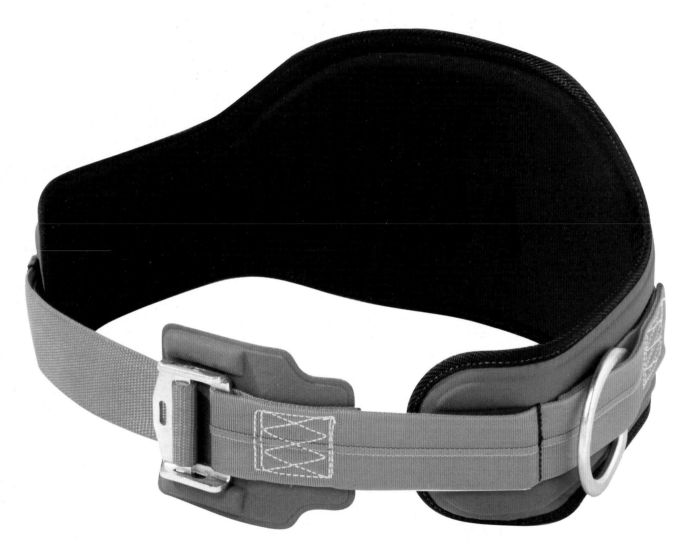

Positioning belt
SPERIAN

Adjustable back support,
galvanized steel roller buckle,
2 stainless steel rings at the sides.

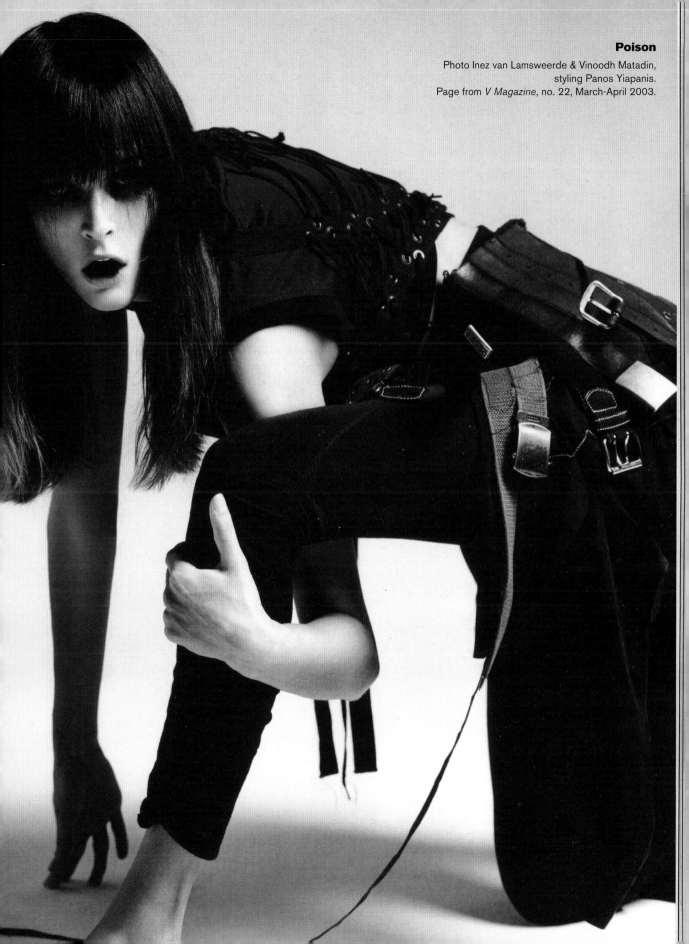

Poison

Photo Inez van Lamsweerde & Vinoodh Matadin,
styling Panos Yiapanis.
Page from *V Magazine*, no. 22, March-April 2003.

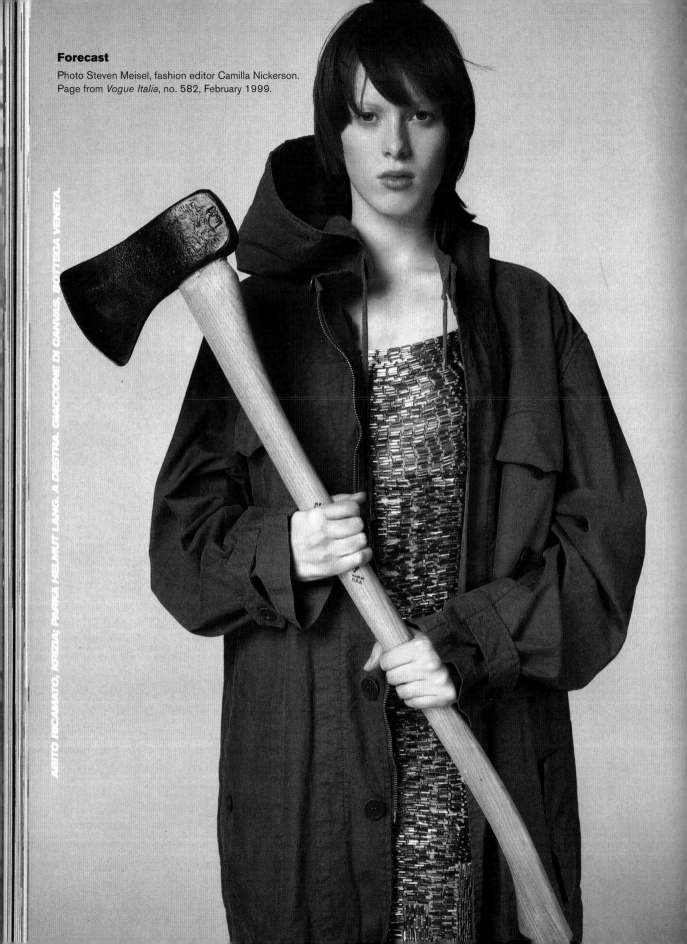

Forecast

Photo Steven Meisel, fashion editor Camilla Nickerson.
Page from *Vogue Italia*, no. 582, February 1999.

ABITO RICAMATO, KRIZIA. PARKA HELMUT LANG. A DESTRA, GIACCONE DI CANVAS, BOTTEGA VENETA.

SAFETY FOOTWEAR

OBLIGATORY

Segnaletica Italiana D.L. 493 del 14/08/96 - CEE 92/58 - UNI

Accident-prevention shoe
LOTTO WORKS

Suede leather upper, rubber toecap, water-resistant nylon trims, air mesh
lining. Anatomical polyethylene insole and dual-density polyurethane sole.
Rexist (non metal) midsole.

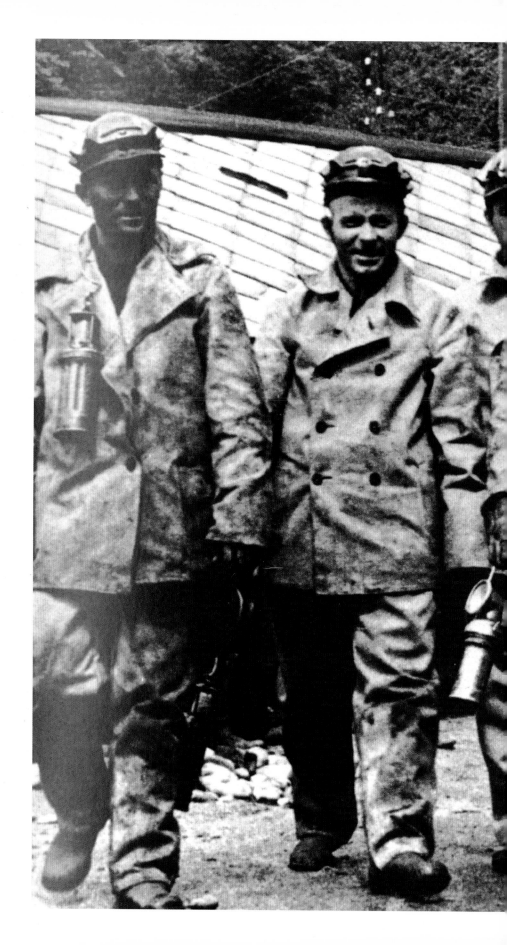

Alexei Stakhanov

(in foreground)
Photo RIA Novosti, 1930.
Page from Bruce Bernard (ed.),
*Century: One Hundred Years
of Human Progress, Regression,
Suffering and Hope*. London:
Phaidon, 1999.

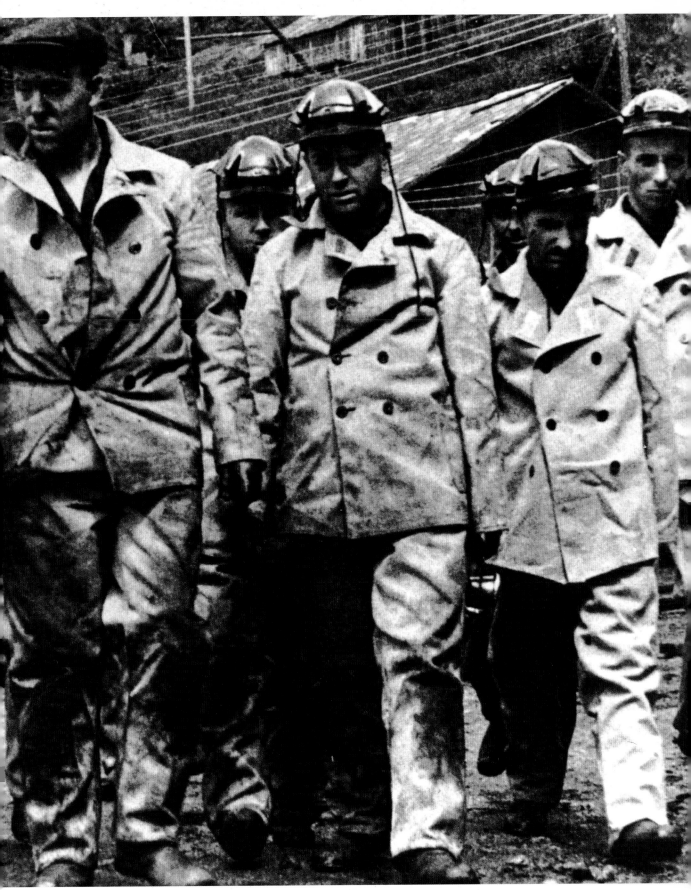

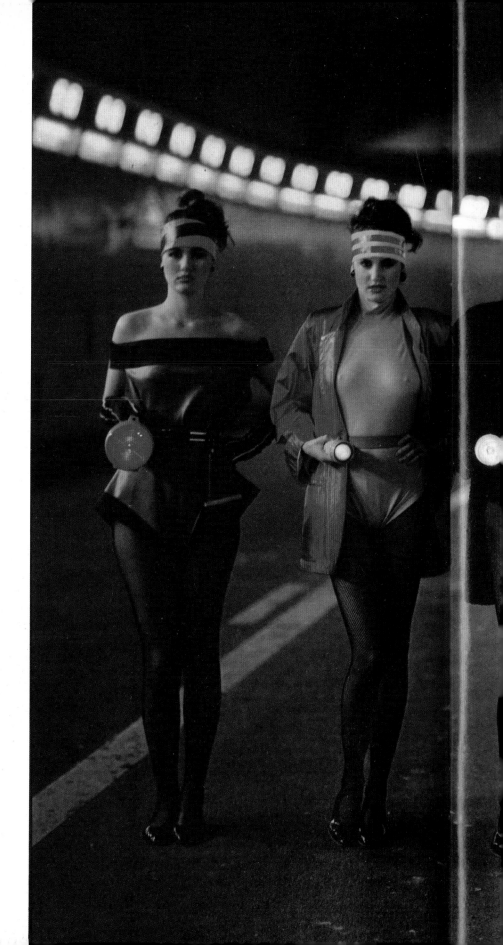

Forum des Halles

Photo Oliviero Toscani,
editorial for the magazine *Elle*.
Pages from *Frigidaire*, no. 38,
January 1984.

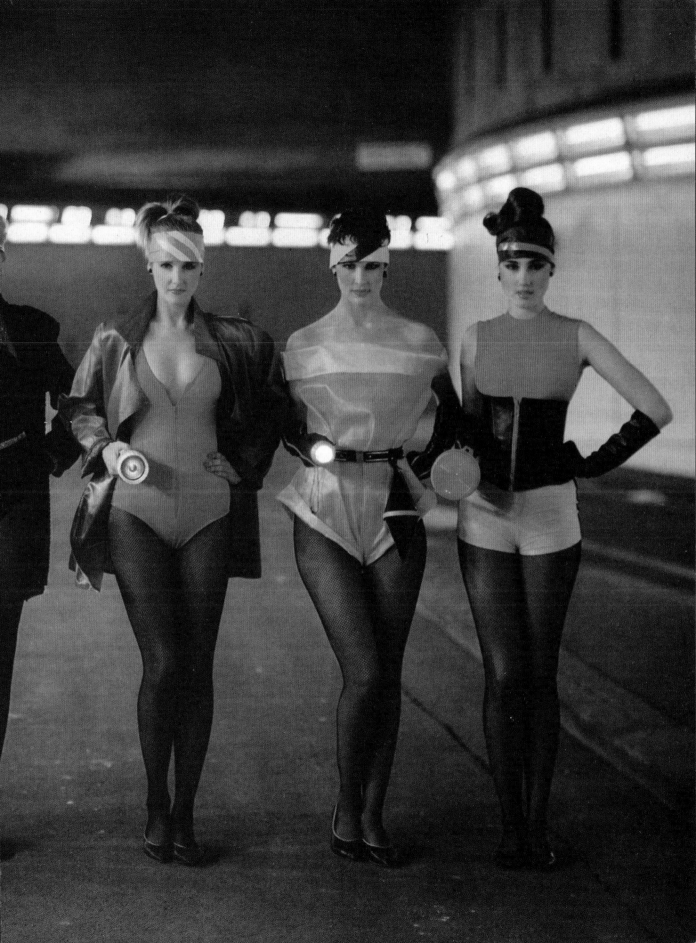

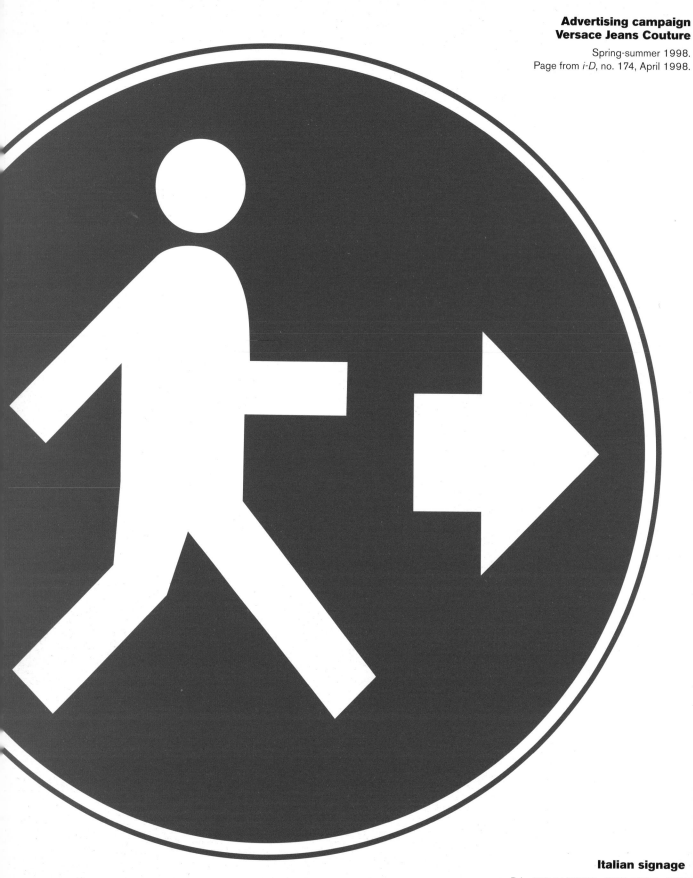

**Advertising campaign
Versace Jeans Couture**
Spring-summer 1998.
Page from *i-D*, no. 174, April 1998.

Italian signage
D.L. 493 14/08/96 - CEE 92/58 - UNI

VERSACE
JEANS COUTURE

NATI IN **FABBRICA: CRESC**

Born in the Factory

Photo Oliviero Toscani
published in
L'Uomo Vogue, 1975.
Oliviero Toscani archive

UTI NELLA VIA

Headlight, water resistant
ARGO FLASHLIGHT

Light thermoplastic structure turned on by push-button
and with various levels of illumination. Rubber bands
included. Water resistant to a depth of 1 m for one hour.

South Africa

Photo James P. Blair, 1976. Page from Jane Livingstone
(ed.), *Odyssey: l'arte della fotografia al "National
Geographic"*, catalogue of the exhibition *Odyssey: the
Art of Photography at "National Geographic"* (Corcoran
Gallery of Art, Washington D.C., 1988). Florence: Alinari,
1989.

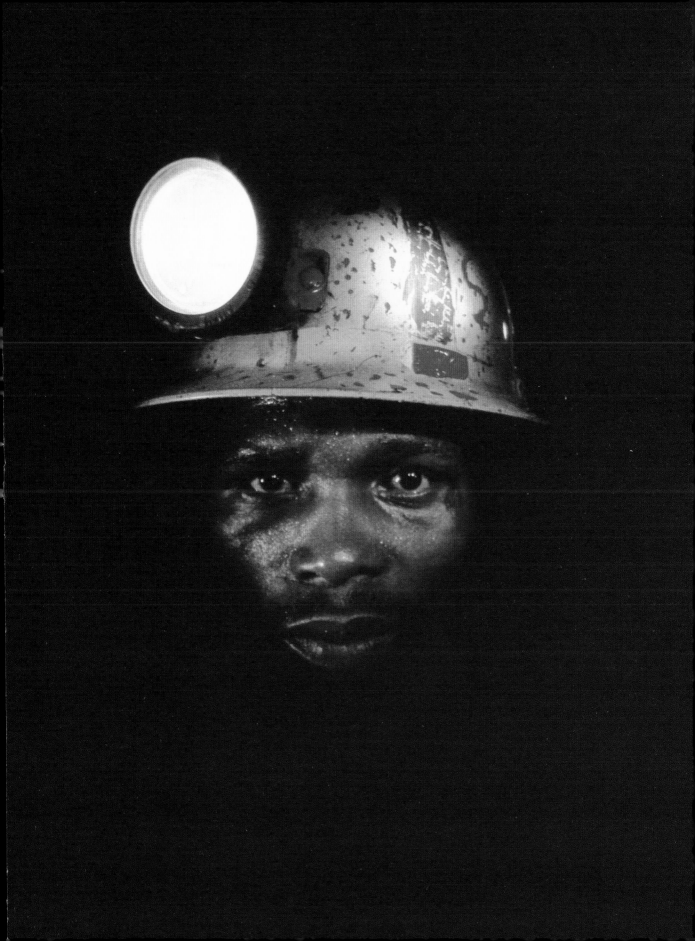

Earplugs
MOLDEX

Earplugs that adapt perfectly to the acoustic duct. Available in various versions.

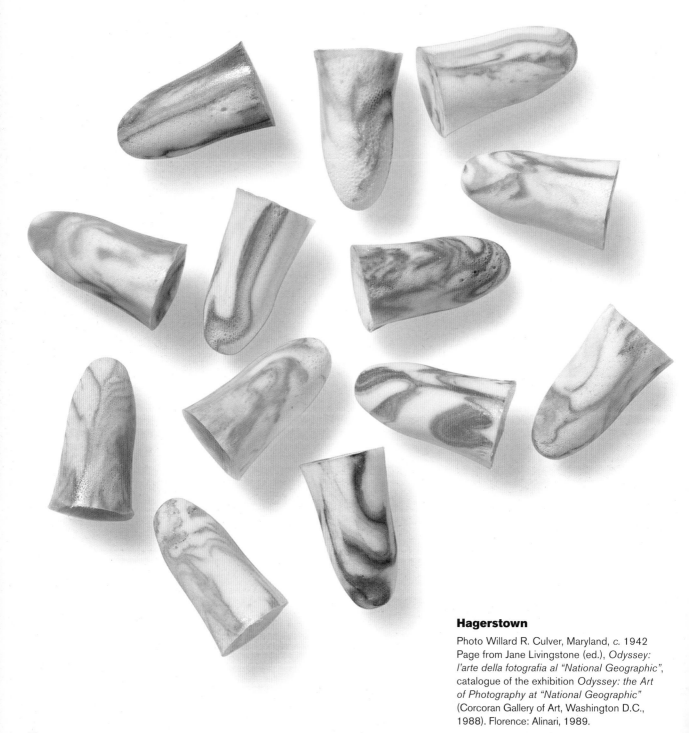

Hagerstown

Photo Willard R. Culver, Maryland, *c.* 1942
Page from Jane Livingstone (ed.), *Odyssey: l'arte della fotografia al "National Geographic"*, catalogue of the exhibition *Odyssey: the Art of Photography at "National Geographic"* (Corcoran Gallery of Art, Washington D.C., 1988). Florence: Alinari, 1989.

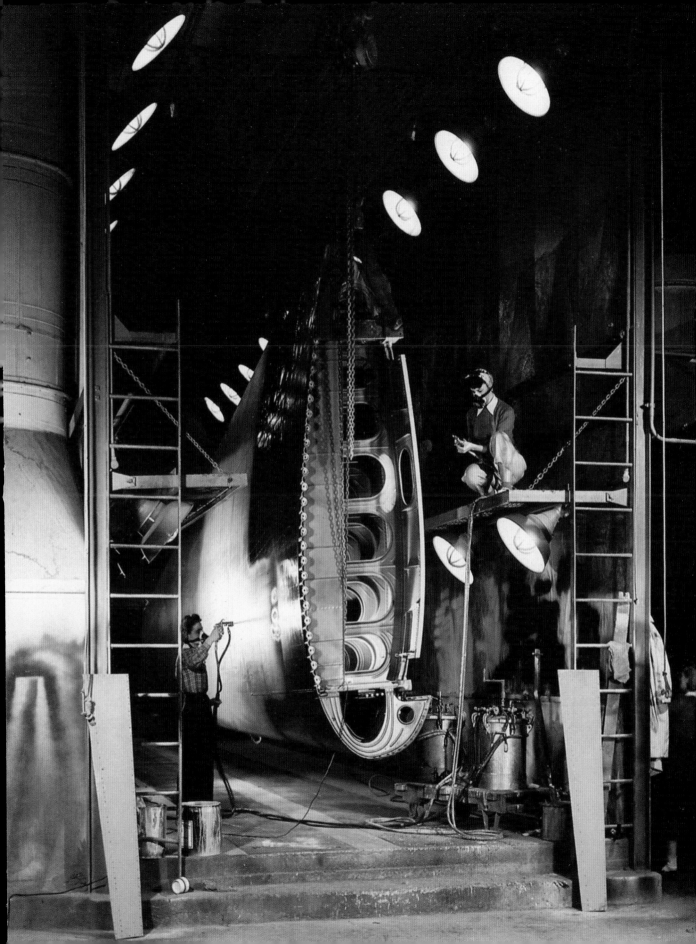

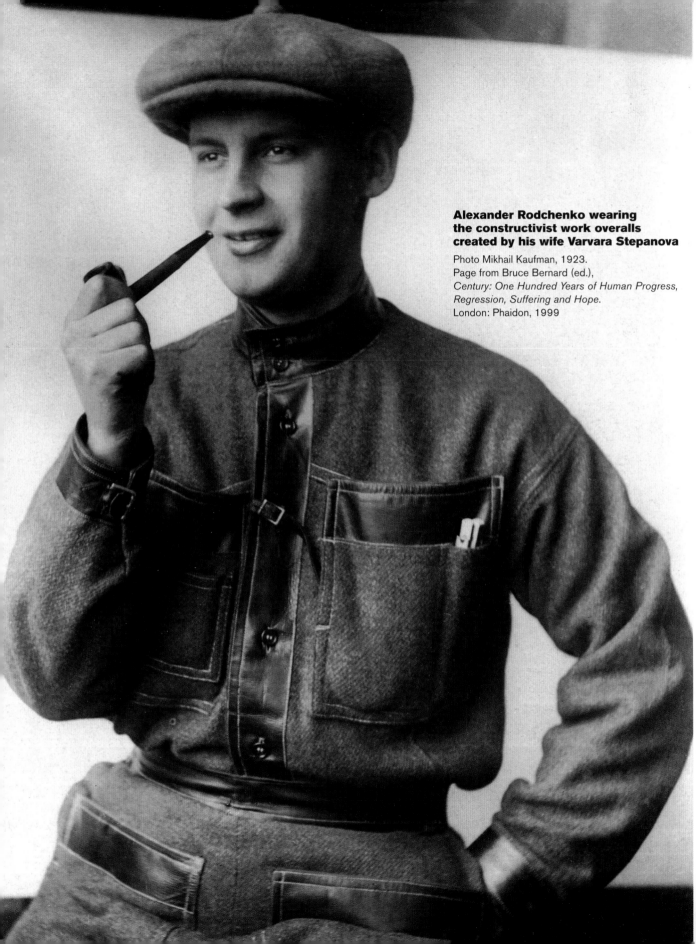

Alexander Rodchenko wearing the constructivist work overalls created by his wife Varvara Stepanova

Photo Mikhail Kaufman, 1923.
Page from Bruce Bernard (ed.),
Century: One Hundred Years of Human Progress, Regression, Suffering and Hope.
London: Phaidon, 1999

Dressing like the workers

Photo Oliviero Toscani published in
L'Uomo Vogue, 1976.
Olivero Toscani archive.

L'UOMO VOGUE

settembre 1976

VA A SINISTRA L'ASSE DELLA MODA?
VESTIRE COME GLI OPERAI

C'è da chiedersi perché il berrettuccio di lana da operaio e lo
scarponcino da lavoro siano una costante di quasi tutte le collezioni
dei giovani stilisti e di quelle di nomi
legati ad una produzione costosa, tipo
Dior Valentino Albini, e siano il primo
sintomo di un vestire più semplificato,
volutamente spoglio e apparentemente
quasi anonimo.

Che sia perché gli orientamenti politici
si fanno sentire anche nella moda e fanno andare anche questo
tipo di scelte più a sinistra? O forse perché la sensazione che tutte
le spese, abbigliamento compreso, andranno ridimensionate, sposta
l'interesse verso capi più « basic » e più spartani? O ancora perché,
in momento di compromessi più o meno storici, forte è la tentazione
di mimetizzarsi il più possibile con le masse emergenti?

Che sia invece per la praticità d'uso e la facilità di manutenzione dei veri abiti
da lavoro scoperti nei mesi passati come utilizzabili nella vita di tutti i giorni, e di cui
l'industria – alla ricerca di prodotti alternativi e di minor costo – tenta di trasportarne
il concetto anche nelle proposte realizzate dai normali canali di produzione?
Che sia semplicemente una evoluzione nella ricerca degli « addetti », che dopo
aver attinto ad ogni tipo di folk e di revival, trovano ora nel mondo del
lavoro i giusti spunti?

O, tornando a buttarla in politica, che tutto questo sia davvero la spia
di un eurocomunismo di cui molto si parla e che sta forse maturando,
e di cui la moda anticipa tendenze egualitarie e influenze dei
lavoratori?

Interrogativi a cui solo a posteriori si potrà tentare di dare
una risposta esatta. Ad ogni modo registriamo il fenomeno:
in questo numero tutte le proposte per un vestire
« casual » dei nomi che contano,
e che, per un verso o per
l'altro, tengono d'occhio
questa nuova svolta
« operaia » del gusto
e del costume. *G.B.*

Nella foto:
berretto di Robert Bruno
per Tescosa. Gli scarponcini
sono di Tiber.

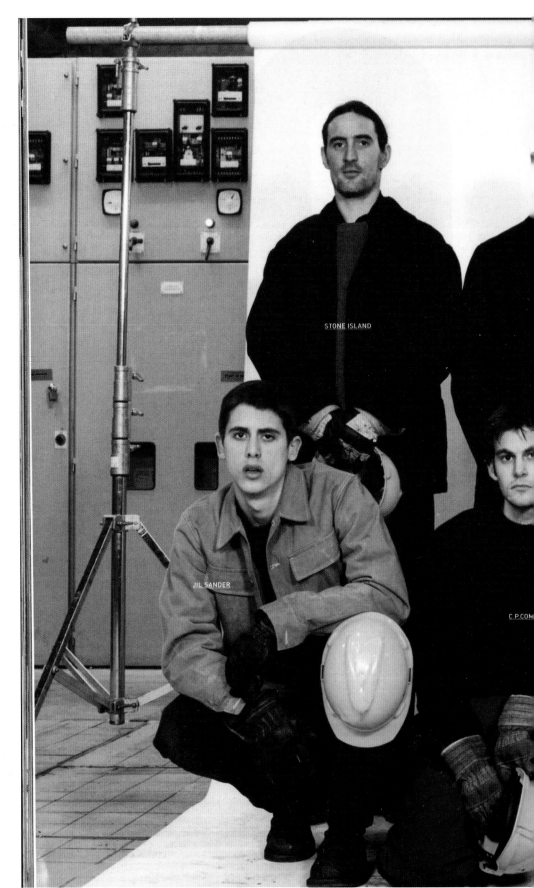

Factory boys

Photo Nathaniel Goldberg,
fashion editor Jane How.
Pages from *L'Uomo Vogue*,
no. 294, October 1998.

FACTORY BOYS

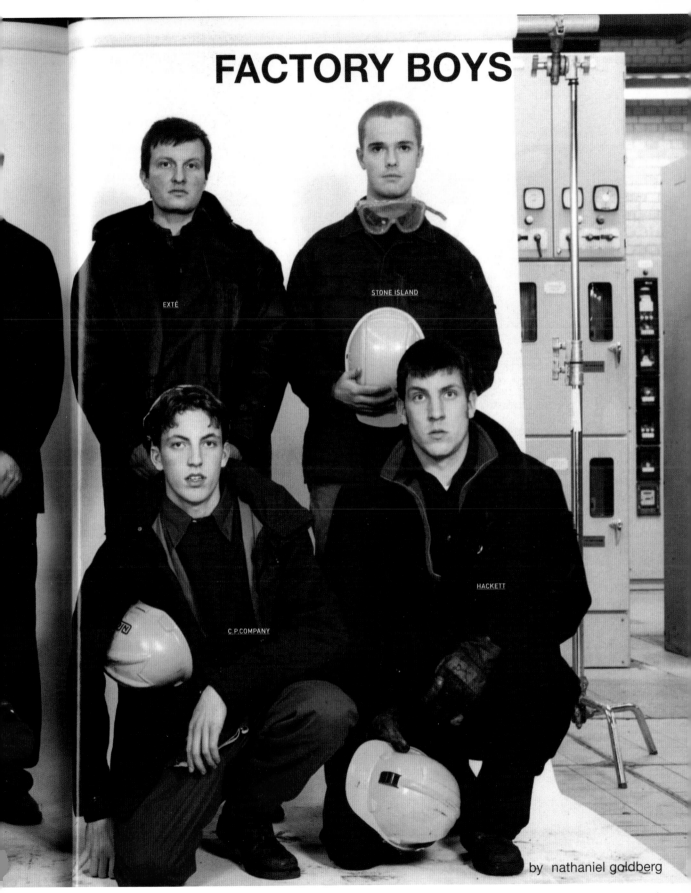

EXTÉ

STONE ISLAND

C.P. COMPANY

HACKETT

by nathaniel goldberg

Windproof jacket
DIADORA

Jacket in crushproof, windproof, rainproof and coldproof fabric. Lining and padding 100% polyamide. Sulfur yellow color.

Three-layer waterproof pants
DIADORA

Windproof and rainproof pants. Prevents any infiltration of water.

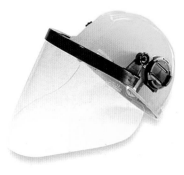

Face protection
SAFETY

Visor mounted directly on safety helmet. Neutral color, in acetate. Protects against electric shocks. Scratchproof and shockproof.

Single lens safety spectacles
MILLENIA SPORT

Wraparound scratchproof lens. Light and balanced frame.

Protective mask
3M

Mask designed for protection from particulates and dust. Can be used when grinding. Large and comfortable.

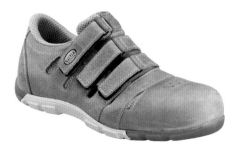

Safety shoe
DIADORA

Pull-up shoe with aluminum 200 joule toecap. Bicolor antiperforation rubber outsole.

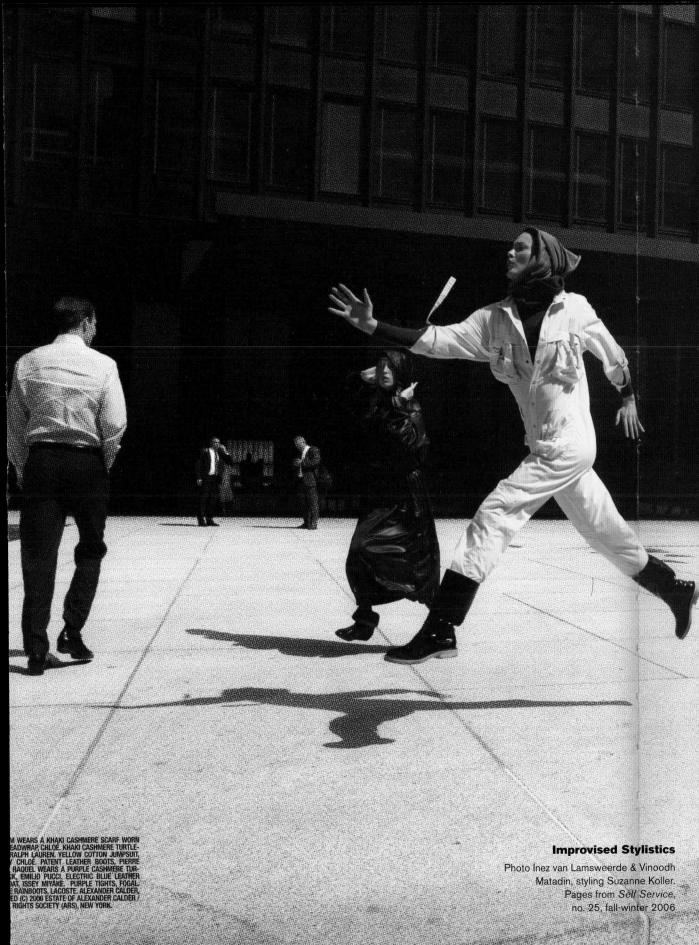

Improvised Stylistics

Photo Inez van Lamsweerde & Vinoodh
Matadin, styling Suzanne Koller.
Pages from *Self Service*,
no. 25, fall-winter 2006

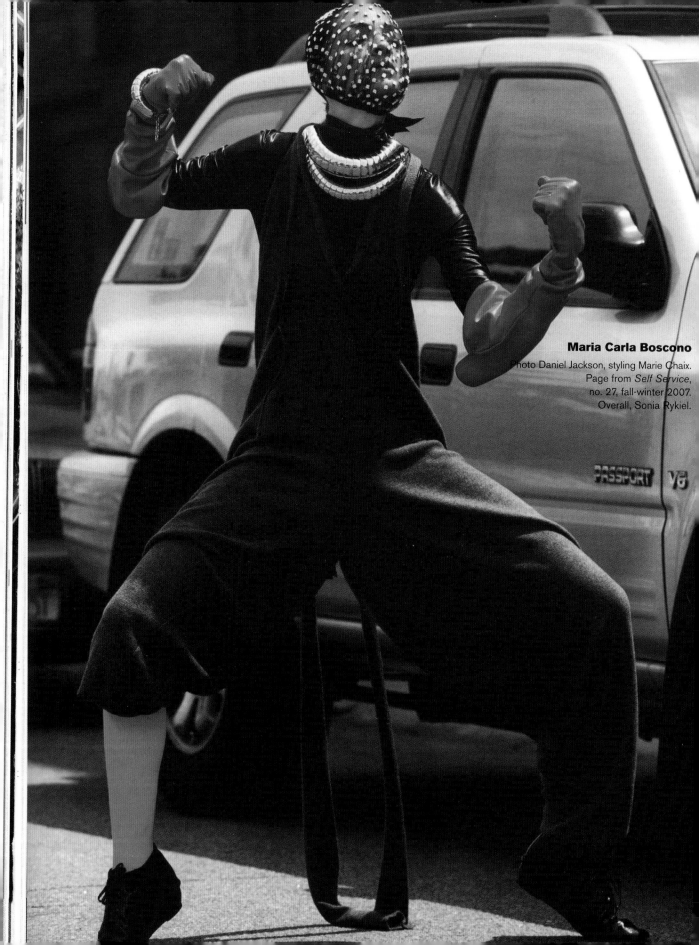

Maria Carla Boscono
Photo Daniel Jackson, styling Marie Chaix.
Page from *Self Service*,
no. 27, fall-winter 2007.
Overall, Sonia Rykiel.

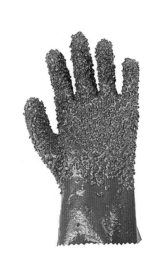

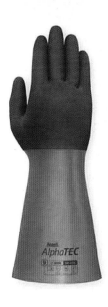

Insulated glove
SALISBURY

To be used with protective leather gloves. Resistant up to a maximum of 5000 V of alternating current. Test every 6 months at a voltage of 1000.

PVC and nitrile-coated glove
WELLS LAMONT

Red PVC with PVC chip surface, fully coated and interlock-lined for easy cleaning. Strong and ideal for abrasive applications. PVC chip surface provides superior wet/dry grip and protects against a wide range of chemicals. Designed for harsh environments.

PVC and nitrile-coated glove
WELLS LAMONT

Nitrile layer actively repels oil and other lubricants, increasing grip control. Comfortable design reduces fatigue and fatigue-related injuries. Seamless knit lining for added comfort. Nitrile surface treatment for extraordinary oil grips, chemical resistance, dexterity and flexibility.

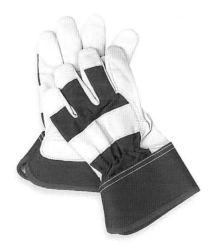

Safety orange jersey gloves
WELLS LAMONT

Black PVC microdots provide a strong, sure grip. Comfortable, washable and brightly colored for high visibility. Clute cut straight thumb and knit wrist.

Welding gloves
CONDOR

14" red cowhide gloves feature one-piece back construction with a full cotton lining. Continuous welting on thumb and forefinger and tips of other fingers provides extra protection against burn-out of seams. Gunn cut with a wing thumb. Reinforced thumb strap.

Leather palm gloves
CONDOR

Safety cuff and gauntlet styles feature leather wrapped index finger, fingertips, knuckle strap and pull with striped canvas back and wing thumb. Double palm has extra layer of leather in high-wear areas. Full leather style protects both palm and back of the hand.

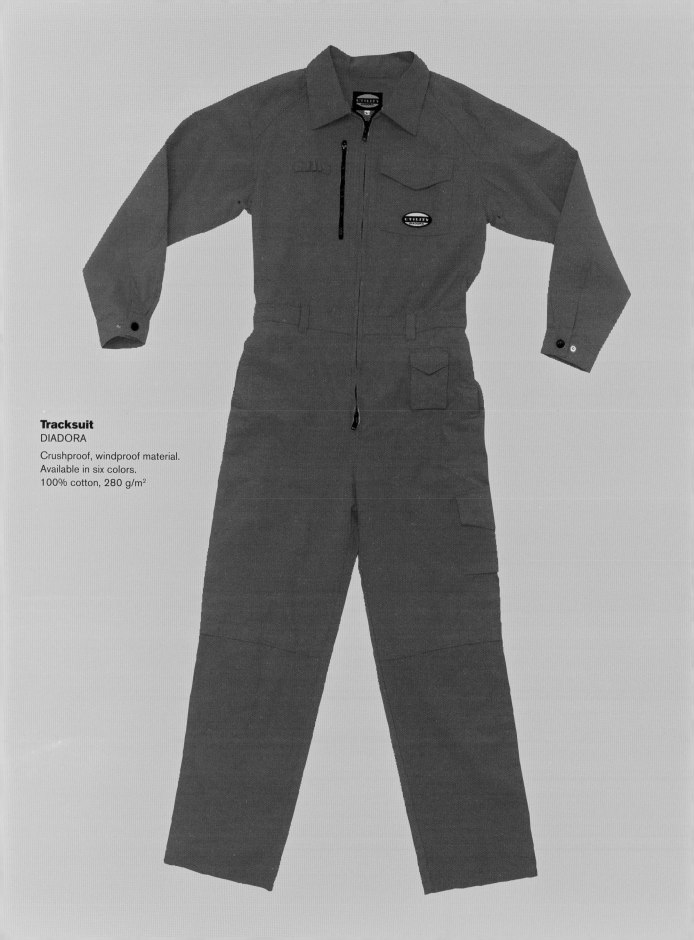

Tracksuit
DIADORA

Crushproof, windproof material.
Available in six colors.
100% cotton, 280 g/m²

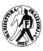

Apron with bib
FRAIZZOLI
Total length *c.* 97 cm.
Apron, length *c.* 78 cm.

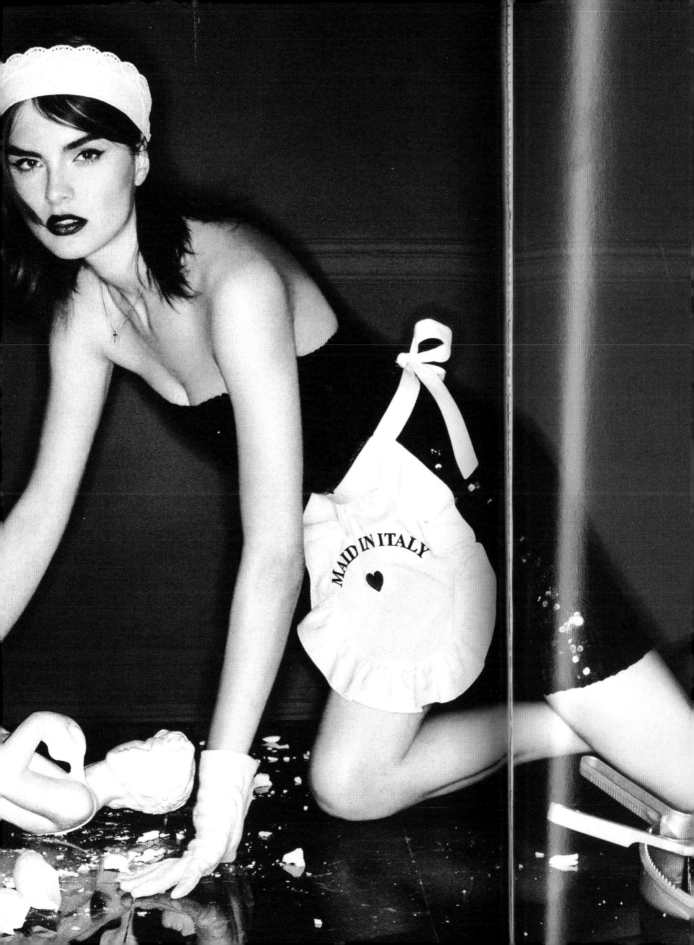

The Gulf Crisis
Photo Magnum .
Page from *The Face*,
no. 28, January 1991

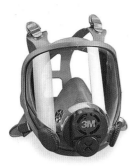

Full facepiece respirator
3M

Protects first-response personnel from most military and industrial materials in the event of local or national emergencies. NIOSH approved.

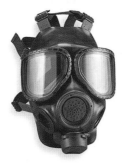

Full facepiece respirator
3M

Soft, comfortable silicone facepiece features a butyl rubber second skin for extra protection against chemical damage. Suspension with six adjustable head straps and clear outserts.

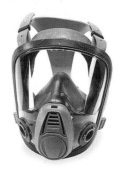

Advantage respirator
MSA

Protects against a variety of respiratory hazards, including nuisance odor, particulates and dust and toxic non-IDLH (Immediately Dangerous to Life or Health) atmosphere.

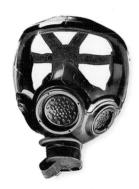

Millennium cbrn gas masks
MSA

Medium-size, military-style gas mask respirator, 40 mm thread canister mount, made of Hycar, with polyurethane lens, dual canister mount, elastic suspension cradle, adjustable head straps.

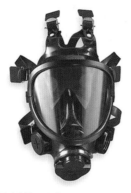

FR-7800B series
3M

Includes a butyl rubber full facepiece and CBRN canister. Optically correct lens meets ANSI standards for high-impact protection, while an exhalation valve cover helps protect the valve against chemical agents.

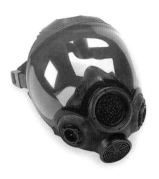

Full-face respirator
MSA

Medium-size full facepiece respirator, made of Hycar, with black facepiece color, elastic-type head strap, urethane lens and wide viewing capability, for use with MSA cartridges. Meets/exceeds NIOSH approval.

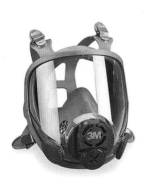

6000 series pressure respirator
3M

These lightweight EDPM/silicone units are flexible and durable for comfortable extended use. Feature polycarbonate lens for a wide field of vision, cradle suspension and easy-to-adjust head straps.

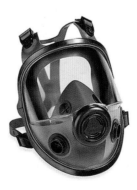

5400 & 7600 series respirator
NORTH SAFETY

Respirators protect eyes and face against irritating gases, vapors and flying particles. Scratch-resistant, polycarbonate lens provides a 200 degree field of vision. Lens fogging is kept to a minimum with the oral/nasal cup.

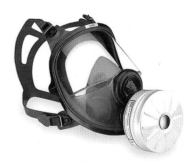

Gas mask
NORTH SAFETY

Includes nuclear/chemical/biological canister, gray facepiece, elastomer mask, polycarbonate lens, suspension cradle, lens with 200 degree field of vision. Features belt-mounted carry bag.

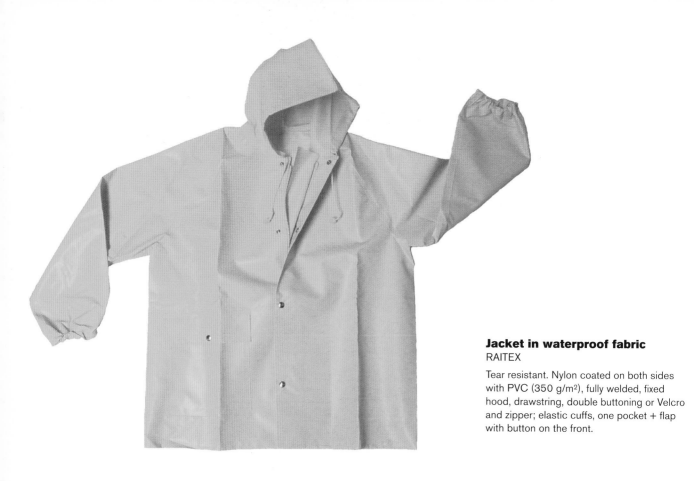

Jacket in waterproof fabric
RAITEX

Tear resistant. Nylon coated on both sides with PVC (350 g/m²), fully welded, fixed hood, drawstring, double buttoning or Velcro and zipper; elastic cuffs, one pocket + flap with button on the front.

Pants in waterproof fabric
RAITEX

Tear resistant. Nylon coated on both sides with PVC (350 g/m²), fully welded, with elastic waistband.

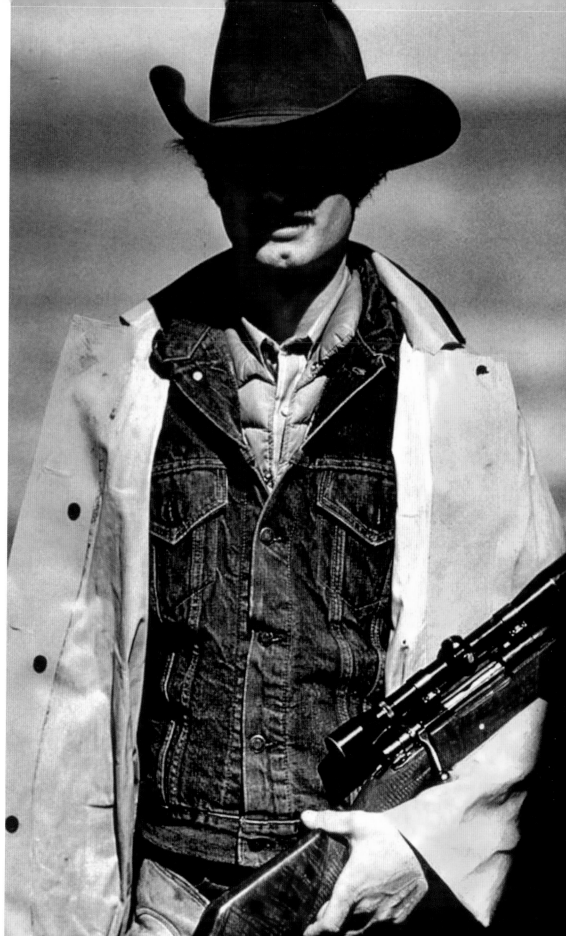

Trapper Cody
Jesus Jeans Advertising
Campaign.
Photo Oliviero Toscani,
Wyoming, 1974.
Olivero Toscani archive.

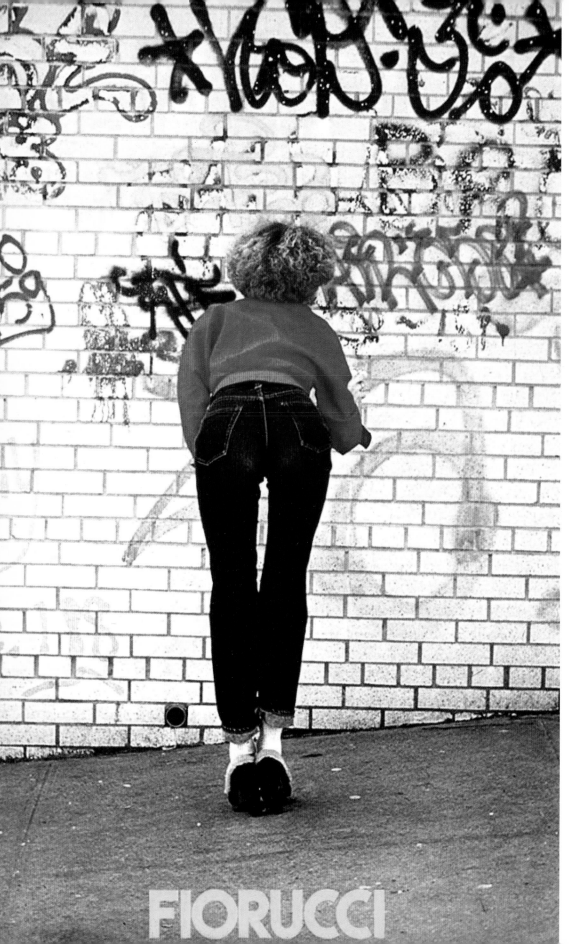

**Fiorucci
Advertising
Campaign**

Photo Oliviero Toscani,
1973.
Olivero Toscani archive.

FIORUCCI

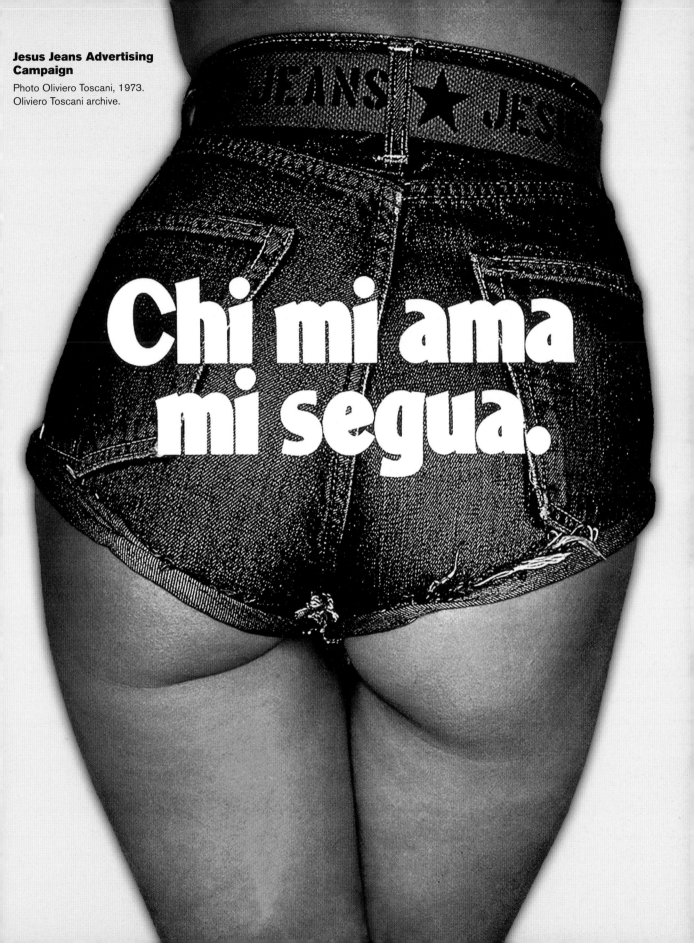

Jesus Jeans Advertising Campaign

Photo Oliviero Toscani, 1973.
Oliviero Toscani archive.

Photo Oliviero Toscani
published in *L'uomo
Vogue*, no. 9, 1975.
Oliviero Toscani archive.

Diving boots

America, year 1980
Stewart private collection

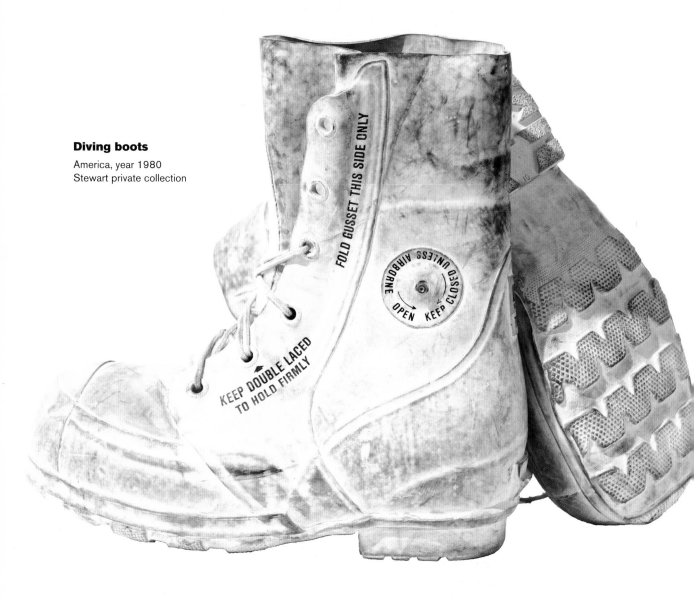

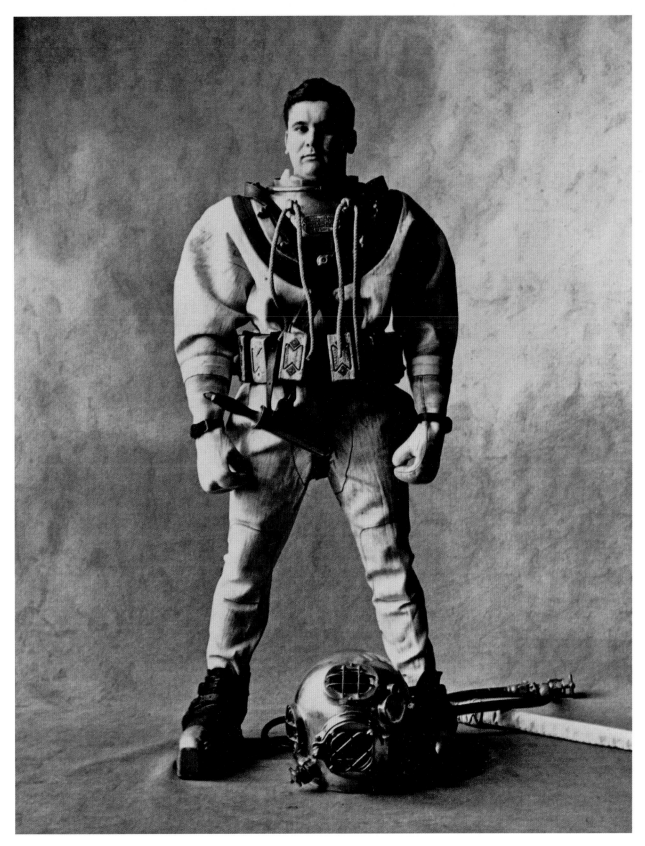

Diver

Photo Irving Penn, New York, 1951.
Page from Irving Penn, *Passaggi: archivio di lavoro*, Milan: Leonardo Editore, 1991.

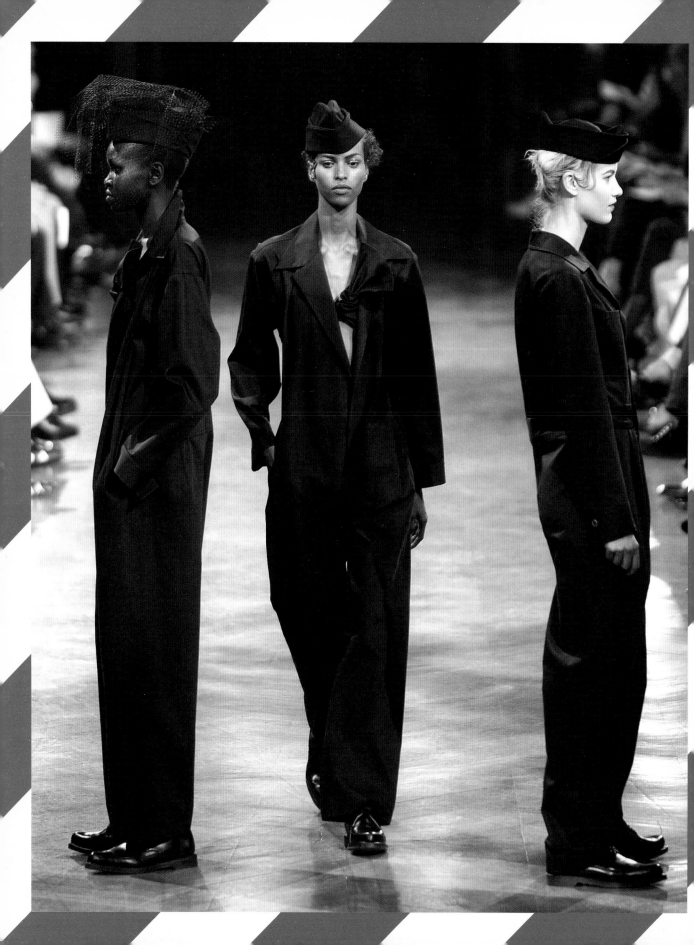

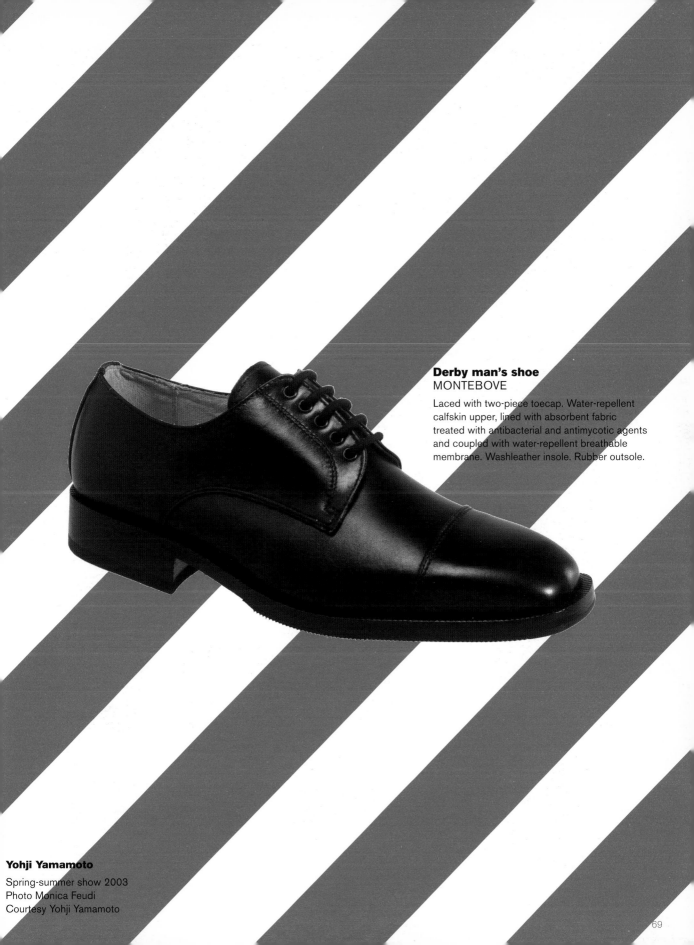

Derby man's shoe
MONTEBOVE

Laced with two-piece toecap. Water-repellent calfskin upper, lined with absorbent fabric treated with antibacterial and antimycotic agents and coupled with water-repellent breathable membrane. Washleather insole. Rubber outsole.

Yohji Yamamoto

Spring-summer show 2003
Photo Monica Feudi
Courtesy Yohji Yamamoto

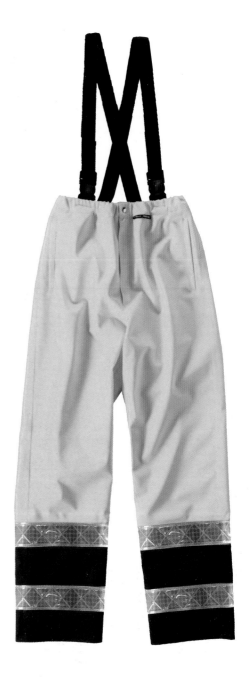

Hi-vis rain pants
SIGGI

Polyester with mesh lining material, elastic waist
with drawstring closure. ANSI certified.

Hi-vis rain pants
SIGGI

Polyester with mesh lining material, elastic waist
with drawstring closure. ANSI certified. Two outside
pockets. Fully washable.

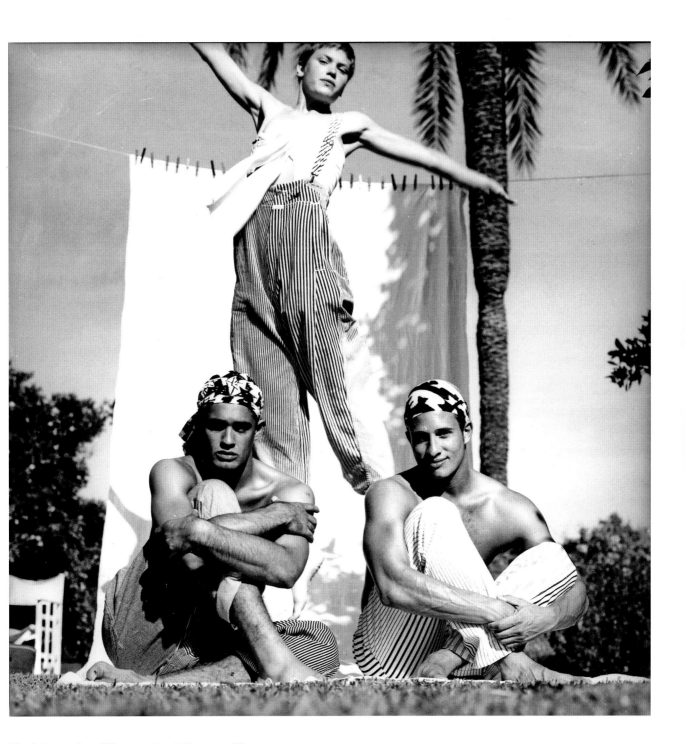

Model wearing "Suspender Bib overall"

Marithé + François Girbaud.
Photo Gilles Tapie, 1988
Courtesy Marithé + François Girbaud.

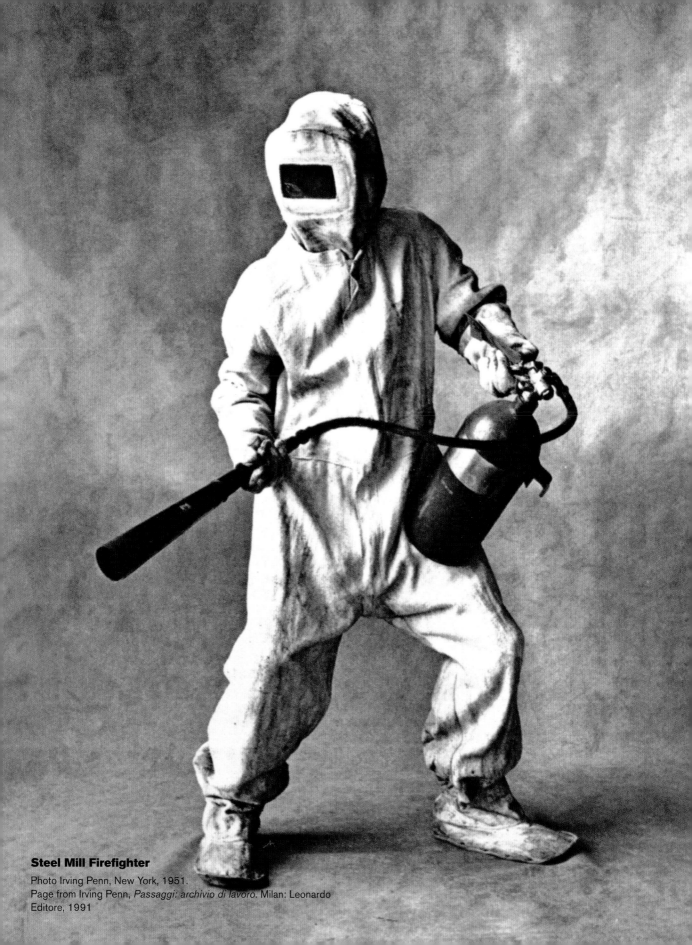

Steel Mill Firefighter

Photo Irving Penn, New York, 1951.
Page from Irving Penn, *Passaggi: archivio di lavoro*. Milan: Leonardo
Editore, 1991

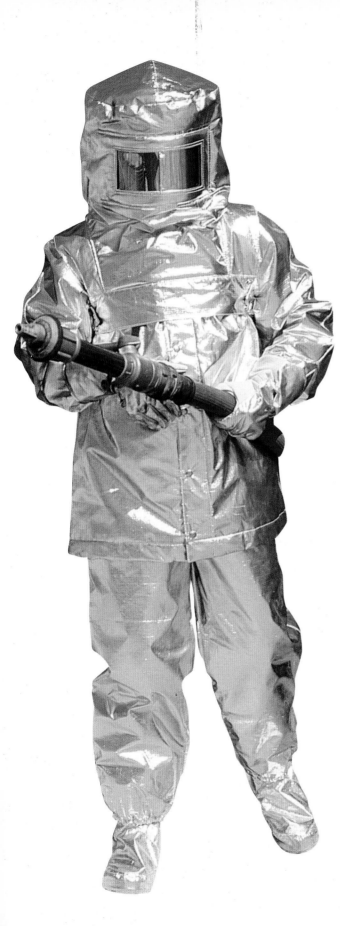

Fire proximity suit in aluminized glass fiber cloth
SPERIAN

Fire proximity suit in aluminized glass fiber cloth. Multilayer inner lining, integrated hood with 100 x 220 mm visor in laminated safety glass. 600 x 330 x 500 mm pouch on back to hold breathing apparatus, integrated boots with zipper fastening. 40 cm gloves.

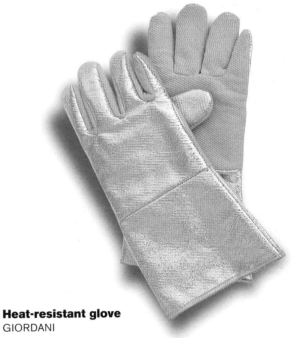

Heat-resistant glove
GIORDANI

Five-finger glove with palm in aramidic fiber and back made of aluminized rayon and 15 cm aluminized glass fiber sleeve.

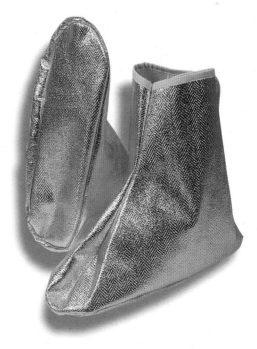

Heat-resistant boots
GIORDANI

Boots in aluminized aramidic fiber with opening at back closing, fastened with Velcro. Suitable for welding activity. Universal size.

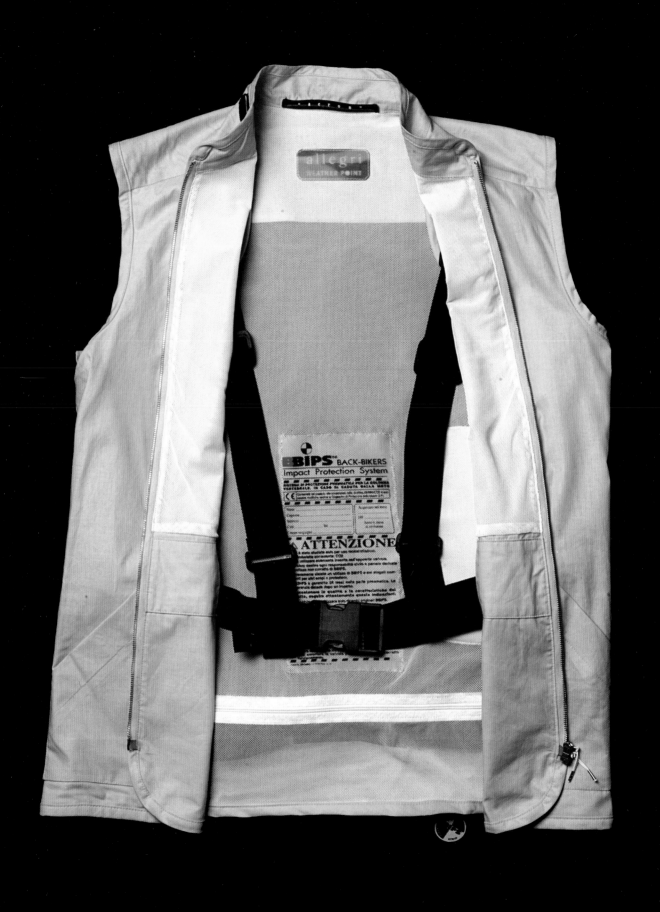

The essential collections story for a/w 08, featuring rubber tops, MA1's, plaid shirts, leotards, feathers, shells and keys. It's the time of year to start planning your winter wardrobe, so get your shopping on and start working out your top-to-toe killer looks. It's a lot.

"Aeron" vest
ALLEGRI

Spring-summer 1999.
Garment made of technical fabric with incorporated airbag.
Courtesy Allegri

I Wish I Had Invented Blue Jeans

Photo Simon Thiselton, styling Simon Foxton.
Page from *i-D*, no. 290, August 2008.
Vest and pants, Maison Martin Margiela.

PHOTOGRAPHY SIMON THISELTON
STYLING SIMON FOXTON

I wish I had invented blue jeans

Rufai wears vest and jeans Maison Martin Margiela. Armband Michael Costiff's WORLDarchive.

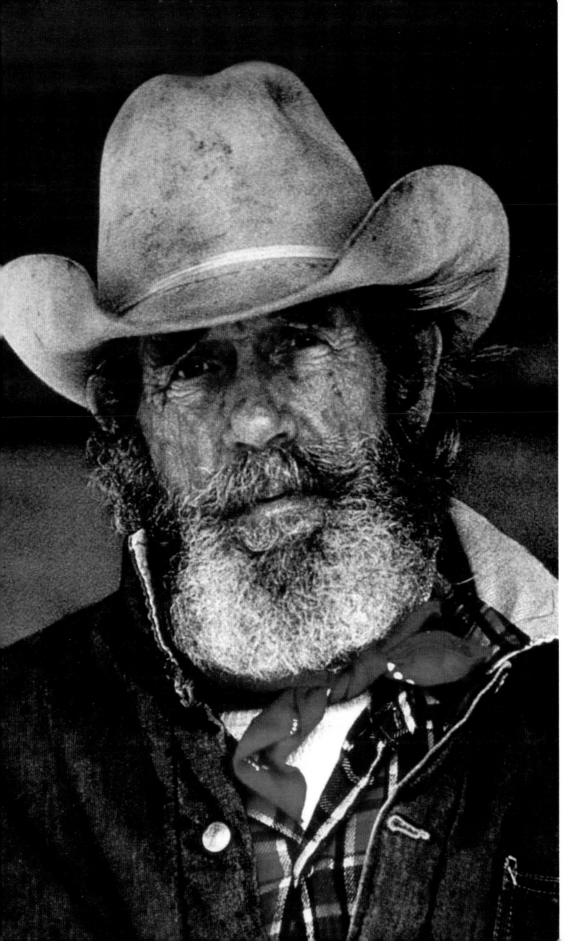

**Cowboy
Billings**

Jesus Jeans Advertising
Campaign.
Photo Oliviero Toscani,
Montana.
Oliviero Toscani archive.

Chic pocket

Un été *in the pocket* chez Hermès, avec la ceinture-
poche(s). L'article phare de la collection se porte
asymétrique (version solo) ou non (version duo), en cuir
ou en toile. Les poches, découpées comme des quar-
tiers de selle, permettent de se balader le nez en l'air et
les mains libres. Au petit mousqueton on accrochera
l'objet le plus indispensable : portable, clés, grigri…
Un seul problème : que mettre dans le sac "Kelly" ?

Chic Pocket

Photo Christophe Chavan
Page from *Numèro*,
no. 11, March 2000.
Bag, Hermès

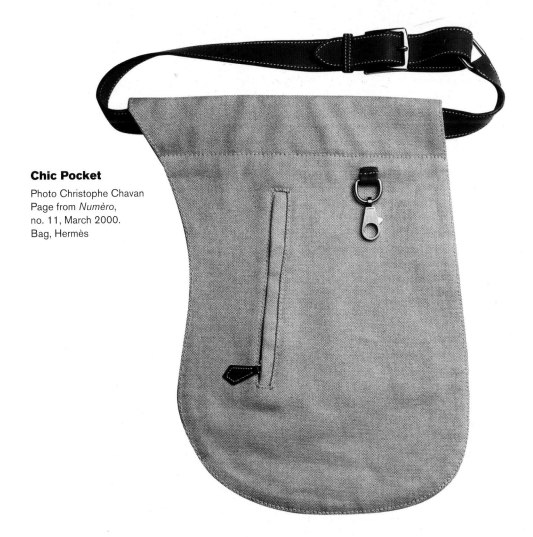

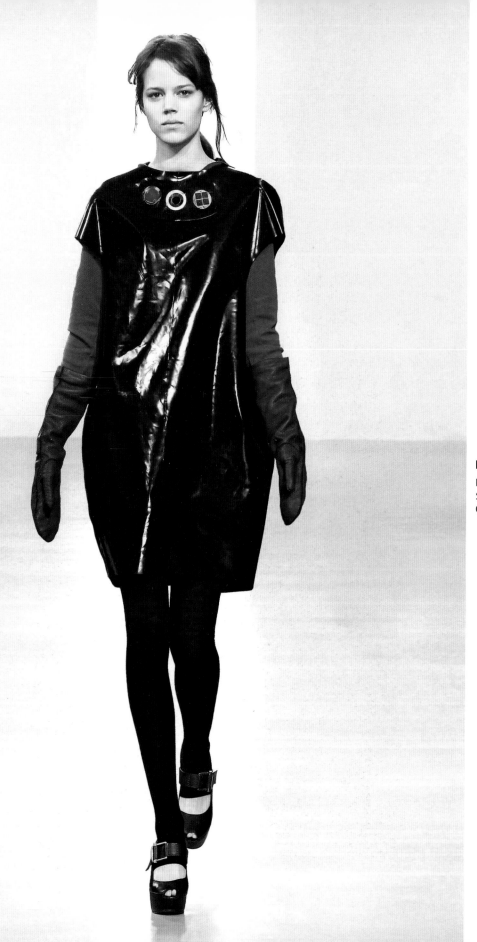

Marni
Fall-winter show
2007-08
Courtesy Marni

Sailor's overalls

England 1940
Stewart private collection

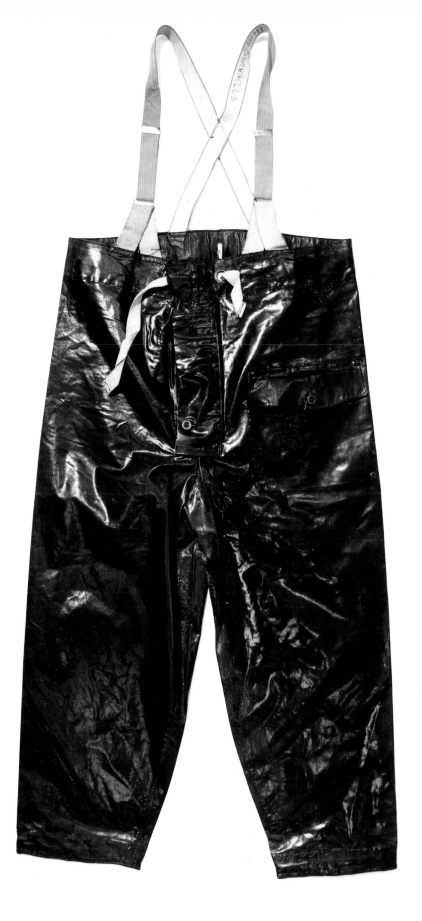

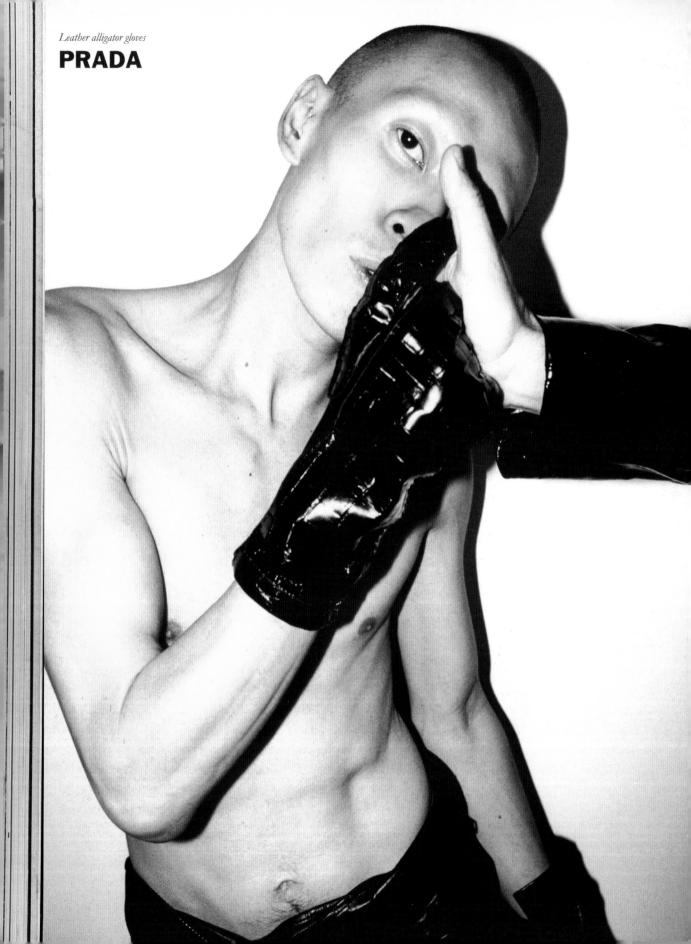

RULES OF CONDUCT

The use of rubber or leather gloves, equipped with special nonslip welting on palm and fingers, ensures a better grip on the objects to be handled. It is advisable to utilize safety gloves when handling slippery materials, when handling heavy objects and in general whenever a good grip is needed.

(UNI 8479 OF APRIL 1, 1989).

Private collection

Photo Magnus Unnar, styling Terence Koh. Page from *Purple Fashion Magazine*, no. 9, spring-summer 2008. Glove, Prada.

**Sreet sweepers
in Bryant Park
New York**

Page from *Colors*, July
- September 2000,
n. 38

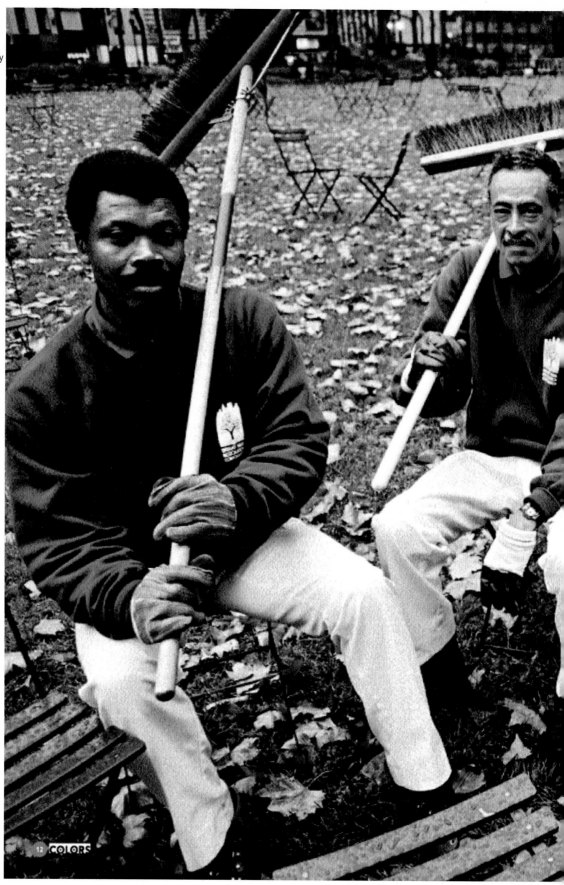

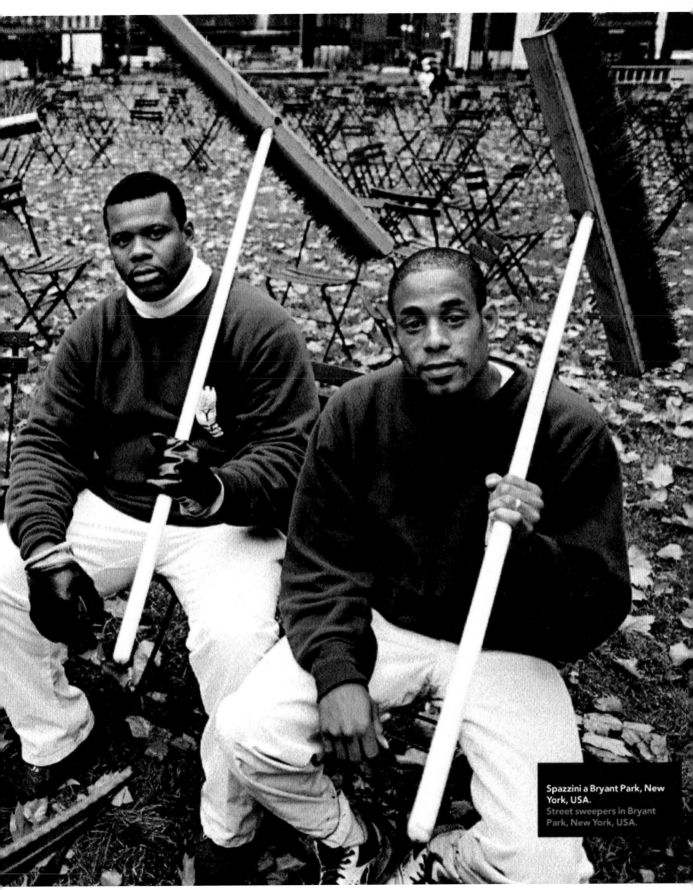

Spazzini a Bryant Park, New York, USA.
Street sweepers in Bryant Park, New York, USA.

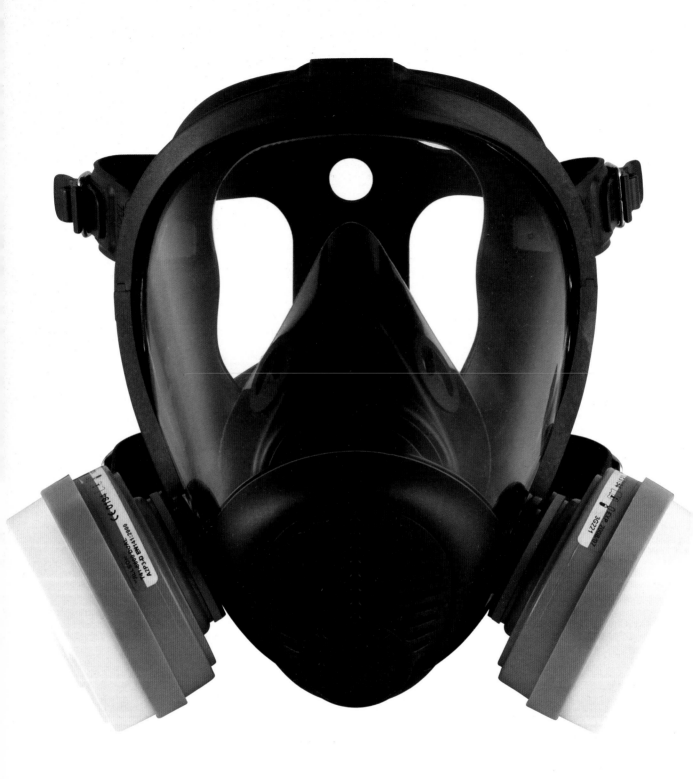

Respirator
SPERIAN

Protection of the respiratory tract is achieved by means of a gas filter when the risk presents itself in the form of gases (and vapors), an aerosol filter when the risk presents itself in the form of solid (dust) or liquid particles. Often it is recommended to combine the two types of filter, i.e. a gas filter and protection from aerosols, especially when operating in the presence of vapors, at ambient temperature, that can give rise to condensation.

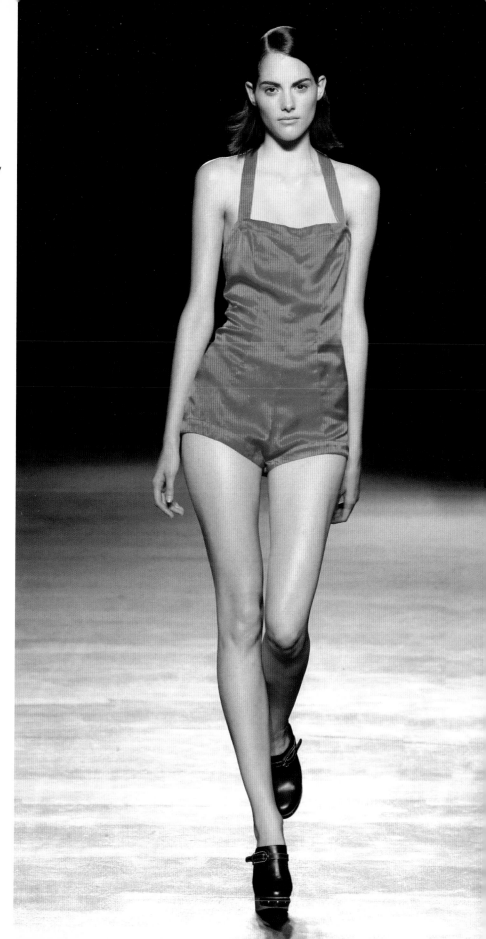

Paul Smith
Spring-summer women's wear show 2007
Courtesy Paul Smith

Protective gloves
WELLS LAMONT

Yellow color, braided mesh, protection for the knuckles.

Cut and sewn gloves
NORTH SAFETY

Heavy cotton impregnated with nitrile. Resistant but flexible gloves that can be used to handle any metal, whether smooth or abrasive. They allow full mobility of the thumb. Can be washed and dried.

Leather palm gloves
WELLS LAMONT

The leather covering protecting the palm, index finger and fingertips and the leather strip on the knuckles allow full mobility of the thumb. Double layer of leather on the part of the palm subject to greater wear.

Protective gloves
CONDOR

The leather covering protecting the palm, index finger and fingertips and the leather strip on the knuckles allow full mobility of the thumb. Double layer of leather on the part of the palm subject to greater wear.

Brown Jersey
CONDOR

Gloves made of brown cotton and polyester jersey with elastic knit cuff.

Safety boot
SPERIAN

Upper in water-repellent full grain leather. Top of the ergonomic upper is lined and padded. Lined and padded tongue with waterproof gusset. Lining in fast-drying, breathable double-face fabric.

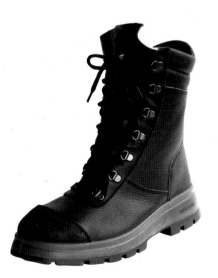

Safety boot
SPERIAN

Upper in full grain leather, lined with warm fur. Padded top of the ergonomic upper and waterproof leather gusset. Fastening with zipper and laces. Protection on the forefoot.

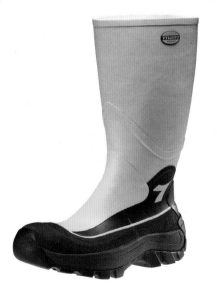

Safety boot
DIADORA

Upper in waterproof rubber. Steel 200 joule toecap. Nitrile rubber outsole, steel antiperforation insole. Removable anatomical arch support.

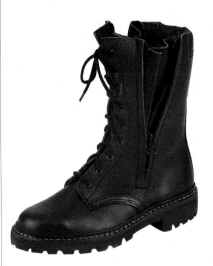

Safety boot
SPERIAN

Upper in water-repellent soft leather. Neoprene outsole, steel antiperforation insole. Steel toecap.

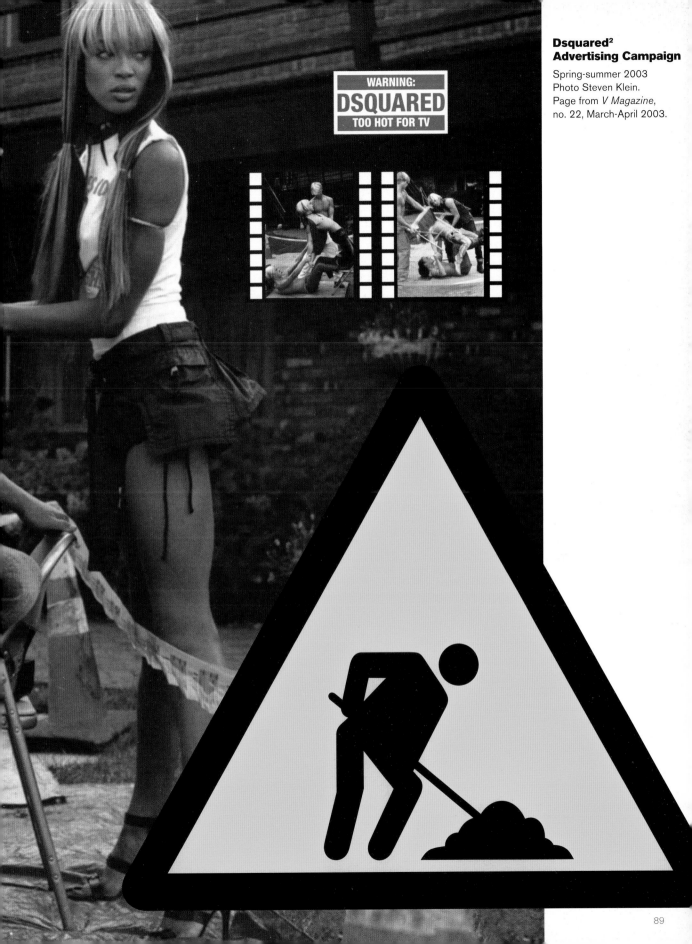

Dsquared²
Advertising Campaign
Spring-summer 2003
Photo Steven Klein.
Page from *V Magazine*,
no. 22, March-April 2003.

Boot
SPERIAN

Upper in water-repellent full grain leather.
Stitching in NOMEX heat- and fire-resistant
thread. Steel antiperforation insole.
Grips to make it easier to pull the boot on.

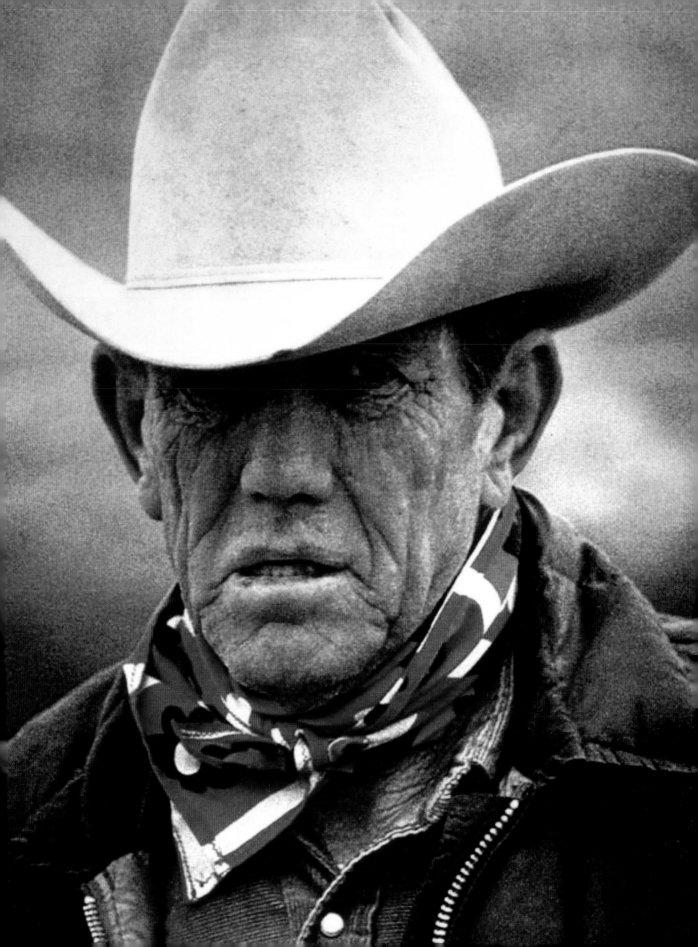

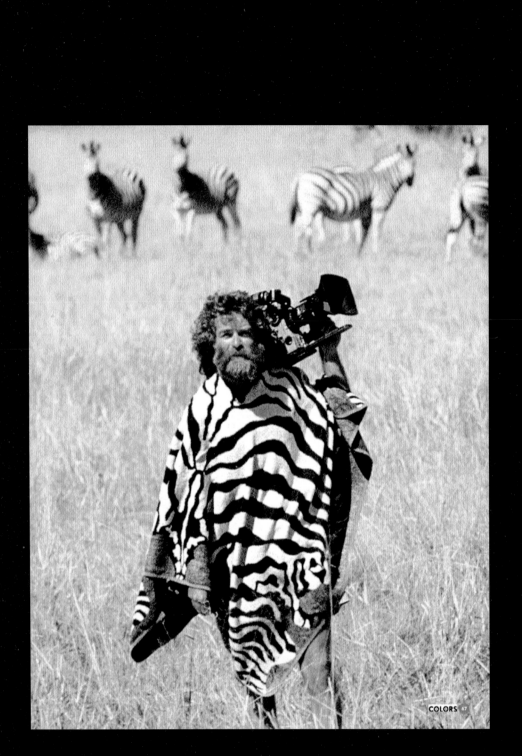

Page from *Colors* July
- September 2000,
n. 38

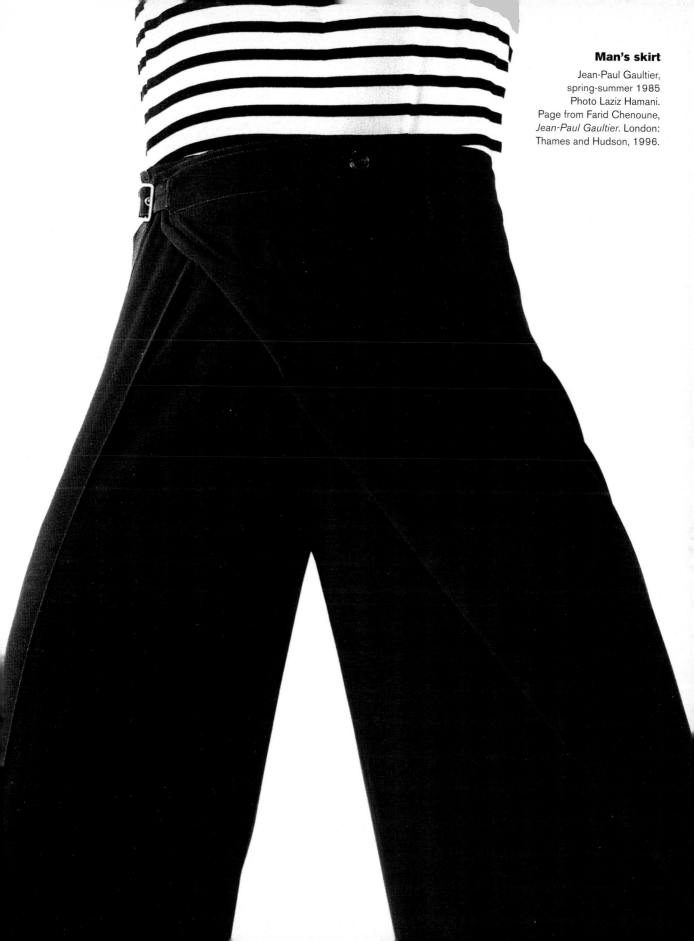

Man's skirt
Jean-Paul Gaultier,
spring-summer 1985
Photo Laziz Hamani.
Page from Farid Chenoune,
Jean-Paul Gaultier. London:
Thames and Hudson, 1996.

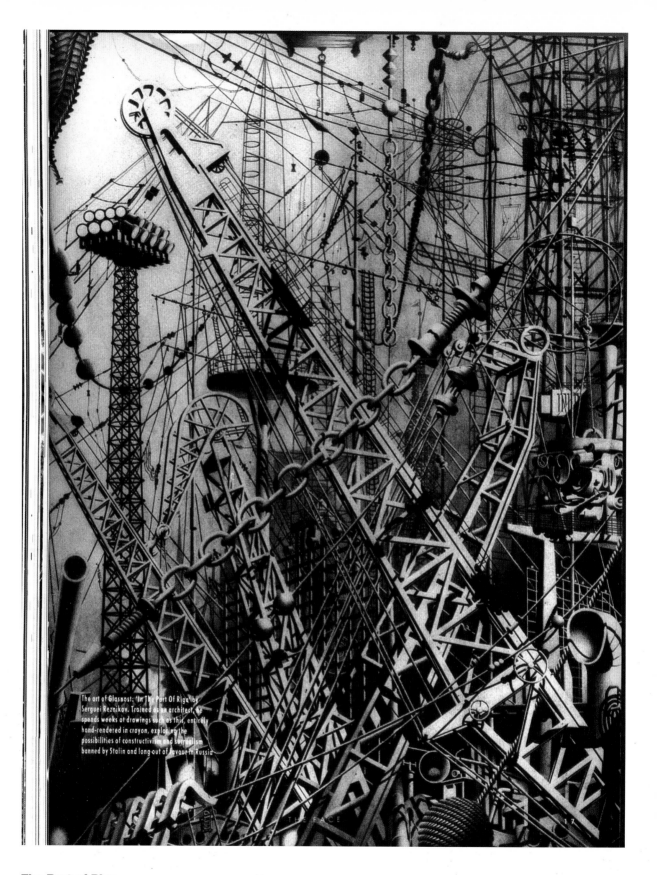

The art of Glasnost: 'In The Port Of Riga' by
Serguei Reznikov. Trained as an architect, he
spends weeks at drawings such as this, entirely
hand-rendered in crayon, exploring the
possibilities of constructivism and surrealism
banned by Stalin and long out of favour in Russia.

The Port of Riga

Drawing by Sergei Reznikov, text by Paul Rambali. Page from *The Face*, no. 93, January 1988.

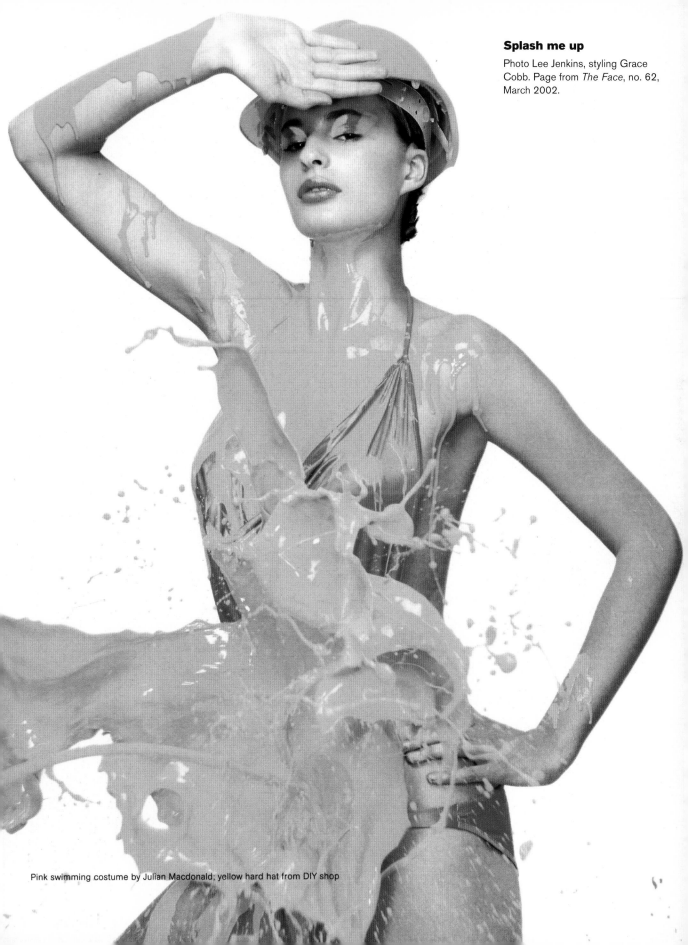

Splash me up

Photo Lee Jenkins, styling Grace
Cobb. Page from *The Face*, no. 62,
March 2002.

Pink swimming costume by Julian Macdonald; yellow hard hat from DIY shop

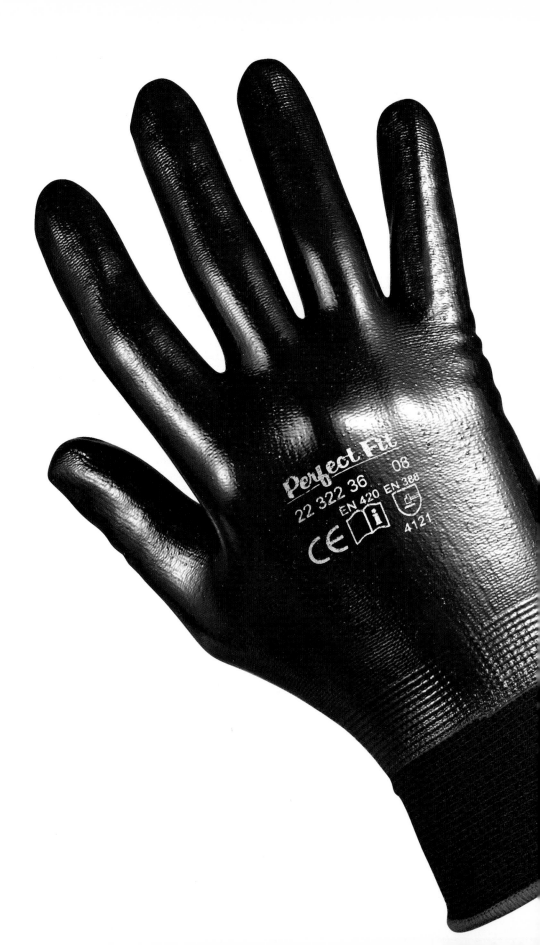

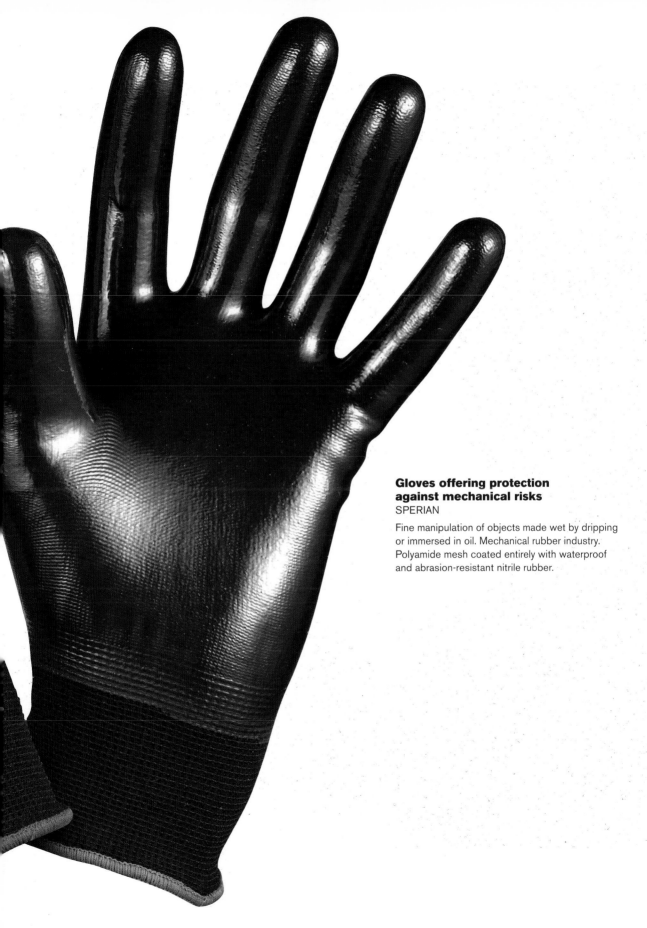

Gloves offering protection against mechanical risks
SPERIAN

Fine manipulation of objects made wet by dripping or immersed in oil. Mechanical rubber industry. Polyamide mesh coated entirely with waterproof and abrasion-resistant nitrile rubber.

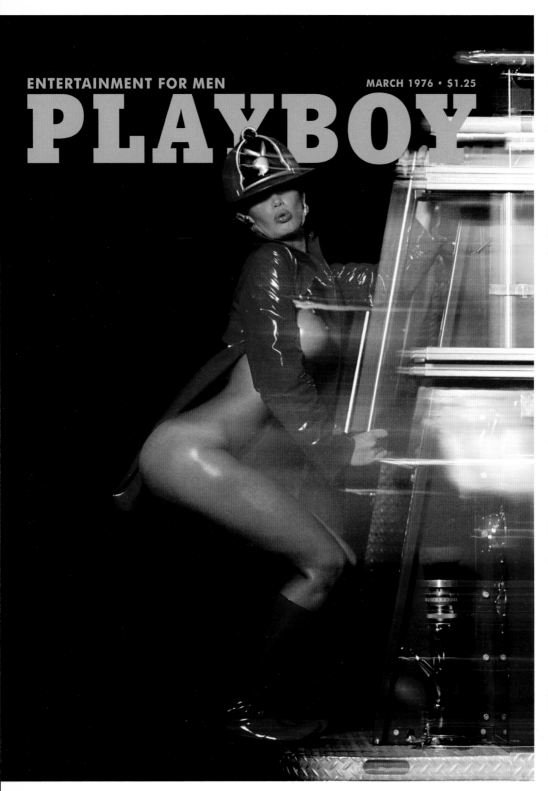

ENTERTAINMENT FOR MEN

MARCH 1976 • $1.25

PLAYBOY

Cover from *Playboy*

March 1976 - © Playboy archive/Corbis

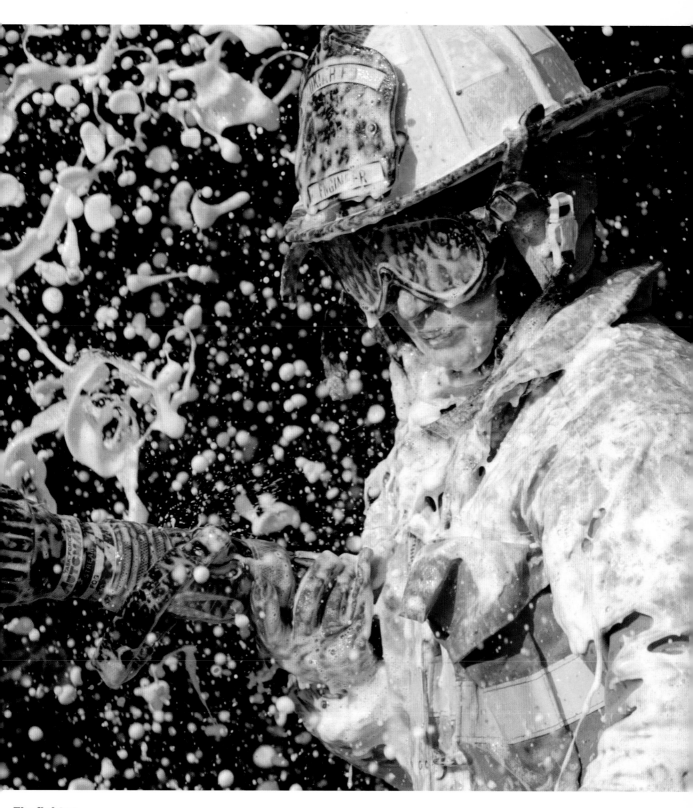

Firefighter

Photo Ivan Kashinsky - © Corbis

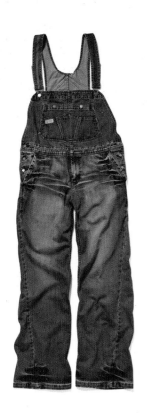

Helmet
MSA

Layers of resin-impregnated textiles, laminated under pressure. Offers heavy duty protection in steel and other industries where metal splash and high temperatures are common.

Bib overalls
LOTTO WORKS

Denim, 100% cotton

Helmet
BULLARD

Helmet, classic style, yellow color, 6 different sizes, ribbed

Bib overalls
DIADORA

100% Ottoman cotton, 280 g/m²
Colors: rope, navy blue, yellow, mud, black

Helmet
V-GARD

The cap and suspension units offer protection from light weights with a limited resistance to weights from above and to perforations.

Helmet
BULLARD

Helmet, economic style, blue color,
4 different sizes, ribbed

Helmet
NORTH SAFETY

Helmet, classic style, orange color,
6 different sizes, ribbed

Helmet
BULLARD

Helmet, traditional style, green color,
4 different sizes, ribbed

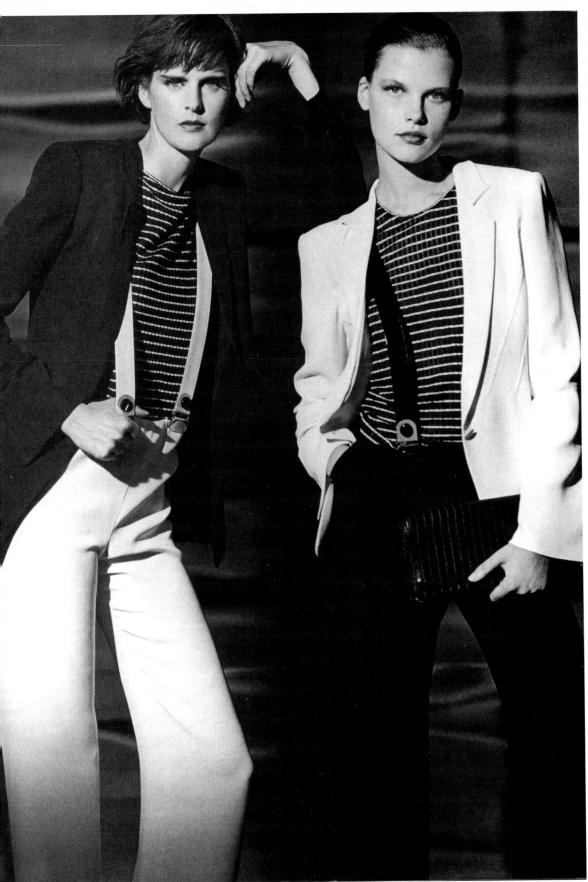

**Giorgio Armani
Advertising
Campaign**

Spring - summer 2001
Photo Peter Lindbergh
Page from *Numéro*
No. 21, March 2001

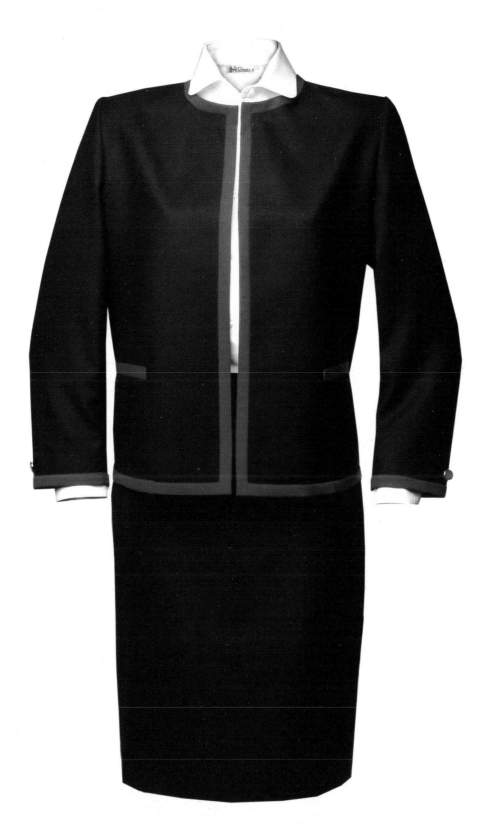

Jacket and skirt
FRAIZZOLI

Single-breasted and lined jacket trimmed with contrasting fabric.
Straight skirt with overlapping slit at the back.

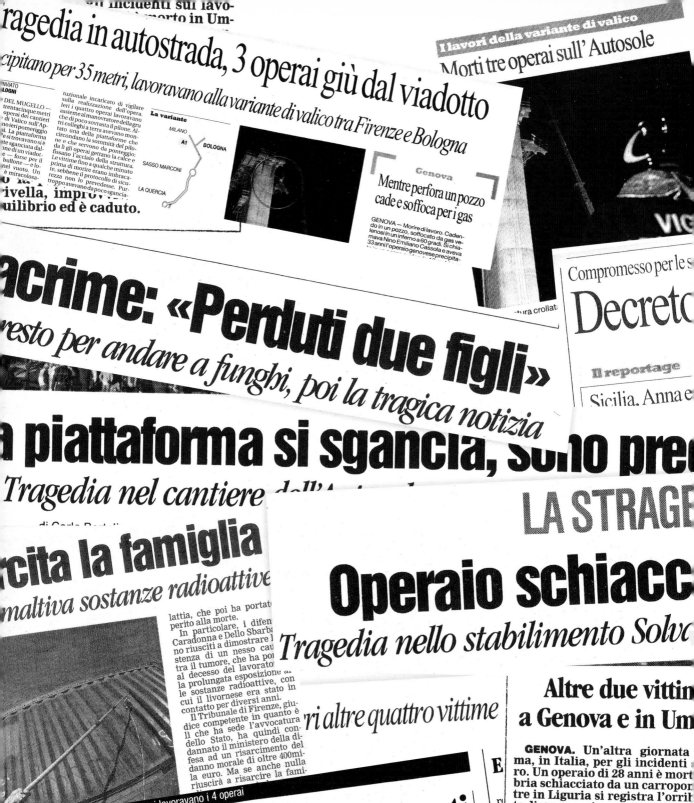

...i incidenti sul lavo-
...orto in Um-

ragedia in autostrada, 3 operai giù dal viadotto

cipitano per 35 metri, lavoravano alla variante di valico tra Firenze e Bologna

INVIATO
...LOGNI

...DEL MUGELLO —
...trentacinque metri
...operai dei cantieri
...di Valico sull'Ap-
...noi pomeriggio
...La piattaforma si
...si trovavano si è
...sganciata dal-
...one di un bullone:
...bullone — e lo-
...nel vuoto. Un
...è miracolosa-
...ivella, improvv...
...uilibrio ed è caduto.

...tuzionale incaricato di vigilare
sulla realizzazione dell'opera.
...ieri i quattro operai lavoravano
assieme al manovratore della gru
che di poco sovrasta il pilone. Al-
tri colleghi a terra avevano mon-
tato una della piattaforme che
circondano da ponteggio
ne e che servono da ponteggio:
fissano l'acciaio della calce e
gli operai gettano la struttura.
Le vittime fino a qualche minuto
prima di morire erano imbraca-
te, sebbene il protocollo di sicu-
rezza non lo prevedesse. Pur-
troppo avevano da poco sgancia-

La variante

MILANO
A1
BOLOGNA
SASSO MARCONI
LA QUERCIA

I lavori della variante di valico

Morti tre operai sull'Autosole

Genova

**Mentre perfora un pozzo
cade e soffoca per i gas**

GENOVA — Morire di lavoro. Caden-
do in un pozzo, soffocato da gas ve-
lenosi in un inferno a 60 gradi. Si chia-
mava Nino Emiliano Cassola e aveva
33 anni l'operaio genovese precipita-

...ura crollata...

Compromesso per le s...

Decreto

Il reportage

Sicilia. Anna e...

acrime: «Perduti due figli»

resto per andare a funghi, poi la tragica notizia

a piattaforma si sgancia, sono prec

Tragedia nel cantiere dell'A...

di Carlo B...

LA STRAGE

cita la famiglia

maltiva sostanze radioattive

lattia, che poi ha portato...
perito alla morte.
In particolare, i difen...
Caradonna e Dello Sbarba...
no riusciti a dimostrare l...
stenza di un nesso cau...
tra il tumore, che ha por...
al decesso del lavorator...
la prolungata esposizion...
le sostanze radioattive, con...
cui il livornese era stato in
contatto per diversi anni.
Il Tribunale di Firenze, giu-
dice competente in quanto è
lì che ha sede l'avvocatura
dello Stato, ha quindi con-
dannato il ministero della di-
fesa ad un risarcimento del
danno morale di oltre 400mi-
la euro. Ma se anche nulla
riuscirà a risarcire la fami-

...a indica la piattaforma crollata su cui lavoravano i 4 operai

Operaio schiacc

Tragedia nello stabilimento Solva

**Altre due vittim
a Genova e in Um**

GENOVA. Un'altra giornata
ma, in Italia, per gli incidenti
ro. Un operaio di 28 anni è mort
bria schiacciato da un carropon
tre in Liguria si registra l'orrib
te di un operaio genovese di 33 a
no Emiliano Cassola, precipita
pozzo profondo 18 metri per l'
ne del biogas nella discarica
di Scarpino, sulle colline di
Non c'è alcuna speranza che l'u
sopravvissuto alla caduta: ne
che ha un diametro di solo un
non c'è ossigeno. L'operaio
guendo la perforazione del po
una trivella, improvvisamen
so l'equilibrio ed è caduto.

...ri altre quattro vittime

ecipitano da un pilone: tre morti

Barberino lavoravano a 35 metri, salvo un altro operaio

BARBERINO DI MUGELLO. Un'altra trage-
dia ...i morti sul lavoro in Toscana. A perde-
...i pomeriggio erano al la-
...iano che erano al la-
...ione

scampato per puro miracolo alla morte. Era-
no al lavoro su una piattaforma ancorata a un
pilone di cemento in costruzione, sospesa a cir-
ca 35 metri, quando la struttura ha ceduto tra-
sformandosi in uno scivolo micidiale. I 4 si era-
...appena tolti le imbracature di sicurezza
...a scendere a terra.

La neo presidente di Confindustria: il mio impegno sulla sicurezza sarà fo

un'altra catasta a ottanta centimetri di distanza. Non ha avuto scampo Girolamo di Maio.

230

Gli incidenti mort

chiacciato dai tubi d'acciai

peraio di 32 anni muore nell'azienda del gruppo Marceg

bilimento si è
fermato. È stato
mato che si conclude
mezzogior

La tragedia

devano non han

a multa se l'azienda si adegua. Montezemolo: legge punitiva e de

lavoro, via tra le polemiche

ROMA — Il Consiglio dei ministri ha approvato il decreto contro i morti sul lavoro: tra le sanzioni previste c'è l'arresto fino a 18 mesi per gli imprenditori che non fanno rispettare le aziende che però

Veltroni agli artigiani: un giorno
per far nascere un'impresa

Mastella

Due morti in 24 ore nei cantieri livornesi

Dopo la Solvay, l'Interporto: giovane albanese vola dal capannone

FINITA

o dalla benna

Rosignano, ferito un colle

coletta integra così il racconto: «Stavano cercando di ripala pala meccanica, a un

to, che era in posizione più defilata, di fianco, è stato scaraventato via e si è rotto la cavigliaglia

«Aggiunge dolore e sconforto - prosegue Martini, che sta tragedia del luogo dell'incidente mortale ieri a Livorno A sinistra un reparto della Solvay a Rosignano

sunto da una ditta del Consorzio lato da un mese ammatico racconto peraio schiacciato tini: «E' un incubo»

Due morti in 24 ore nei cantieri l

Dopo la Solvay, l'Interporto: giovane albanese vola de

costruzione.

«È stata una disgrazia - dice l'uomo e non ho fatto in tempo a realizzare come quella la abbia potuto schiacciare

to, che era in posizione più scar filata, di fianco, è stato scar ventato via e si è rotto la cav glia

la grave ferit

coletta integra così il racconto: «Stavano cercando di riparare la pa tratto i bra scavatore

sul lavoro in
ambi gio-
un incu-
parola
ini - non

il tragino, do-
la vita
ntaduen-
Livor-
La vit.

va anche in Toscana. Riza era stato assunto circa due settimane fa.
Il capannone è stato subito posto sotto sequestro dal dot
TO: una delle vittime era in ner

280.000

Le aziende

dove nel corso
del 2006
si è verificato
almeno
un incidente
sul lavoro.
Rappresenta
il 7,6% del tota
delle imprese

Catania L'assessore regionale

Operai morti, 7 indagati
Sotto accusa il sindaco

«Omicidio colposo». Sacconi: ora un piano straordinar

Avvisi anche a quattro
al capo

nico e Sebastiano Carfi titolare della ditta di espurgo di Ragusa. «Si tratta di un atto do
il procuratore

prio lavoro. Uno stillicidio su cui il ministro Sacconi annuncia «un piano straordinario da mettere a punto assieme al ti sociali» mentre il mi

A Mineo, intanto, resta più interrogativi che certez Per il semplice fatto che suno dei sei operai de trare all

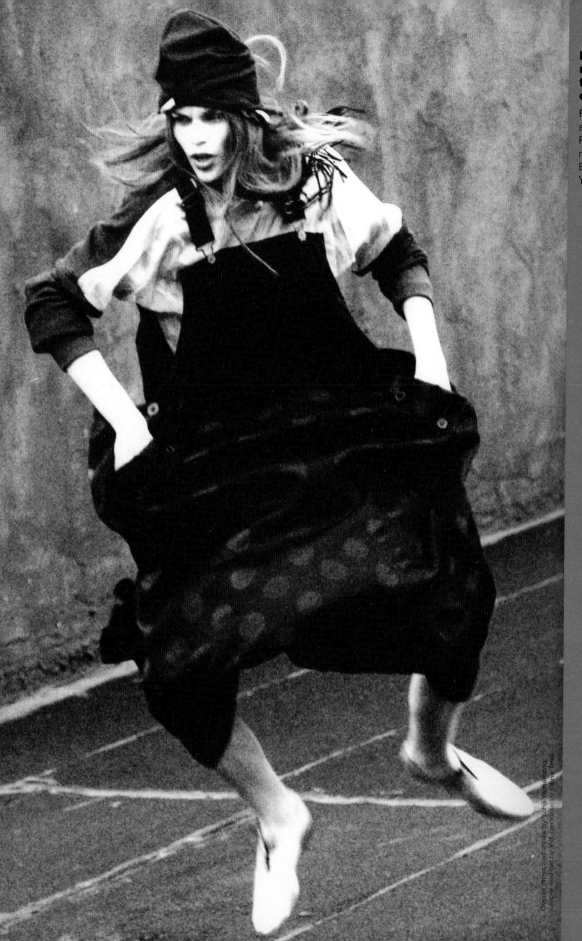

**In bloom, grunge
revisits
the summer
of its youth**

Photo Seiji Fujimori,
styling Akari Endo.
Page from *Tank*, vol. 5,
no. 2, 2008.
Bib overalls,
Yohji Yamamoto.

Overall, dress, and shoes by Yohji Yamamoto;
jumper and hat by Y-3; necklace by Claro, Titan

Safety shoe
UVEX

Innovative design, with no metal parts, very
light, new UVEX Climatec® technology with
waterproof, breathable material, surface
perforated at the sides to allow perspiration.

Lire 1,37 per "ora portata"

Jesus Jeans Advertising Campaign
Photo Oliviero Toscani, 1975.
Oliviero Toscani archive.

Questa ragazza
è Monica Traglio, di Milano,
ha 17 anni.

Veste jeans;
li ha comprati il 15 luglio 1975.
Ad oggi,
le costano lire 1,37
per ora portata.

basta jesus necessario e sufficiente

390 5ª Avenue New York / NY 10018

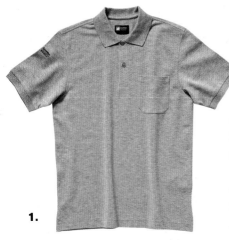

1.

2.

T-shirt (1.)
LOTTO WORKS
Cotton piquet, 100% cotton, 180 g/m²

T-shirt (2.)
LOTTO WORKS
Jersey, 100% cotton, 160 g/m²

Jeans rio (3.)
LOTTO WORKS
Denim, 100% cotton

Jeans (4.)
LOTTO WORKS
Denim, 100% cotton

Boot, insulated (5.)

Watertight cold weather boots have rubber
bottoms, leather uppers, and removable
insulated sock made with 200g 3M (TM)
Thinsulate (TM).
Lace-up style with black nickel hardware
and tractor tread sole. Steel shank pro-
vides firm arch support.

Pullover boot (6.)

17" Heavy-Gauge Rubber
Over-the-shoe boots have an adjustable
top strap for snug fit and a black cleated
outsole for longer wear.

3.

4.

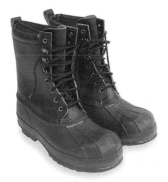

5.

6.

Chem resistant suit
DUPONT

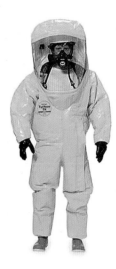

Tychem® TK Level A Suit
So durable, it can handle both
emergency response and remediation
work.
Provides high-level protection against
toxins, corrosives, gases, liquids, and
solid chemicals. Successfully tested
against more than 320 chemicals. Both
rear and front entry models are full
encapsulating with 3-layer Pana Vu face
shield PVC/Teflon(R)/PVC, expanded
back for SCBA, Barrier (TM)/Butyl dual
glove system, and attached socks made
of garment material. Lime yellow color.

Chem Resistant Suit
DUPONT

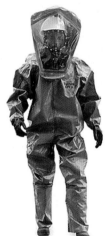

CPF4 Fully Encapsulated Level B Suits
A multilayer composite barrier is
laminated to a strong, nonwoven
substrate for one of the broadest ranges
of chemical protection available for Level
B suits.
Set-in sleeves provide ease of motion.
Feature 20-mil PVC faceshield, expanded
back, 2 exhaust vents, and rear entry.

Chem resistant suit
DUPONT

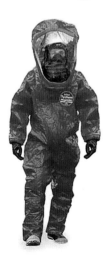

Tychem® Responder® Level A Suit
Provides high-level protection against
toxic and corrosive gases, liquids,
and solid chemicals. Ideally suited for
HazMat and domestic preparedness
situations. Patented, lightweight fabric
has multiple film barriers laminated
to both sides of 3-oz. polypropylene.
Successfully tested against more than
280 chemicals.

Lunar visitor

Photo Neil Armstrong, August 1969
page from David E. Sherman (ed.),
The Best of LIFE, New York:
Avon Books, 1973

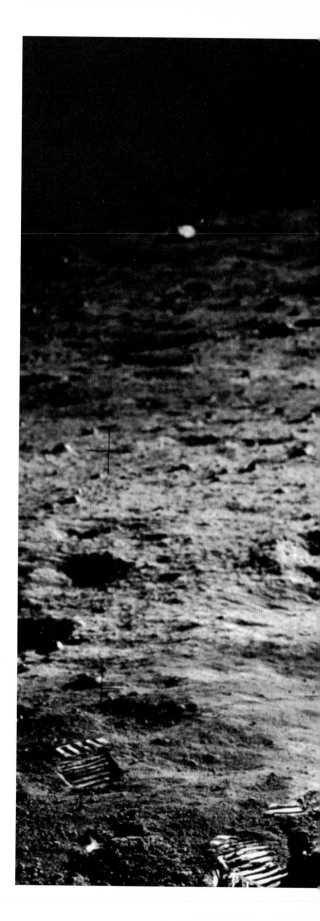

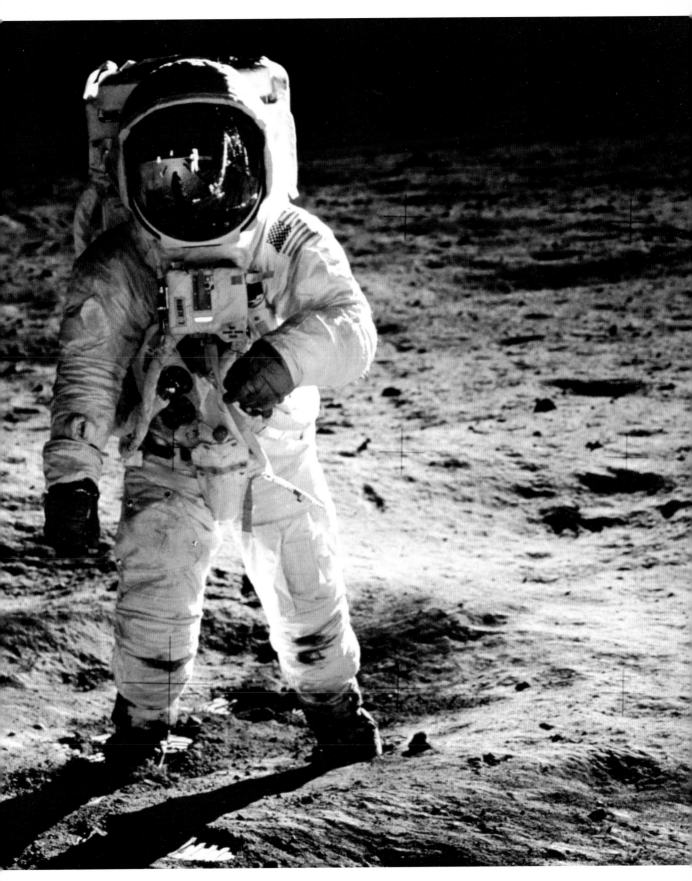

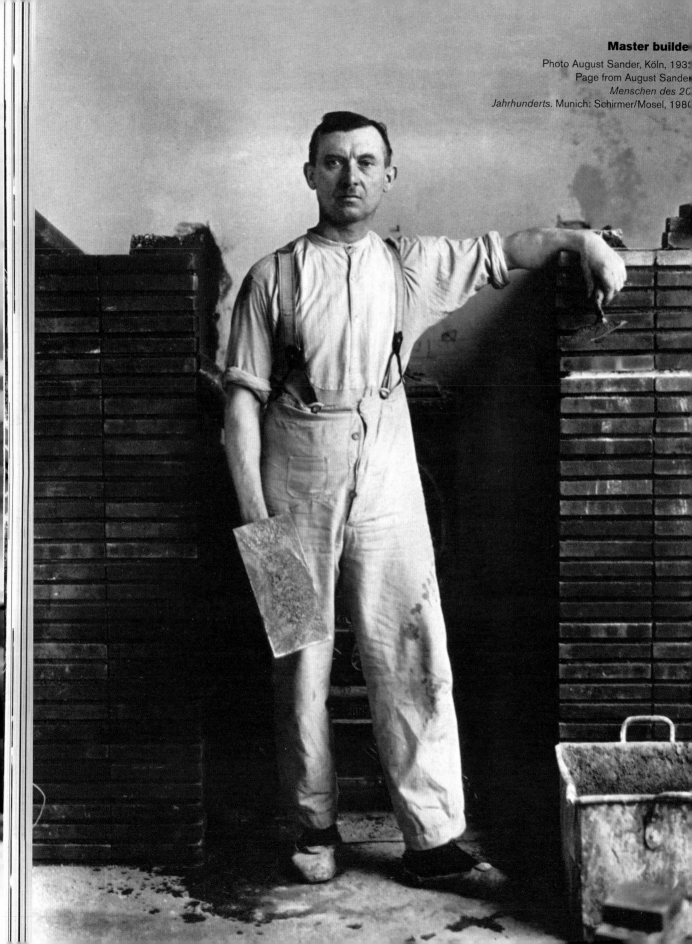

"Summer" worker bib
LOTTO WORKS
100% cotton

Harness
SPERIAN

Two-point - fall arrest full-body harness, rear and front anchorage. With Teflon® finish. Fitted with slots for rear anchorage.

THE

Natalia
FROM RUSSIA, WITH LOVE

Natalia from Russia with love

Photo Vincent Peters,
fashion editor Karina Givargisoff.
Cover of *The Face*, no. 82,
November 2003.

FACE

NO. 82
NOVEMBER 2003
£3.20

WET
IN THE BATH
WITH PARIS &
NICKY HILTON

WILD
DITA VON TEESE
STRIPS IN HER
BEDROOM

WONKY
SEX LIVES OF
THE BONOBO
MONKEYS

+

ON TOUR WITH
THE NEW
JET-SET
STRIPPERS

NODESHA
SHERI MOON
DIEGO LUNA
PINK

RED HEAT: Natalie by Vincent Peters

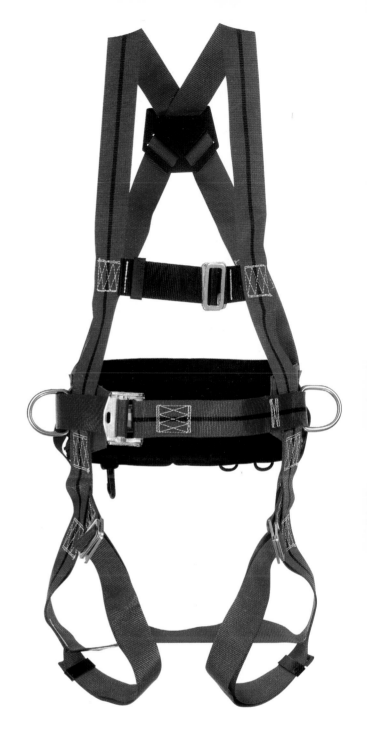

Harness
SPERIAN

One-point dorsal ring harness.
Light and durable, made of polyamide,
adjustable and adaptable. 45 mm chest webbing.

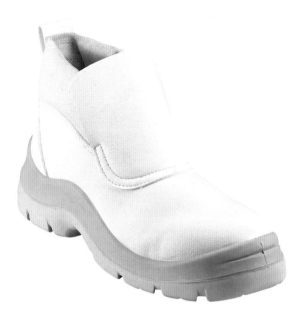

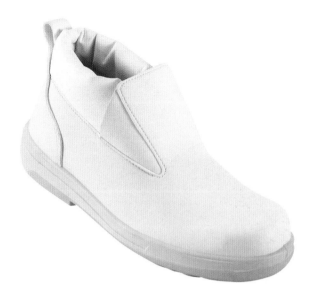

Antibacterial shoe
SPERIAN

Upper in white leather with antibacterial treatment.
Men's model. PU.2D sole. Free of stitching on the
forefoot to limit contamination.

Antibacterial shoe
SPERIAN

Upper in white leather with antibacterial treatment.
PU.2D sole. Free of stitching on the forefoot to limit
contamination.

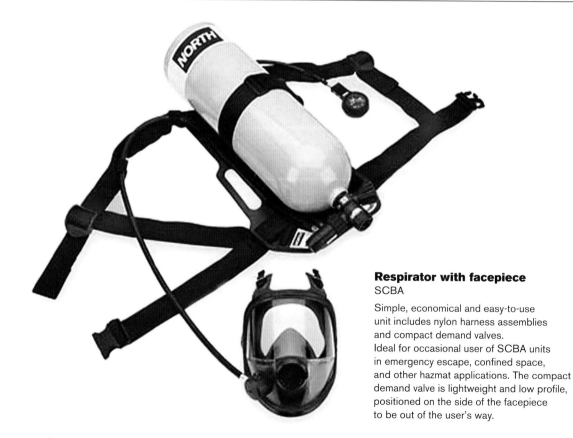

Respirator with facepiece
SCBA

Simple, economical and easy-to-use
unit includes nylon harness assemblies
and compact demand valves.
Ideal for occasional user of SCBA units
in emergency escape, confined space,
and other hazmat applications. The compact
demand valve is lightweight and low profile,
positioned on the side of the facepiece
to be out of the user's way.

Pleasure is everything

Photo Magnus Unnar,
fashion editor Jodie Barnes.
Page from *10 Magazine*, no. 28, fall 2008.
Shirt, Comme des Garçons..

Welder's helmet
SPERIAN

Helmet with hinged window for welding.

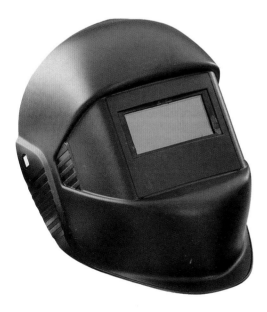

Welder's helmet
SPERIAN

Helmet in reinforced
thermoplastic for welding

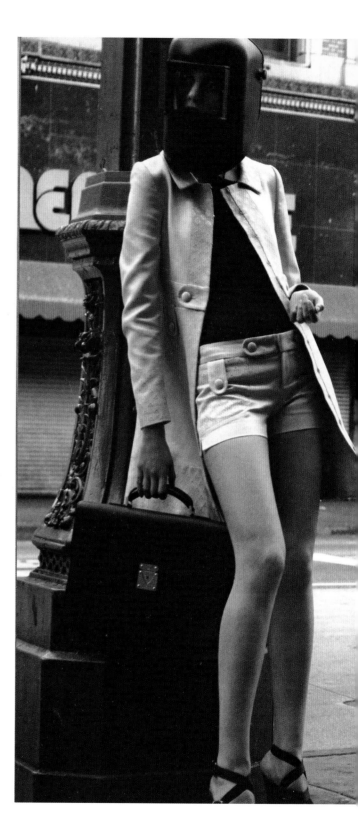

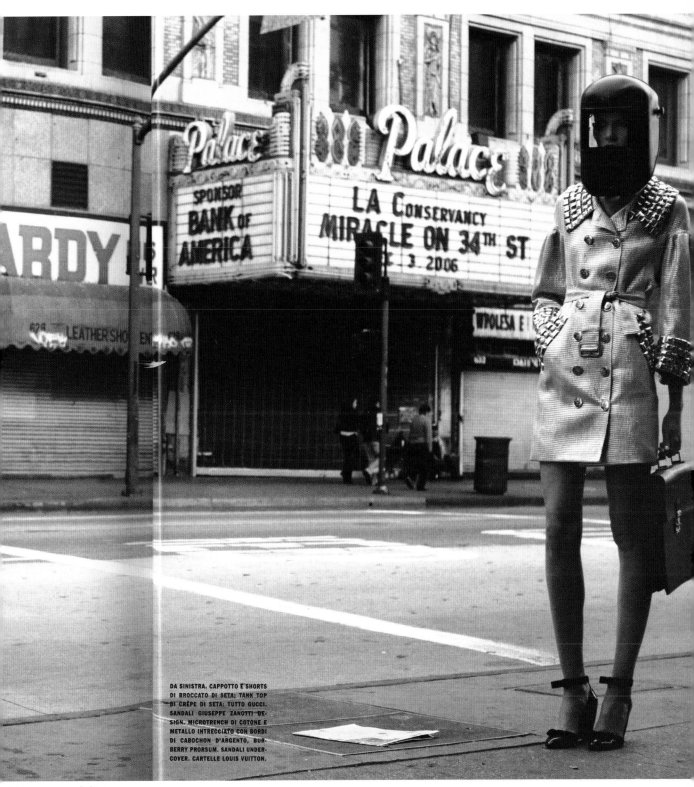

DA SINISTRA. CAPPOTTO E SHORTS
DI BROCCATO DI SETA; TANK TOP
DI CRÊPE DI SETA; TUTTO GUCCI.
SANDALI GIUSEPPE ZANOTTI DE-
SIGN. MICROTRENCH DI COTONE E
METALLO INTRECCIATO CON BORDI
DI CABOCHON D'ARGENTO, BUR-
BERRY PRORSUM. SANDALI UNDER-
COVER. CARTELLE LOUIS VUITTON.

Tomorrow vision
Photo Peter Lindbergh, fashion editor Patti Wilson. Pages from *Vogue Italia*, no. 678, February 2007.

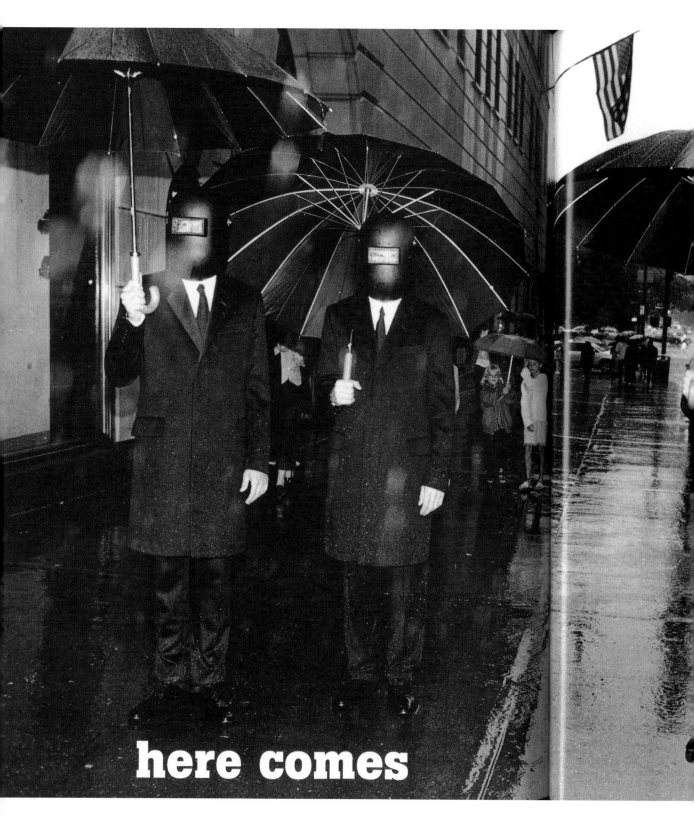

here comes

Here comes the suit

Photo Peter Lindbergh, fashion editor Nicoletta Santoro. Pages from *L'Uomo Vogue*, n. 313, September 2000.

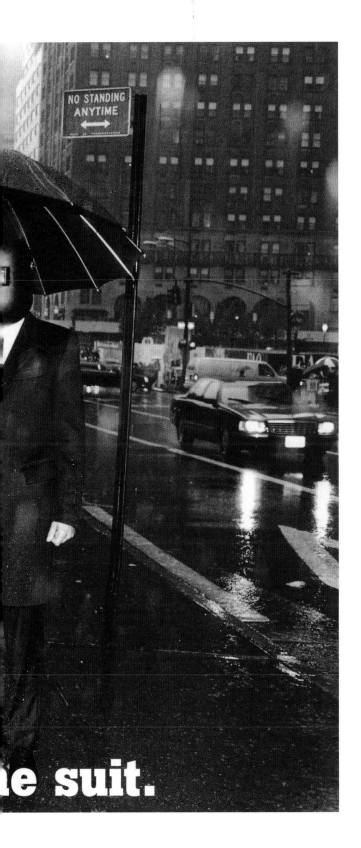

e suit.

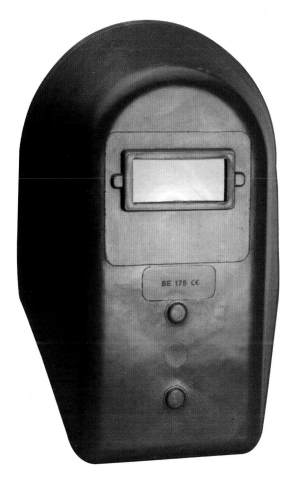

Welding mask
SPERIAN

Welding handshield in high-grade resistant glass-fibre composite material including front cover lens and a welding lens DIN 11, which protects permanently against UV-&IR-radiation.

Hard hat, red
BULLARD

Hard Hat, Style Full Brim Classic, Color Red, 6 Point Ratchet Suspension

Hard hat, red
BULLARD

Hard Cap, Style Classic, Color Red, 6 Point Self Sizing Suspension, Slotted

Hard hat, red
BULLARD

Hard Cap, Slotted, Color Hi Vis Orange, Ratchet Suspension, Polyethylene Shell/ Suspension, Replacement Suspension 4LN52, Standards ANSI Z89.1-2003 Class E and G .

Hard hat, red
MSA

Comfortable, limited resistance to top impact, penetration, and high voltage. Lightweight polyethylene shell. Slotted so accessories can be mounted on cap.

Hard hat, red
MSA

Polyethylene shell comes with either Staz-On(R) (squeeze-and-slide lock) or Fas-Trac(R) (knob adjustment) suspension.

Hard hat, red
BULLARD

Hard Cap, Style Economy, Color Red, 4 Point Ratchet Suspension, Slotted

Heat-protective helmet
GIORDANI

VVFF fiberglass helmet with built-in visor,
leather neck protector.

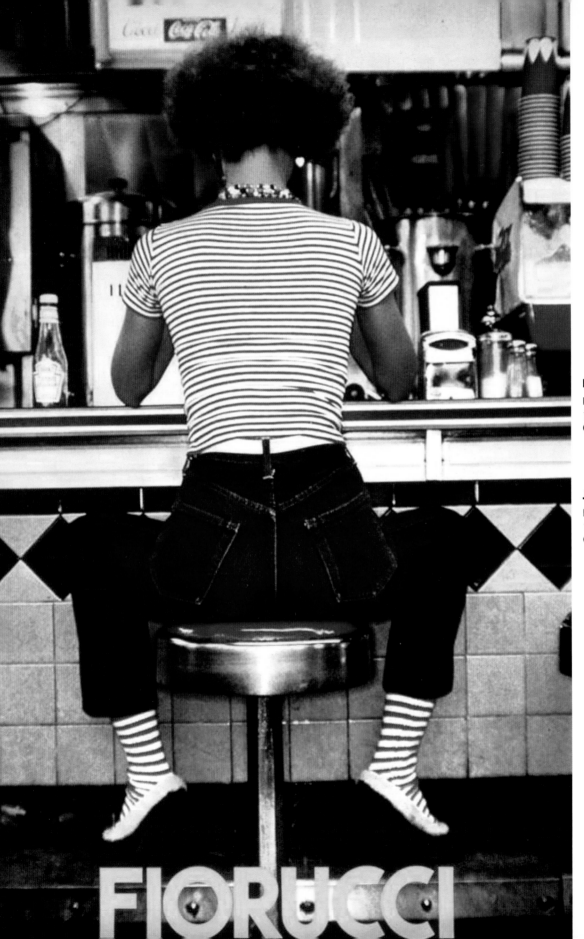

Fiorucci
Photo Oliviero Toscani,
1972.
Oliviero Toscani archive

Jesus Jeans
Photo Oliviero Toscani,
1970.
Oliviero Toscani archive

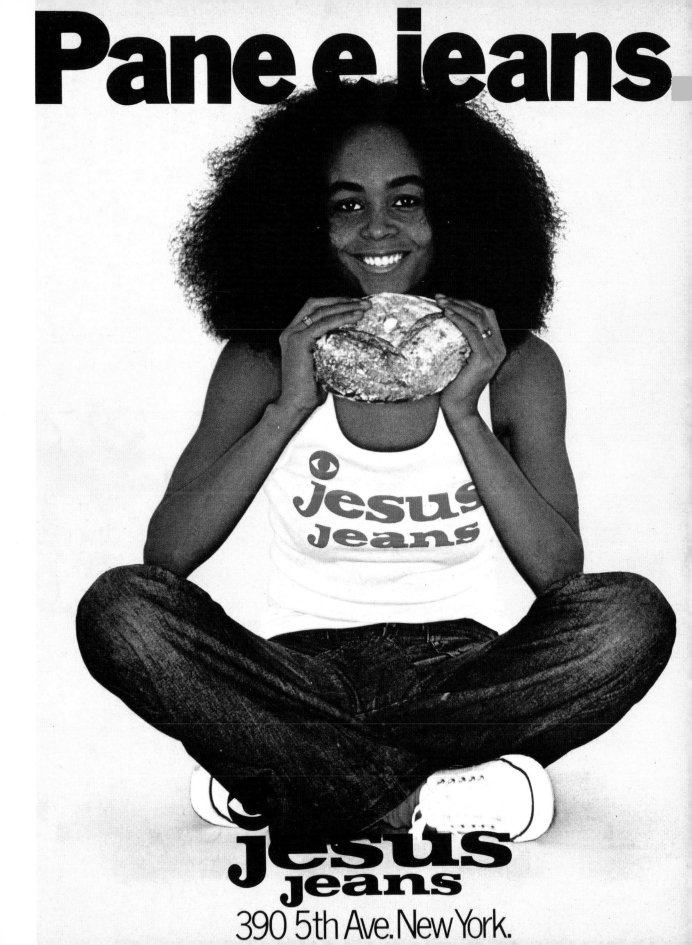

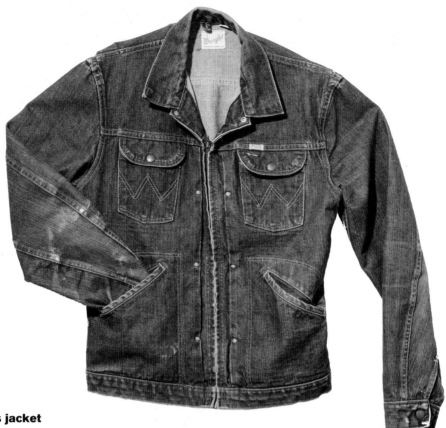

Jeans jacket

Wrangler, 1950s.
Stewart private collection

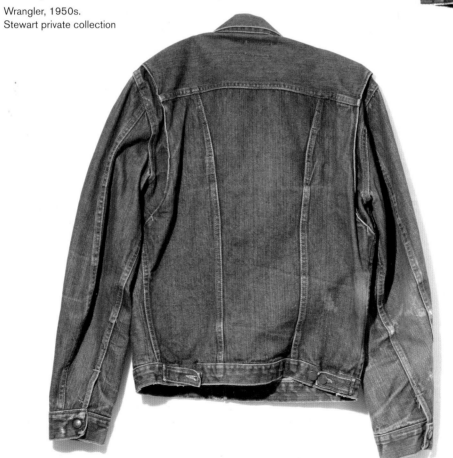

Ufo advertising campaign

Photo Oliviero Toscani, 1973.
Oliviero Toscani archive.

Ufo invece dei soliti jeans

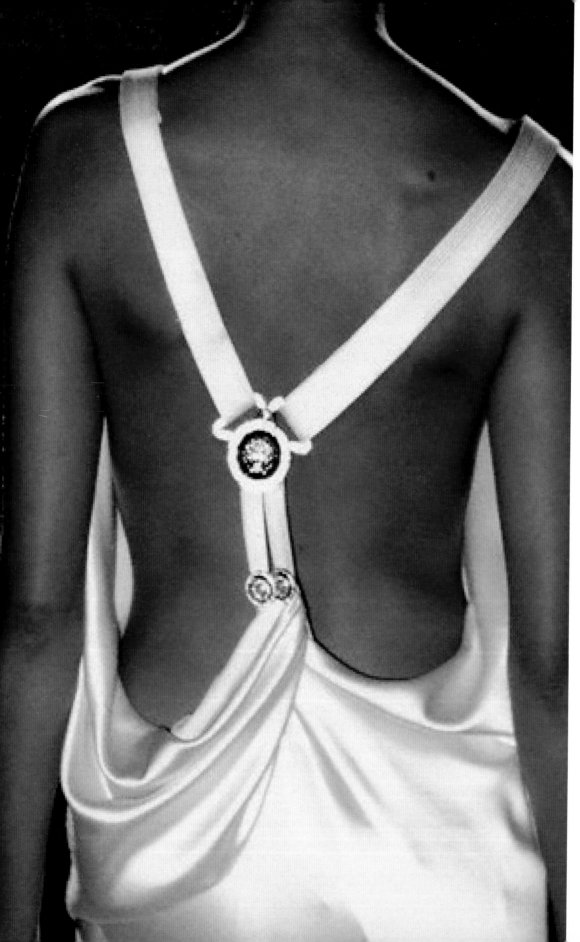

Versace

Spring-summer
haute couture show 19
Photo Thierry Orban.
® Thierry Orban/Corb

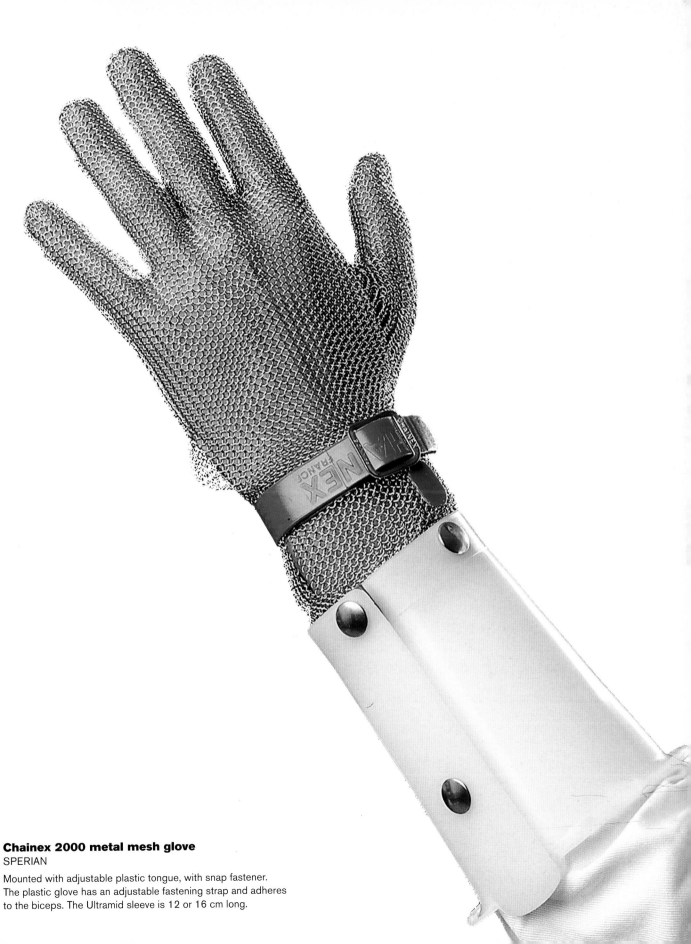

Chainex 2000 metal mesh glove
SPERIAN

Mounted with adjustable plastic tongue, with snap fastener.
The plastic glove has an adjustable fastening strap and adheres
to the biceps. The Ultramid sleeve is 12 or 16 cm long.

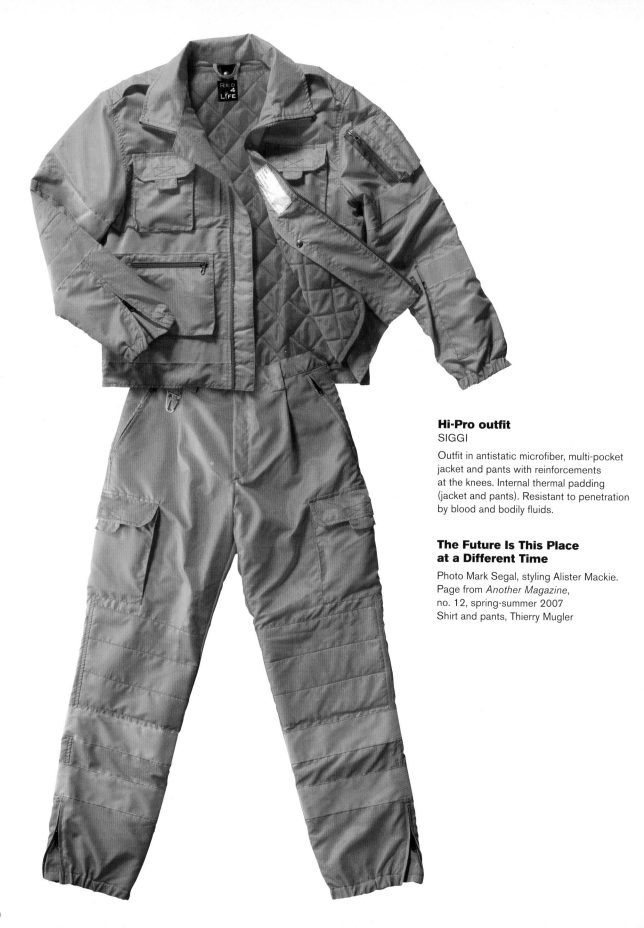

Hi-Pro outfit
SIGGI

Outfit in antistatic microfiber, multi-pocket
jacket and pants with reinforcements
at the knees. Internal thermal padding
(jacket and pants). Resistant to penetration
by blood and bodily fluids.

The Future Is This Place
at a Different Time

Photo Mark Segal, styling Alister Mackie.
Page from *Another Magazine*,
no. 12, spring-summer 2007
Shirt and pants, Thierry Mugler

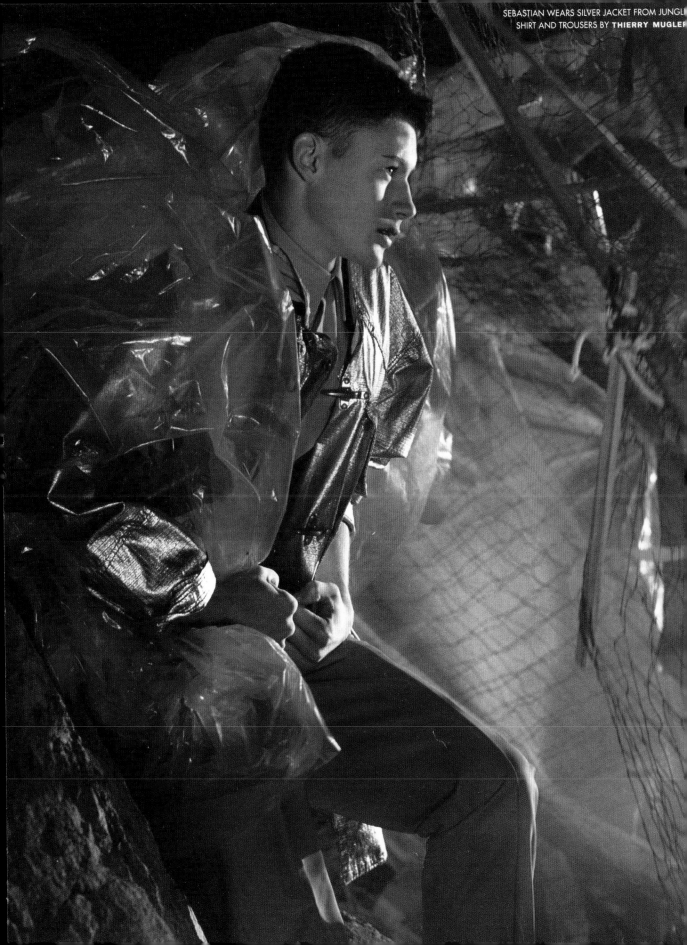

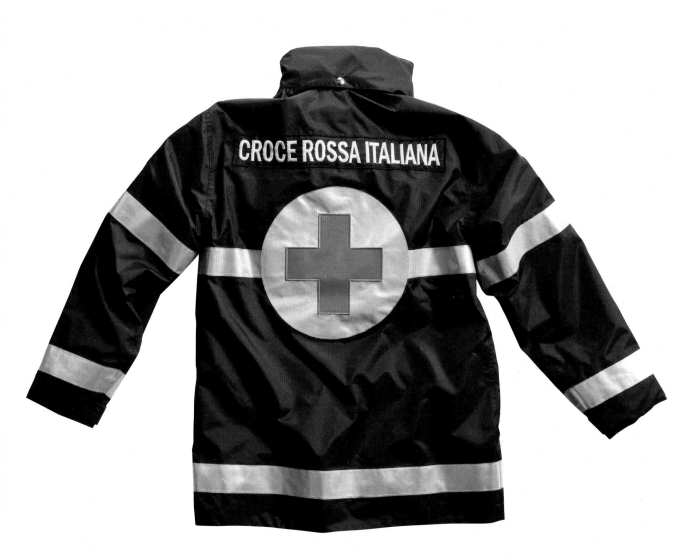

Italian Red Cross high-visibility jacket
SIGGI

Outer fabric: 100% waterproof polyester. Removable self-supporting breathable interior with detachable sleeves.

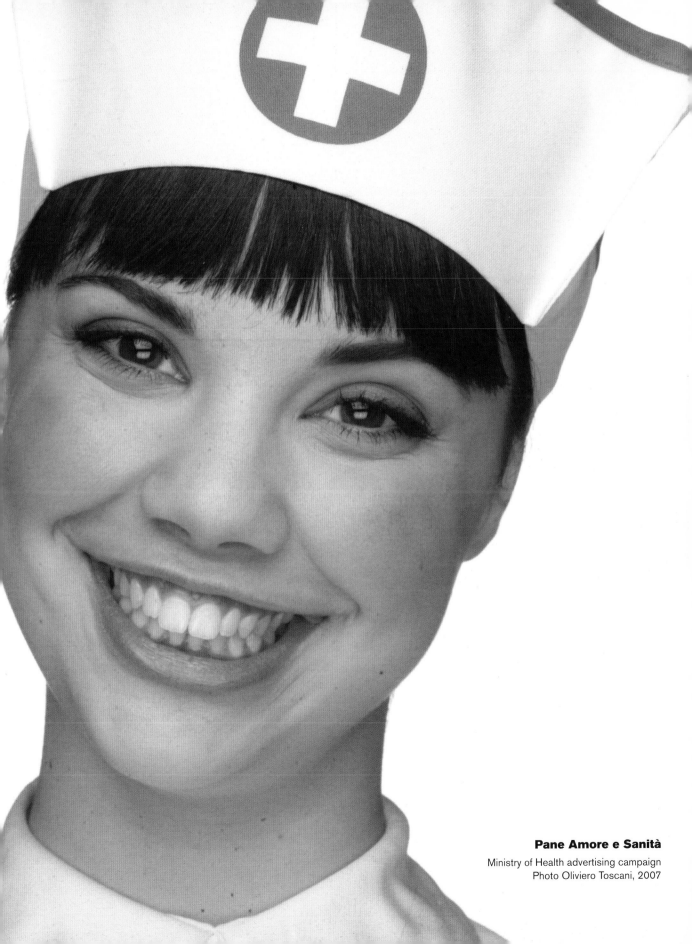

Pane Amore e Sanità
Ministry of Health advertising campaign
Photo Oliviero Toscani, 2007

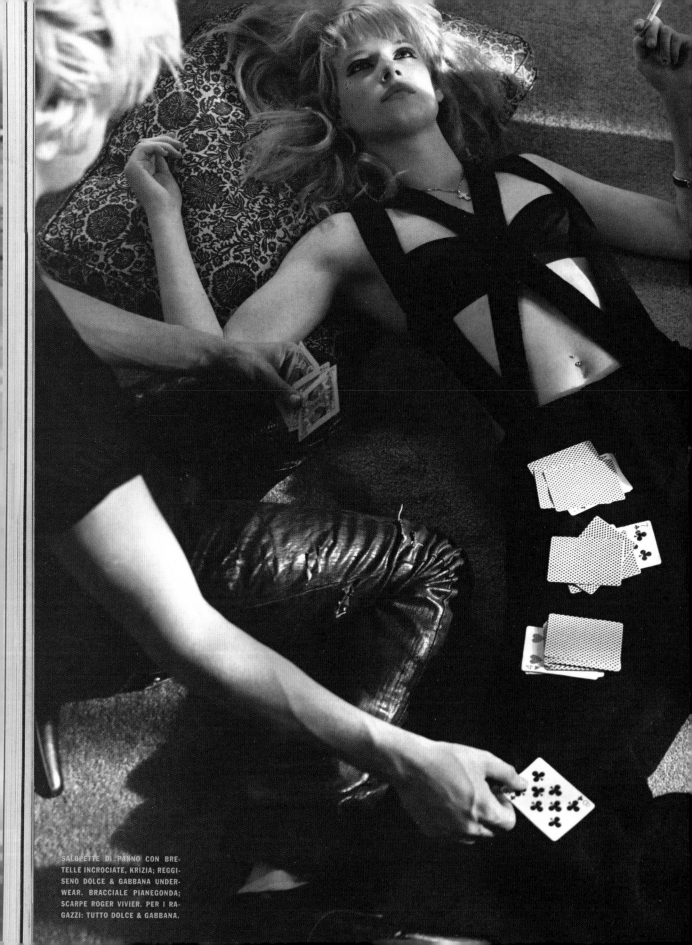

SALOPETTE DI PANNO CON BRE-
TELLE INCROCIATE, KRIZIA; REGGI-
SENO DOLCE & GABBANA UNDER-
WEAR. BRACCIALE PIANEGONDA;
SCARPE ROGER VIVIER. PER I RA-
GAZZI: TUTTO DOLCE & GABBANA.

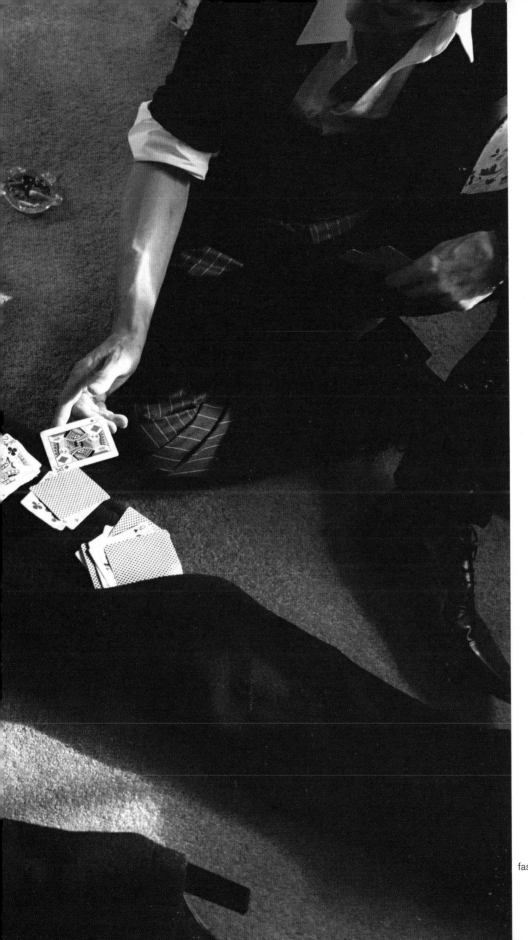

The today way
Photo Steven Klein,
fashion editor Camilla Nickerson.
Pages from *Vogue Italia*,
no. 662, October 2005.
Overalls, Krizia.

Louis Vuitton and Richard Prince

Photo Stéphane Feugère, text Glenn O'Brien
Page from *Purple Fashion Magazine*, no. 9
spring-summer 2008
Nurse's uniform, Louis Vuitton

Antismog mask Metropolis Jacket
C.P. COMPANY

Fall-Winter 1997-98
Metropolis is a jacket fitted with a removable antismog mask, adjustable to fit the face by means of slots in the hood. Windproof double-opening pockets, pouches for computer, cell phone and documents. Detachable C.P. Company logo. Protective Dynafil TS 70 fabric on tear- and abrasion-resistant, waterproof and oil-proof nylon base. High-density pressed synthetic fleece lining.
Courtesy C.P. Company

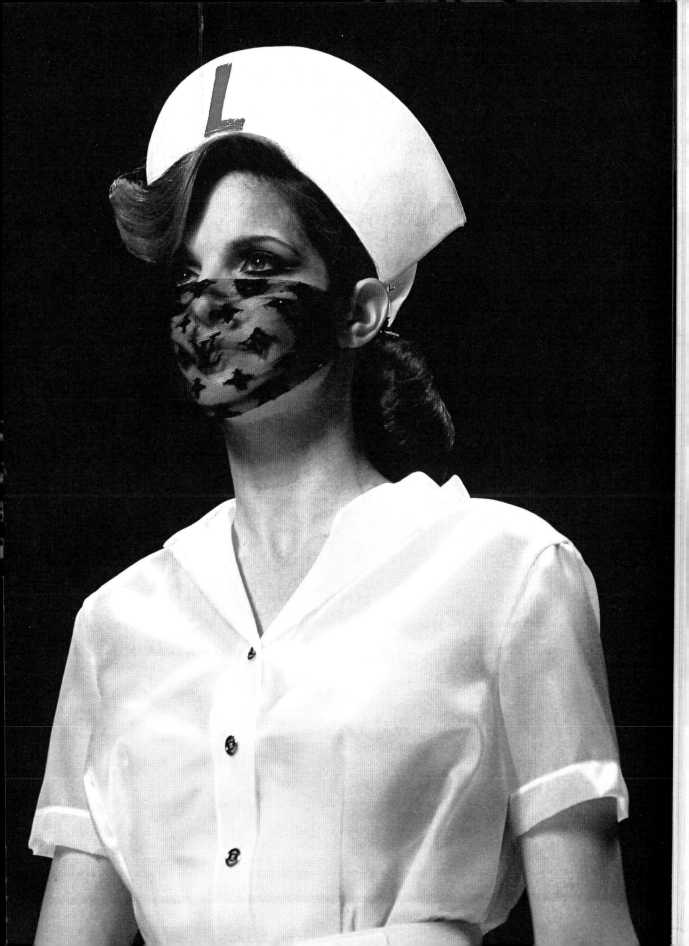

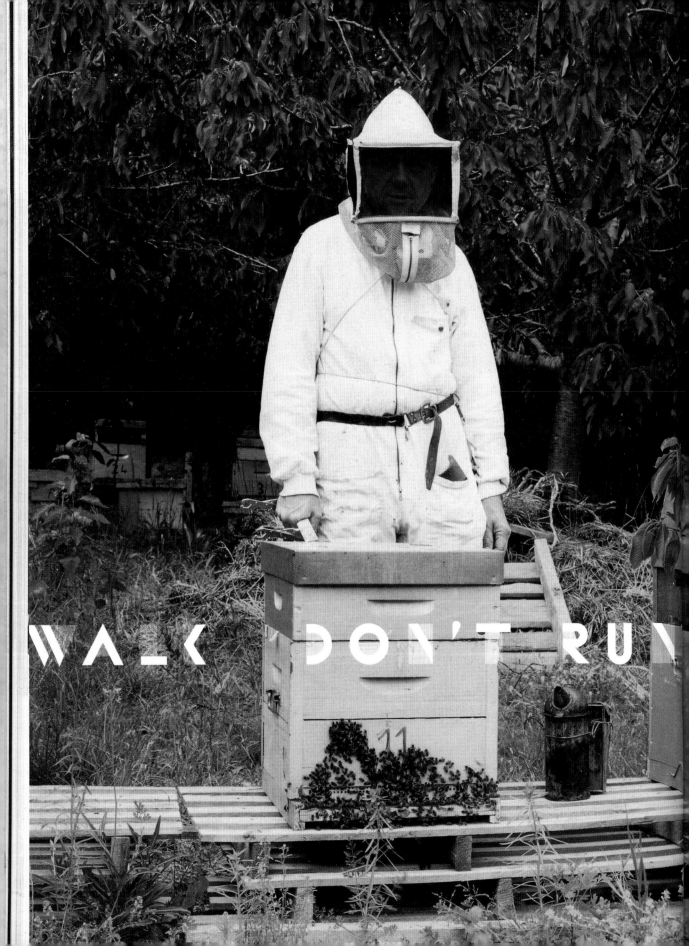

WALK DON'T RUN

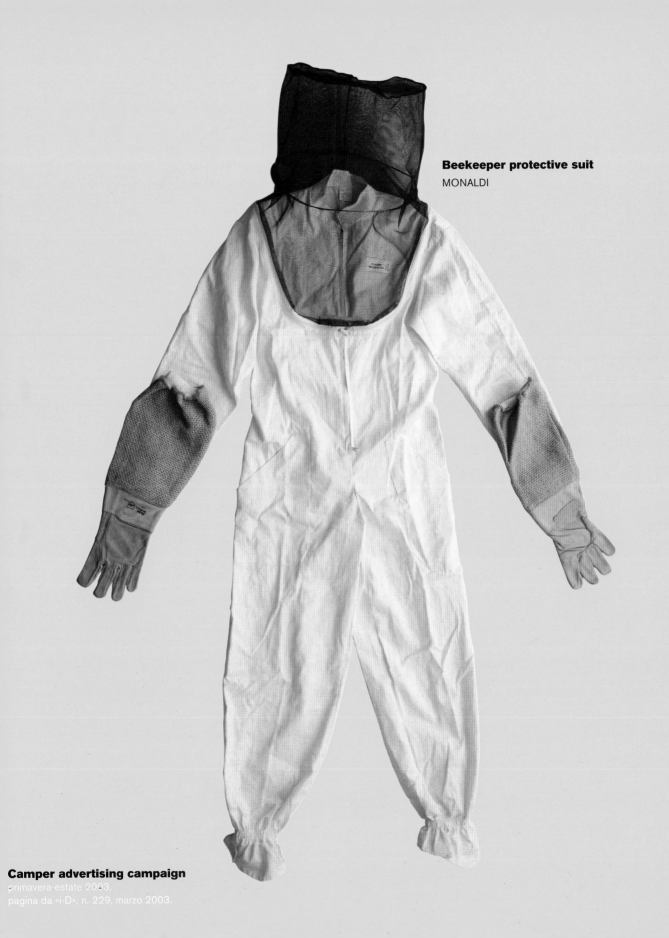

Beekeeper protective suit
MONALDI

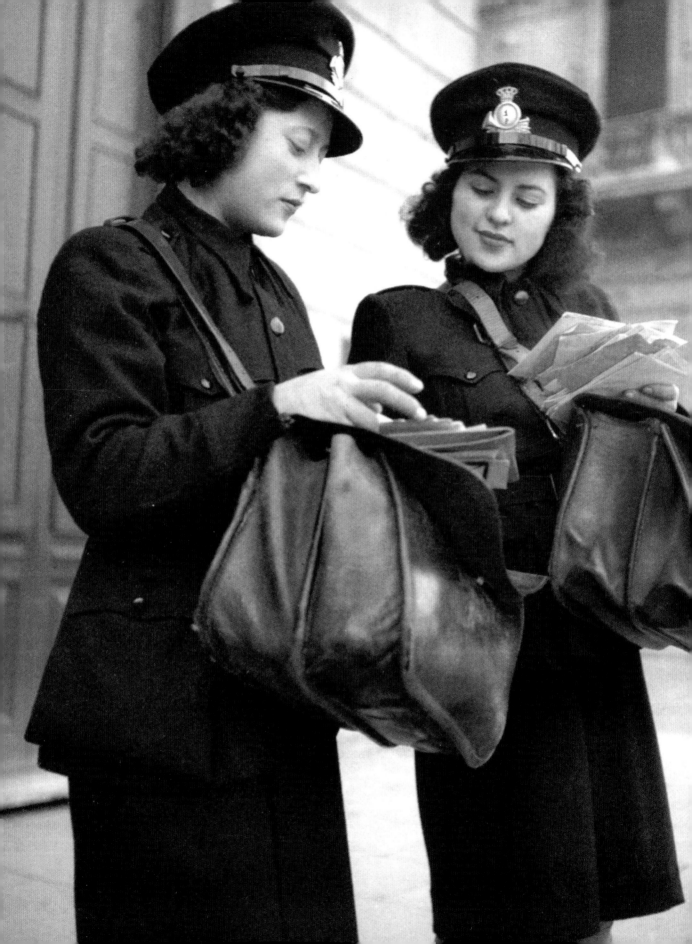

Postwomen
Photo Istituto Luce, February 20, 1942, page 217
Luca Scarlini (ed.) *Donna: una storia italiana.* Milan:
Oscar Mondadori, 2007

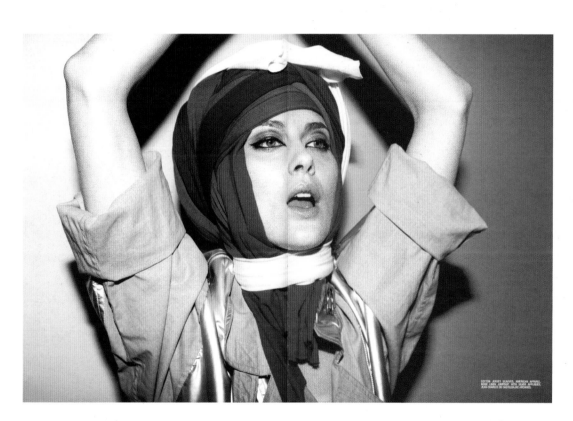

Improvised Stylistics
Photo Inez van Lamsweerde & Vinoodh Matadin,
styling Suzanne Koller.
Pages from *Self Service*, no. 25, fall-winter 2006.
Overall, from the archives of Jean-Charles de Castelbajac.

Nonabrasive kneepads
MCGUIRE-NICHOLAS

Ergonomic kneepads in polyester
and high-density foam, with nonslip collar.

Nonslip kneepads
CUSTOM LEATHERCRAFT

Ultraflexible material, with internal foam
padding. Universal size.

Gel kneepads
WESTWARD

Comfortable Velcro fastening with hooks.
Gel lining and plastic exterior.

Protective kneepads
MCGUIRE-NICHOLAS

Fitted with two hooks and
Velcro fastening, foam lining.

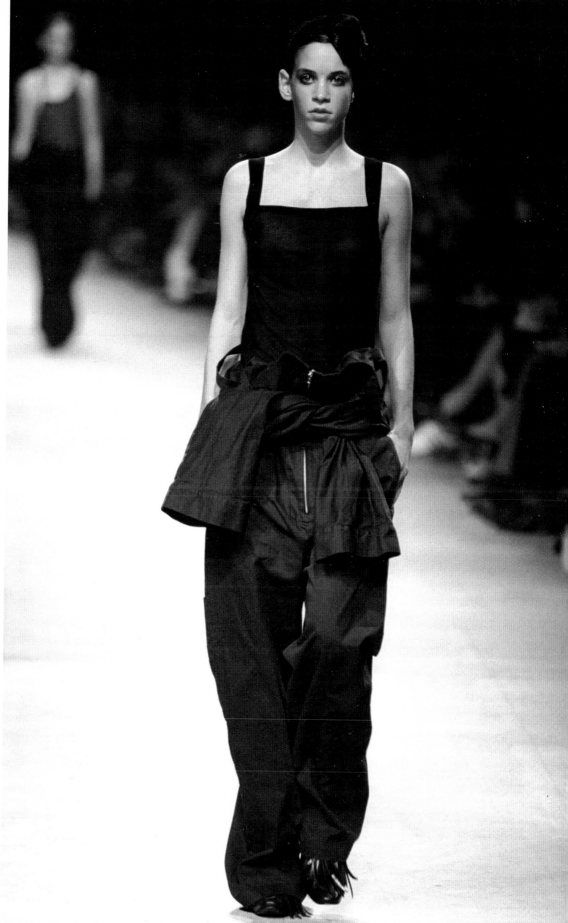

Yohji Yamamoto
Spring-summer show
2003.
Photo Monica Feudi.
Courtesy Yohji Yamamoto.

Dottor Group Company Profile

Photo Oliviero Toscani, 2008

Multi-pocket suit
LOTTO

Suit in stretch twill with inserts and
reinforcements. Completely waterproof fabric.

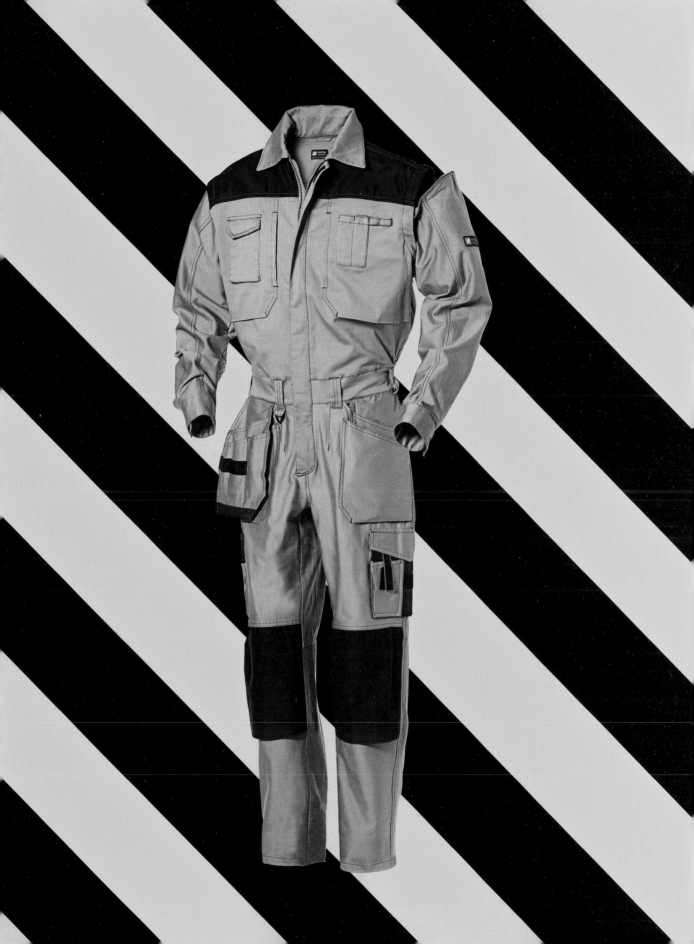

Max Mara

Fall-winter show 2006-07
Photo Bruno Rinaldi, Courtesy Max Mara.

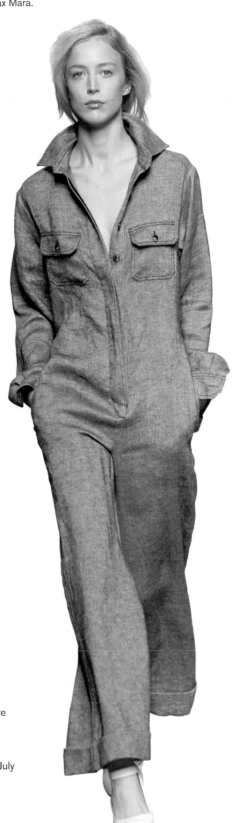

Untangling

Photo Jeff Wall, 1994.
Page from *Kerry Brougher*, ed.
by Jeff Wall, exhibition catalogue
(Hirshhorn Museum and Sculpture
Garden, Smithsonian Institute,
Washington D.C., February
20 - May 11, 1997; Museum of
Contemporary Art, Los Angeles, July
13 - October 5, 1997; Art Tower
Mito, Mito, December 13, 1997
- March 22, 1998). Los Angeles:
Museum of Contemporary Art/
Zurich: Scalo Verlag, 1997.

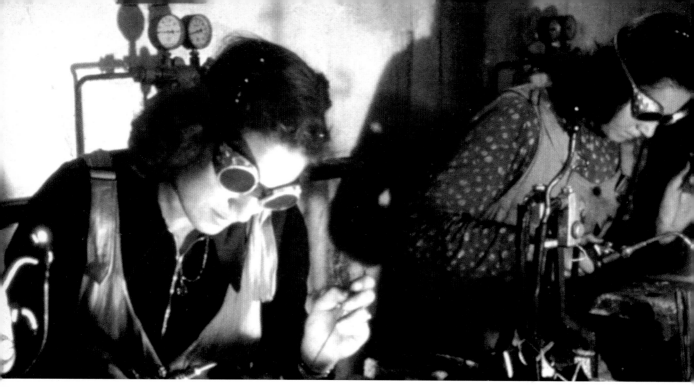

Workers at the Caproni firm

Photo Studio Villani, 1940. Page from Luca Scarlini (ed.), *Donna: una storia italiana*. Milan: Arnoldo Mondadori 2007.

Protective goggles with replaceable lenses
SPERIAN

Screw-in lens system for easy replacement. Soft rubber padded surround, for extra comfort. Certified as meeting the EN I 75 standard (welders' goggles). Green glass lenses, graduation 5.0. Weight: 85 g.

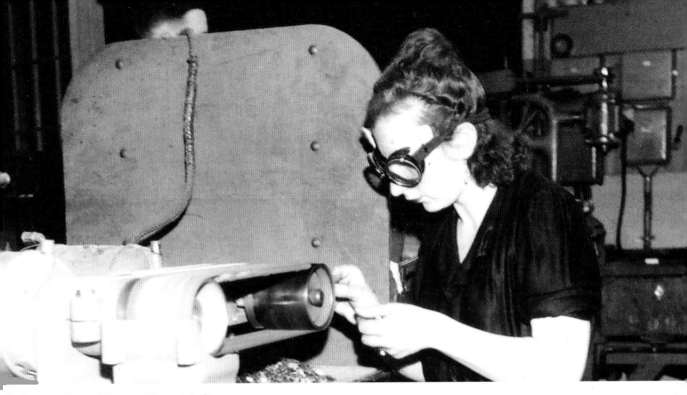

Italian worker at Brown Boveri & Cie

Anonymous photo, Baden, 1940. Page from Luca Scarlini (ed.), *Donna: una storia italiana*. Milan: Arnoldo Mondadori, 2007.

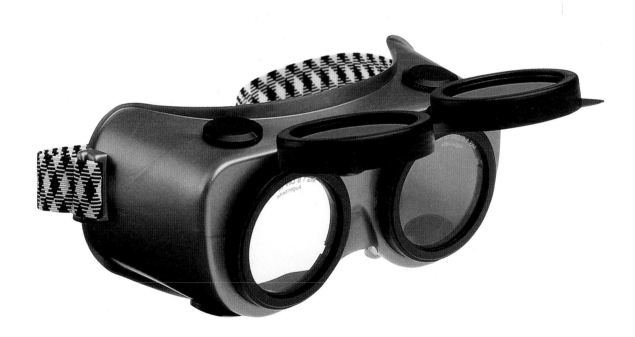

Protective goggles with replaceable lenses
SPERIAN

Box-type goggle for welding, with flip-up lenses and indirect ventilation; can be worn over prescription eyewear. Certified as meeting the EN I 75 standard (welders' goggles). Colorless laminated glass lenses; green flip-up lenses, graduation 5.0. Light silver PVC frame. Weight: 140 g.

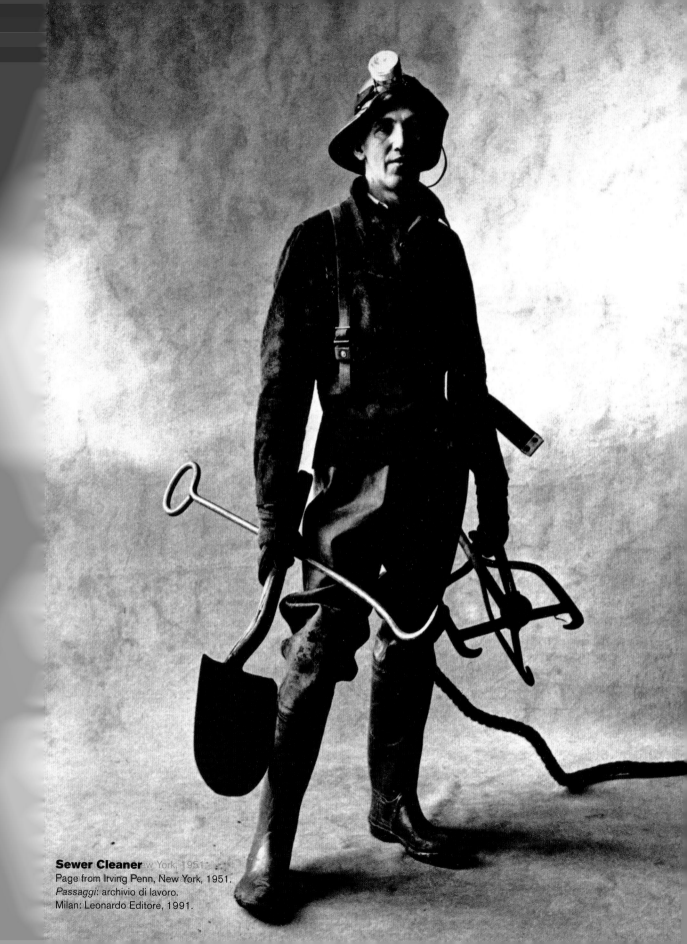

Sewer Cleaner New York, 1951.
Page from Irving Penn, New York, 1951.
Passaggi: archivio di lavoro.
Milan: Leonardo Editore, 1991.

Rubber and neoprene boots
APPROVED VENDOR GRAINGER

Leakproof, abrasion-resistant boots provide long
wear under rugged working conditions. Flexible
ankle, heel and top skirt offer added comfort.
Cleated outsole for sure-footed traction. With knit
lining, cushion insole and steel shank.

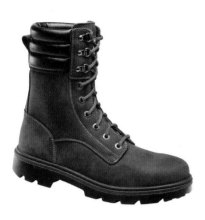

Cordura boot
with Nubuck pull-up upper
DIADORA

Cambrelle 300 lining and solid
polyurethane sole, abrasion-resistant.
Polyurethane foam midsole and steel
200 joule toecap.
Antiperforation steel insole and arch
support with anatomic E.V.A. heel.

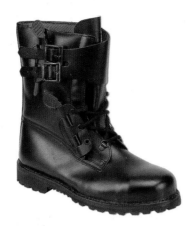

Gumboot
MONTEBOVE

Boot fastened with laces and buckles.
Water-repellent upper, leather lining,
sewn nitrile rubber sole.

Accident-prevention boot
MONTEBOVE

Water-repellent greased full grain leather
gumboot. Lining in breathable water-
absorbent fabric treated with antibacterial
and antimycotic agents and coupled with
"tecnobreath T" PTFE membrane.
Sole in an antistatic, oil and heat resistant
(300°) nitrile rubber mixture.

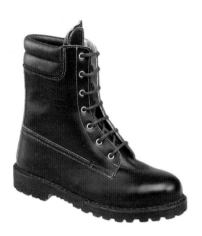

Snow gaiter
MONTEBOVE

Calf-laced boot with water-repellent
upper, leather lining and cleated rubber
sole. ?Ideal mounted production.?

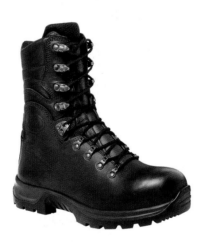

Boot with leather upper
JOLLY

Water-repellent with joint at back.
Antistatic, double-density nitrile rubber sole,
resistant to oils/hydrocarbons, nonslip,
wear-resistant. With shock-absorbing heel
and aluminum toecap.

Leather boot with rubber toe
JOLLY

Boot with rear gusset. Breathable fabric lining and
antiperforation insole. Antistatic, double-density
nitrile rubber sole, resistant to oils/hydrocarbons
and heat, nonslip, wear-resistant, shock-absorbing
heel.

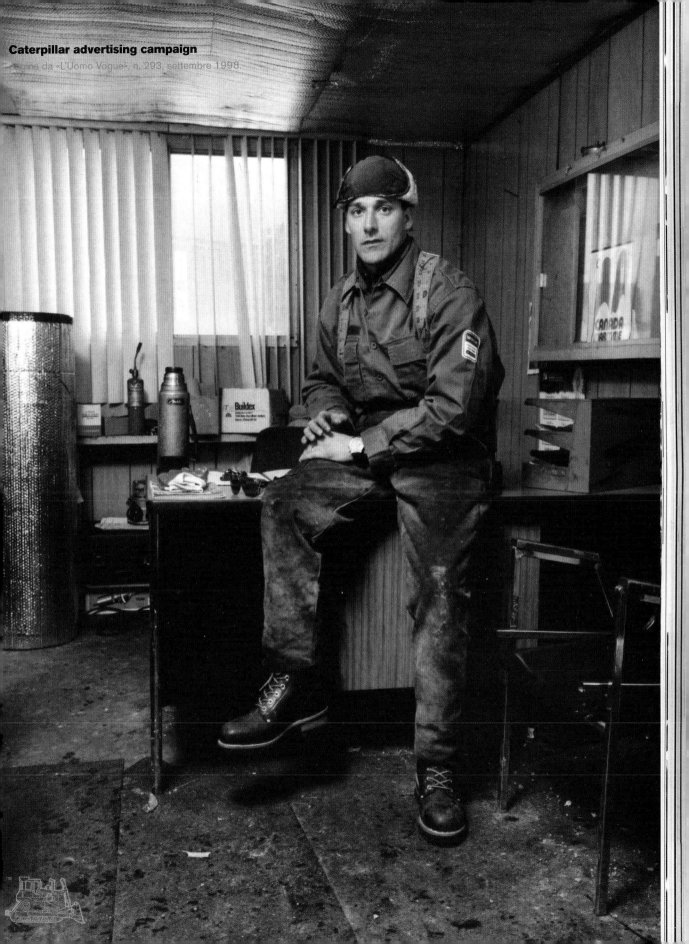

Caterpillar advertising campaign
da «L'Uomo Vogue», n. 293, settembre 1998.

IT IS COMPULSORY

TO WEAR
PROTECTIVE GLOVES

Segnaletica Italiana D.L. 493 del 14/08/96 - CEE 92/58 - UNI

Protective glove
UVEX

PVC glove providing protection against chemical risks,
resistant to mineral oils.

Keaton's Place

HOTOGRAPHER MELODIE McDANIEL
TYLIST LEÏLA SMARA

Keaton's Place

Photo Melodie McDaniel,
styling Leïla Smara.
Page from *Vogue
Hommes International*,
no. 15,
spring-summer 2004.

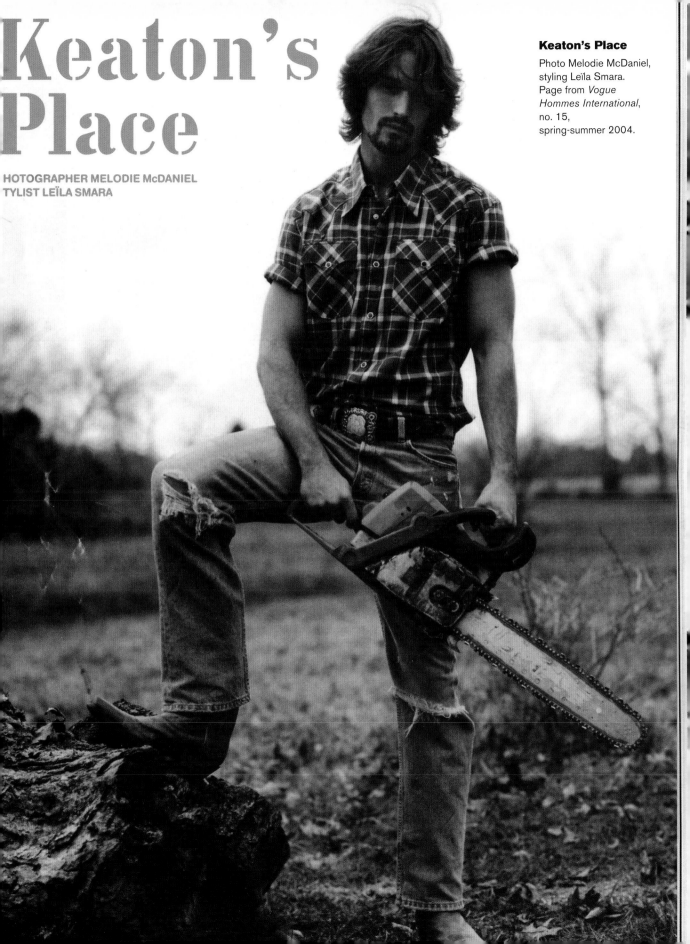

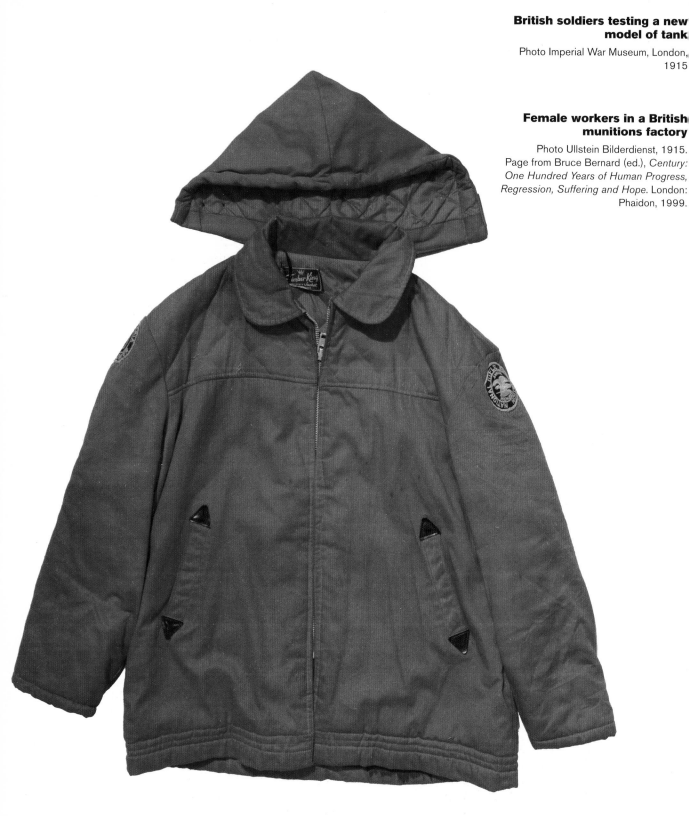

Coastguard jacket

Wrangler, 1950s
Stewart private collection

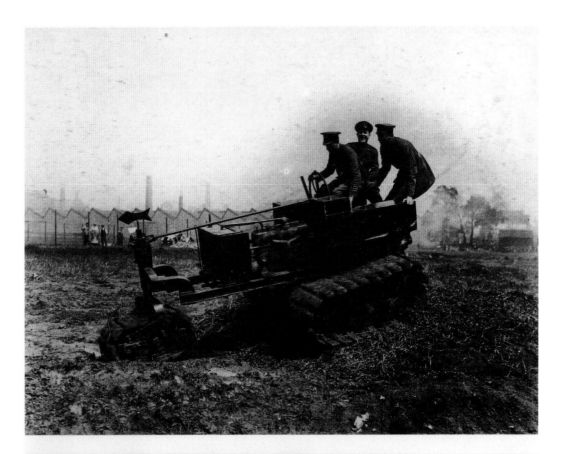

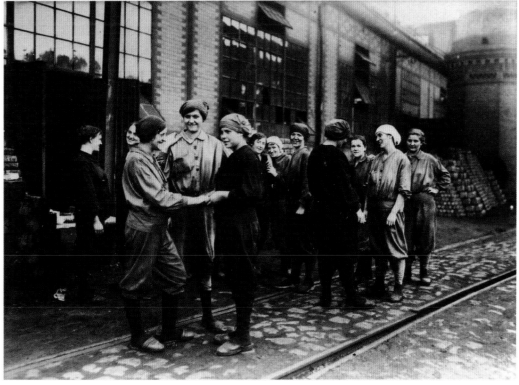

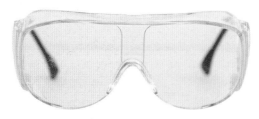

Glasswear
UVEX

The classic: lightweight and ergonomically designed safety spectacles with an extremely large field of vision and outstanding fit.

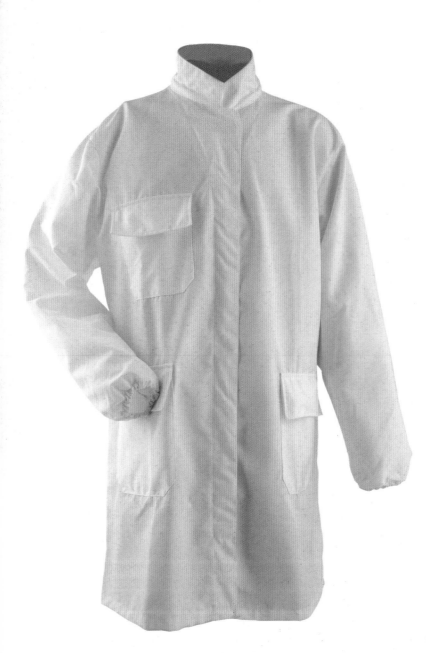

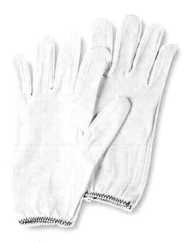

Inspection gloves
CONDOR

Durable, white, ambidextrous gloves absorb perspiration and have thin, two-piece construction. Priced and sold by package of 12 pairs.

White coat
SPERIAN

Reverse collar. Frontal closure with snap fasteners covered by protective flap. Three applied pockets covered by flaps: one on the breast and two on the hips. Fitted sleeve with elastic cuffs.

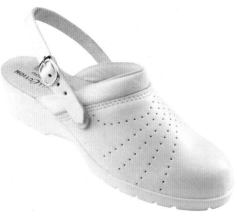

Antibacterial shoe
SPERIAN

Upper in perforated full grain leather. PU sole. Steel 200 joule toecap.

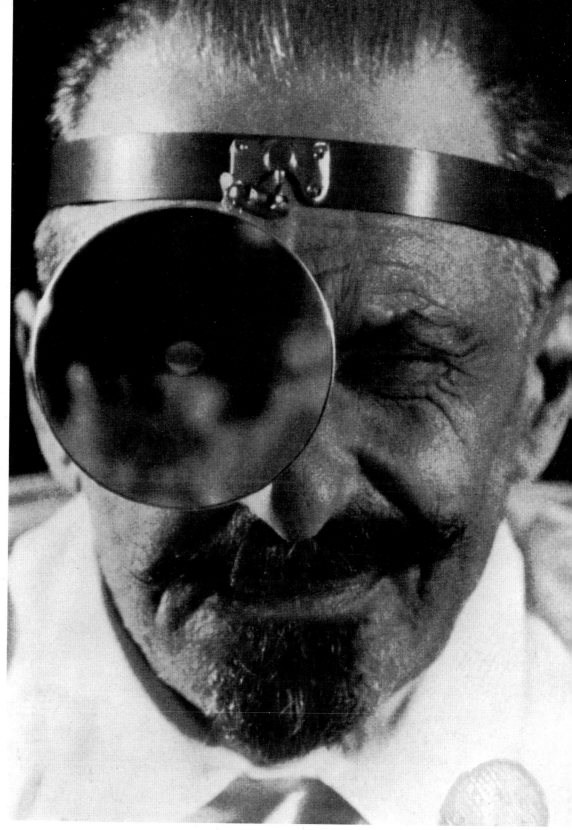

Observation

Photo Vincenzo Balocchi, 1942. Page from Carlo Bertelli
and Giulio Bollati, *Storia d'Italia: L'immagine fotografica,
1845-1945*. Turin: Giulio Einaudi Editore, 1979, vol. II.

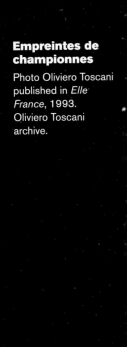

Empreintes de championnes

Photo Oliviero Toscani published in *Elle France*, 1993. Oliviero Toscani archive.

EMPREINTES DE CHAMPIONNES

A l'aise dans ses baskets, pour courir à petites foulées ou pour marcher toute la journée.
1. Baskets hautes, aspect suédé (Nike, 842 F, dans les magasins de sport).
2. Boots en nubuck,

élastiquées sur le côté, semelle crantée (Arche, 595 F).
3. Baskets montantes en cuir noir surpiqué (Boks de Reebok, 300 F, aux Galeries Lafayette).
4. Desert boots en nubuck noir (Bocage, 445 F).

5. Baskets basses en cuir à double surpiqûre, semelle crantée en caoutchouc (T.B.S., 299 F, Au Vieux Campeur).
6. Chaussures de marche à lacets de couleur (André, 269 F).

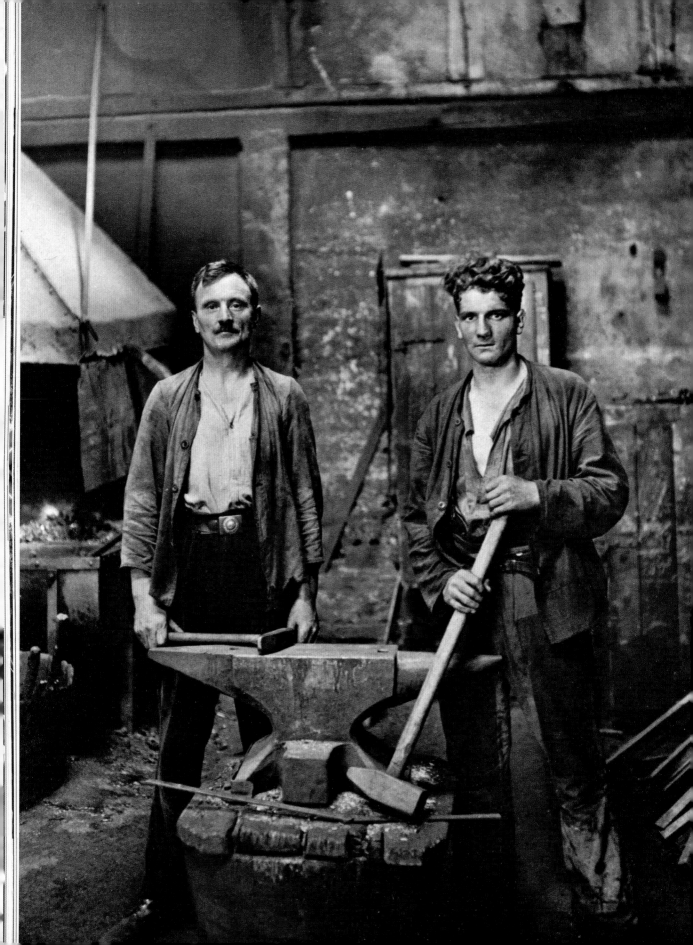

Blacksmiths in Wuppertal

Photo August Sander, 1929
Page from August Sander, *Menschen des 20.
Jahrhunderts*. Munich: Schirmer/Mosel, 1980.

Earmuffs
MOLDEX

SoftCoat® covering in an exclusive
iridescent color. Convenient grips set
in the cups. Wide range of adjustment
of the cups, better distribution of
pressure to suit the size of the head.
The headband can also be positioned
behind the neck.

Leather palm fingerless gloves
CONDOR

The leather protects palm and knuckles, allowing full mobility of the thumb. Double layer of leather in the area of the palm subject to high wear.

Man's safety boot
SPERIAN

Black soft leather boot. Genuine sheepskin lining with Thinsulate™. Black nitrile sole. Steel toecap and steel antiperforation insole.

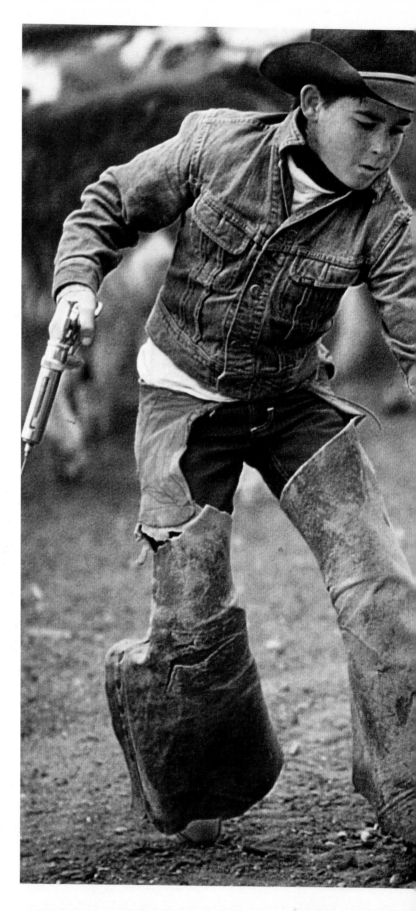

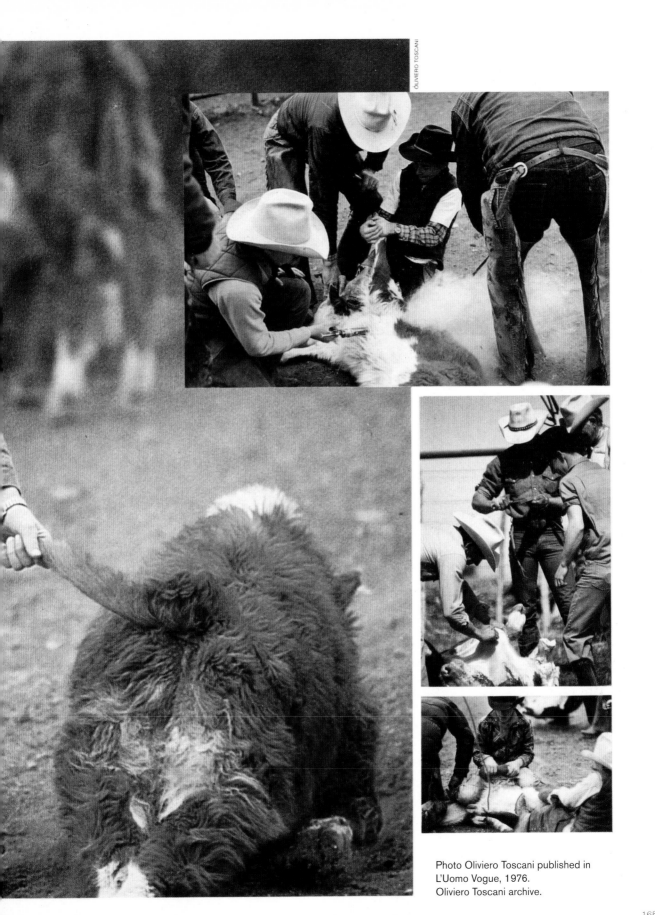

Photo Oliviero Toscani published in
L'Uomo Vogue, 1976.
Oliviero Toscani archive.

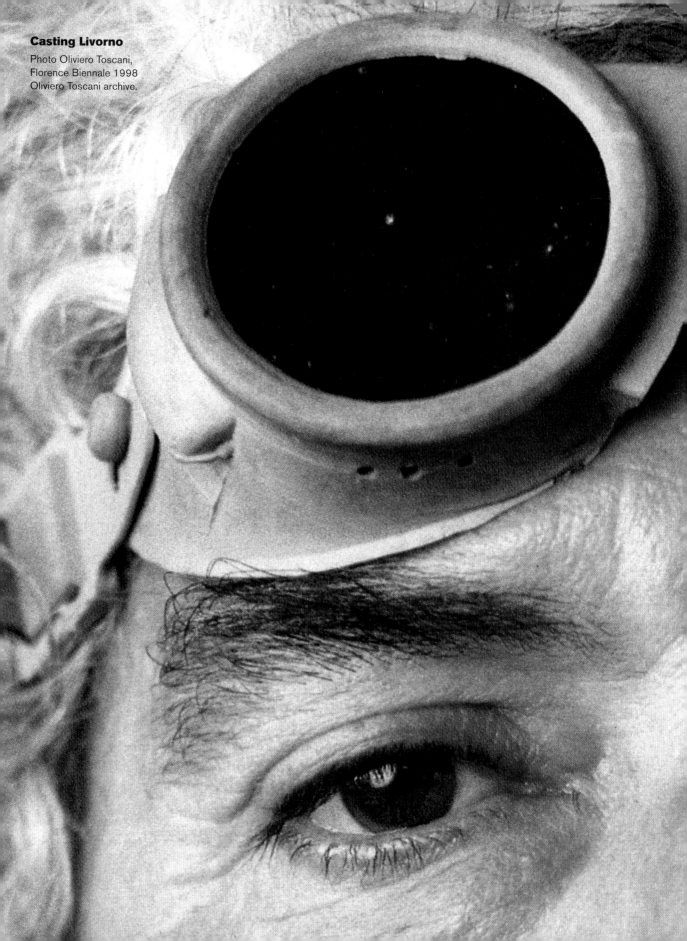

Casting Livorno

Photo Oliviero Toscani,
Florence Biennale 1998
Oliviero Toscani archive.

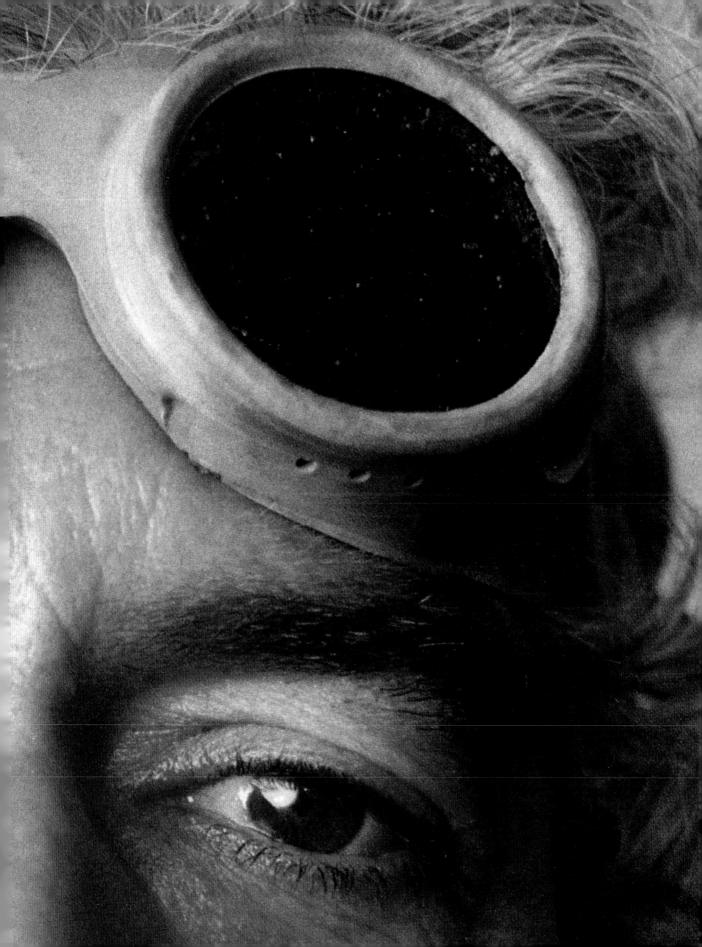

High-visibility vest
SIGGI

Easy to put on, it ensures high visibility even
in the dark and in dangerous situations.
Suitable for emergency services, civil defense,
firefighters.
The special fabric of the vest provides high
protection against splashes.

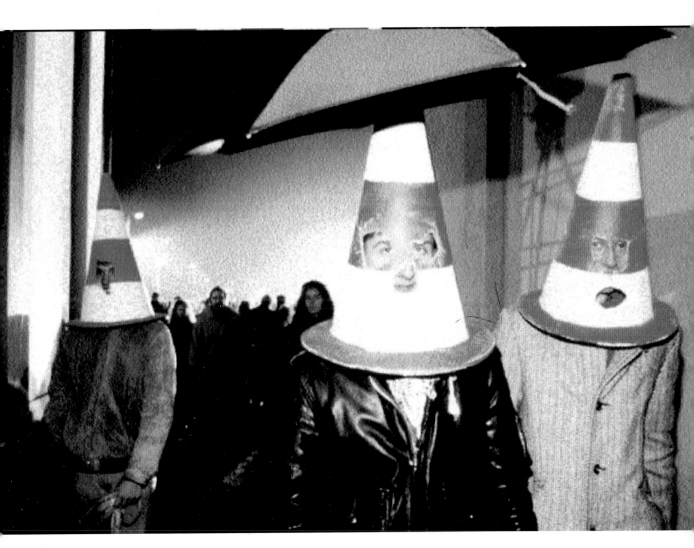

Page from *Colors*, nos. 38/39,
Fashion, June-September 2000.

Ambidextrous mitten
GIORDANI

Outer fabric 620 g/m² PBI/aramidic fiber. Internal
padding of glass fiber and flame-retardant wool,
flame-retardant cotton lining. EN 407.

Apron
GIORDANI

Aramidic fiber apron fastened with ties.
Measurements: 60 x 100 cm, 70 x 100 cm.

Brad Pitt: a visual script
by Steven Klein

Photo Steven Klein, fashion editor
Heathermary Jackson. Page from
L'Uomo Vogue, no. 351, May 2004.

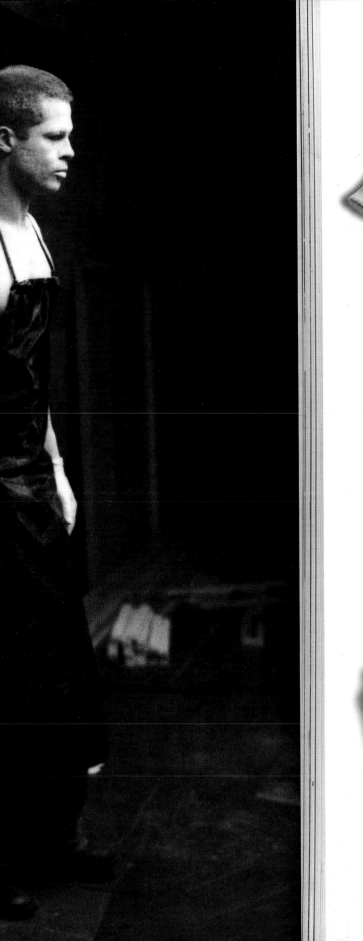

Heat-resistant glove
GIORDANI

Five-finger aramidic glove with heat-resistant leather palm, back made of aluminized Rayon and lining in flame-retardant TNT fabric. Length 35 cm.

Welding apron
GIORDANI

Aluminized aramidic fiber apron with leather strap fastening. Measurements: 60 x 100 cm, 70 x 100 cm. Conforms to EN 470 standard for welding.

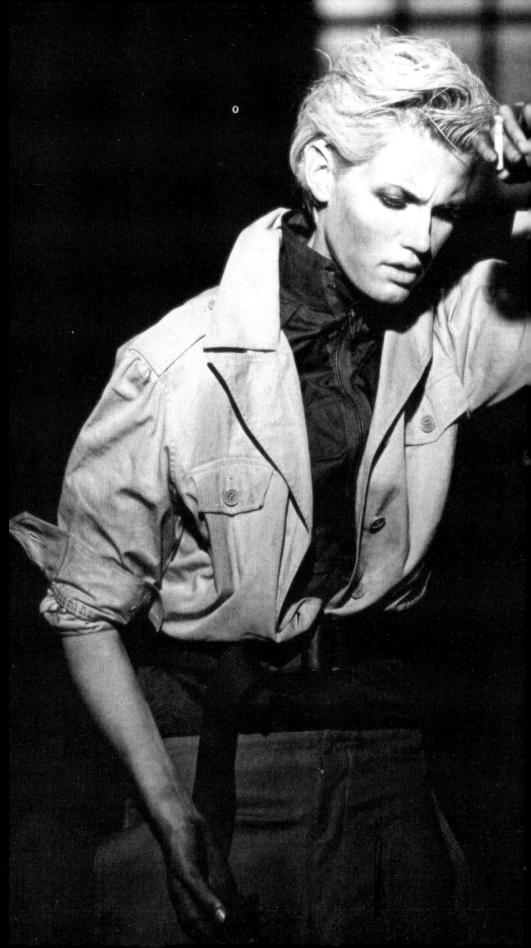

**Le Havre: Eva Jay &
Jean-Hugues Anglade**

Photo Peter Lindbergh,
fashion editor George Cortina.
Pages from *Vogue Italia*,
no. 627, November 2002.
Shirt, blouson and pants,
Yohji Yamamoto.

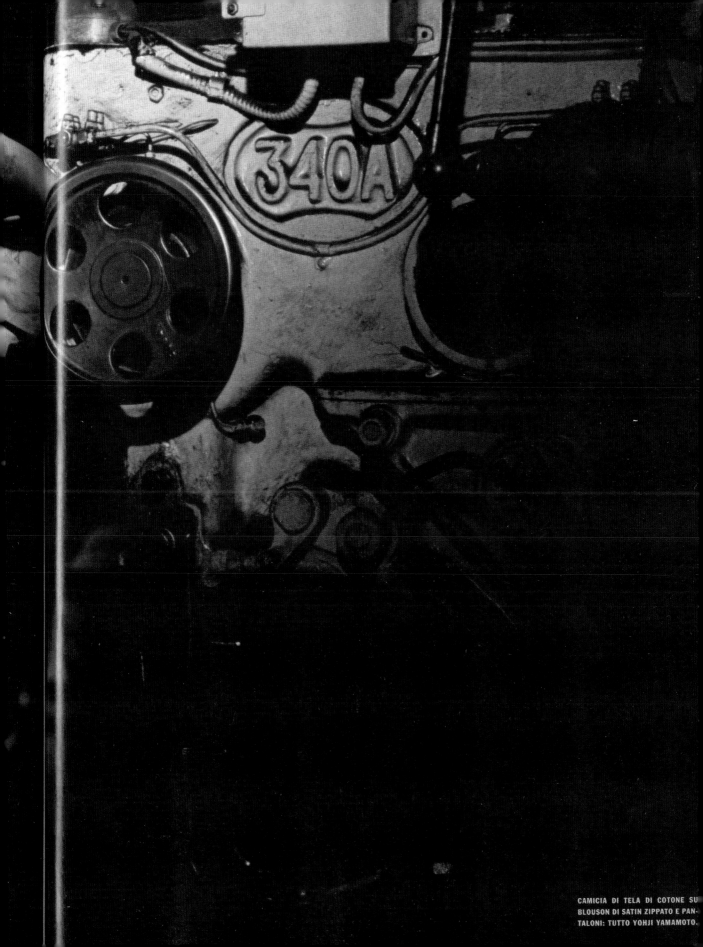

CAMICIA DI TELA DI COTONE SU
BLOUSON DI SATIN ZIPPATO E PAN-
TALONI: TUTTO YOHJI YAMAMOTO.

Torino, perde il lavoro e si dà fuoco

È gravissimo, il padre disoccupato si era ucciso nello stesso modo

«bo»

Due morti in 24 ore nei cantieri liv

Dopo la Solvay, l'Interporto: giovane albanese vola dal

Catania L'assessore regionale al lavoro: una

Operai morti, 7
Sotto accusa il

...a anche in Toscana. Riza era
...tato assunto circa due setti-
...nane fa.

Il capannone è stato subito
...posto sotto sequestro dal dot-
...o, che è il magistrato

costruzione.
«È stata una disg...
l'uomo - e non ho fa...
po a realizzare com...
la abbia potuto...
Francesco. È stat...

...omicidio colposo». Sacconi: or

...bastiano Corfi titolo... prio la...

la Repubblica
GIOVEDÌ 12 GIUGNO 2008

■ 2

LE MORTI BIANCHE

IL TIRRENO

Strage sul lavoro, sei c

...p europeo, scatterà tra 4 anni
Flavio Vanetti alle pagine 8 e 9

...abbracciati nella fossa del depurat

Molfetta, quinta vittima. Domani in Consiglio dei ministri il decreto sicurezza

di **Alessandra Arachi**
a pagina 25

UN AMERICANO A ROMA

«Un america...

più ...

Morti bianche, Damiano accusa

...Sanzioni, Confindustria resiste». La replica: troppo d...

...storia

...o a 20 anni

...ele
...gnava
...lo chef

Politica e q...
Pd: alle d...
pochi pos...

La p

CORRADO SALVINI

Lo strazio intorno alla vasca della morte

25,49%

Il calo
delle vittime
sul lavoro

Quelli che vanno
a lavorare in tuta

Il rischio

esi

mone

Dolore e sconfor-
Martini - che que-

me era in nero

"Fatemi vedere mio figlio l'ultima volta"

Incidenti sul lavoro

Sei operai morti abbracciati mentre tentavano di salvarsi

Strage in un depuratore. Esalazioni o scossa elettrica

I pompieri

agati
daco

ano straordina

A Mineo, intanto

cidio su

**Venerdì
3 Ottobre 2008**

Fatto del giorno

LA STRAGE SUL LAVORO

Altre due vittime a Genova e in Umbria

GENOVA. Un'altra giornata nerissi-
ma, in Italia, per gli incidenti sul lavo-
ro. Un operaio di 28 anni è morto in Um-
bria schiacciato da un carroponte, men-
tre in Liguria si registra l'orribile mor-
te di un operaio genovese di 33 anni, Ni-
no Emiliano Cassola, precipitato in un
pozzo profondo 18 metri per l'estrazio-
ne del biogas nella discarica di rifiuti
di Scarpino, sulle colline di Genova.
Non c'è alcuna speranza che l'uomo sia
sopravvissuto alla caduta: nel pozzo,
che ha un diametro di solo un metro,
non c'è ossigeno. L'operaio stava se-
guendo la perforazione del pozzo con
una trivella, improvvisamente ha per-
so l'equilibrio ed è caduto.

MISERICO
BARBERINO

aforma si sgancia, sono precipitati ir

un quarto operaio salvo per mirac

nel cantiere dell'Autosole,

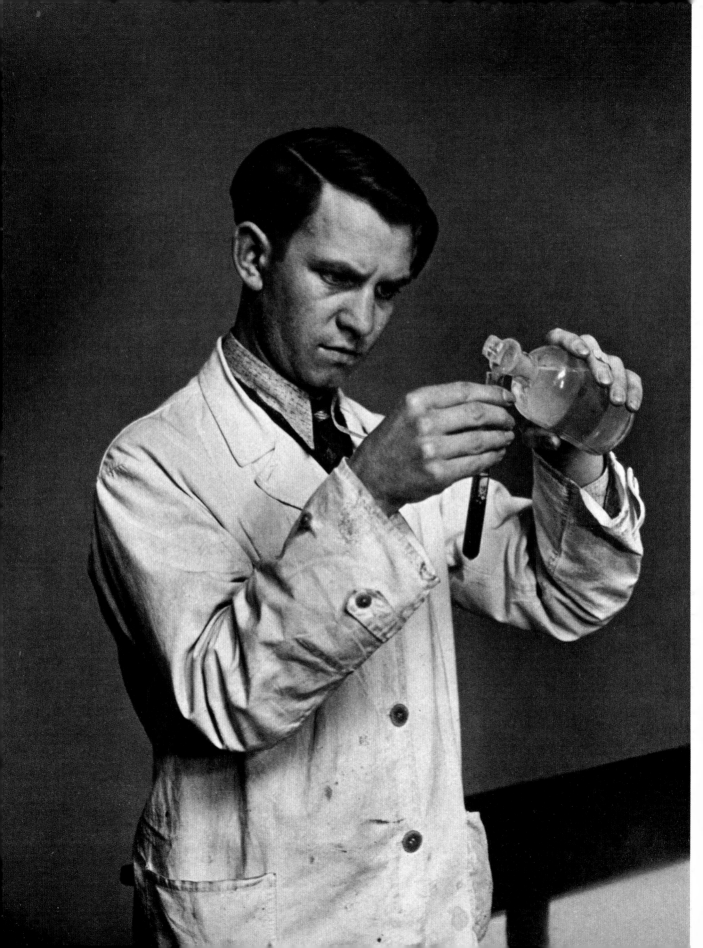

Laborant (lab technician)

Photo August Sander, Lamersdof, 1932/33.
Page from August Sander, *Menschen des 20.
Jahrhunderts.* Munich:
Schirmer/Mosel, 1980.

Orange glove
UVEX

Safety glove offering
protection against
mechanical risks.

Blue glove
UVEX

Gloves resistant to chemical products,
microorganisms and mechanical risks.

Yellow glove
UVEX

Gloves resistant to chemical products,
microorganisms and mechanical risks.

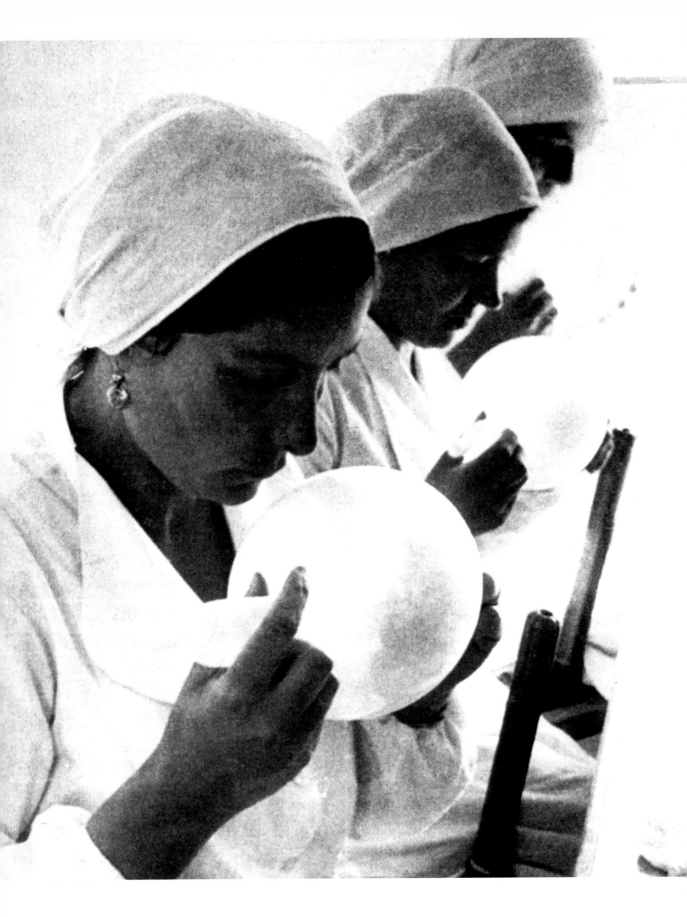

HATU factory

Photo Studio Villani, 1930
Page from Luca Scarlini (ed.),
Donna: una storia italiana.
Milan: Arnoldo Mondadori, 2007

11

uvex
PROFAS

XB27

EN 407 EN 388

CE

X2XXXX 0 5 1 6 1 2 3 0

Safety mitt
UVEX

Mechanical risks and protection
against cuts, heat and cold.

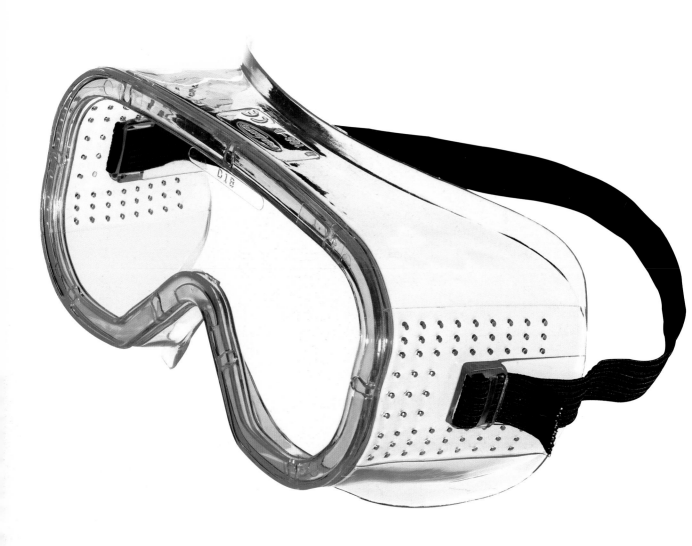

Indirect vent goggles
SPERIAN

Available in various versions: protection against mechanical risks and coarse dust, drops and splashes of chemicals, paint. Soft seal and easily adjustable headband. Clear polycarbonate lens.

Devo

Photo Pennie Smith, 1979
Page from *The Face,*
no. 20, December
1981

Photo Alasdair McLellan, styling Jane
How. Pages from *Self Service*, no.
28, spring-summer 2008. Bib overalls,
Agnès B.

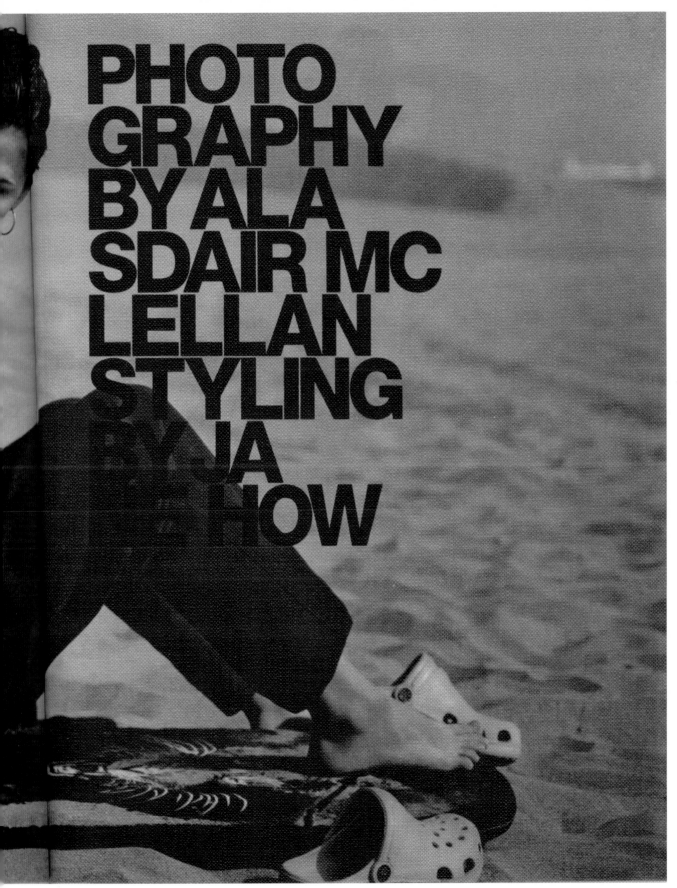

PHOTO
GRAPHY
BY ALA
SDAIR MC
LELLAN
STYLING
BY JA
NE HOW

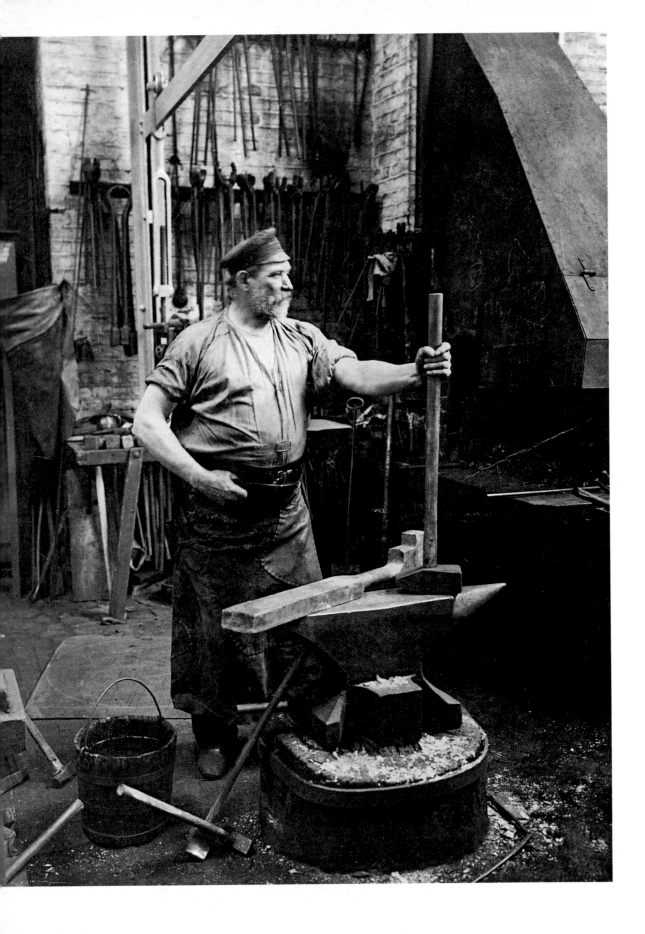

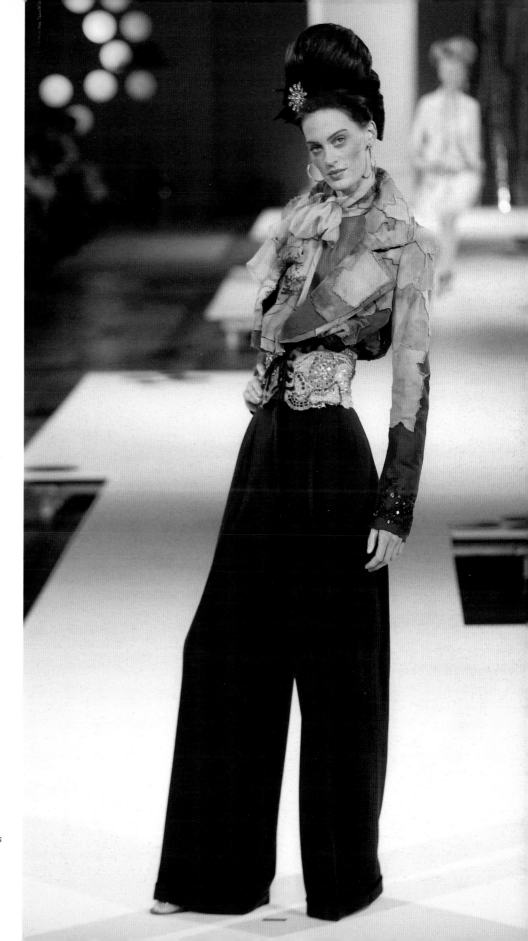

Christian Lacroix

Spring-summer haute couture
show 2004
Courtesy Christian Lacroix

German blacksmith

Visual Arts, Harvard University,
1899. Page from Bruce Bernard
(ed.), *Century: One Hundred Years
of Human Progress, Regression,
Suffering and Hope*. London:
Phaidon, 1999.

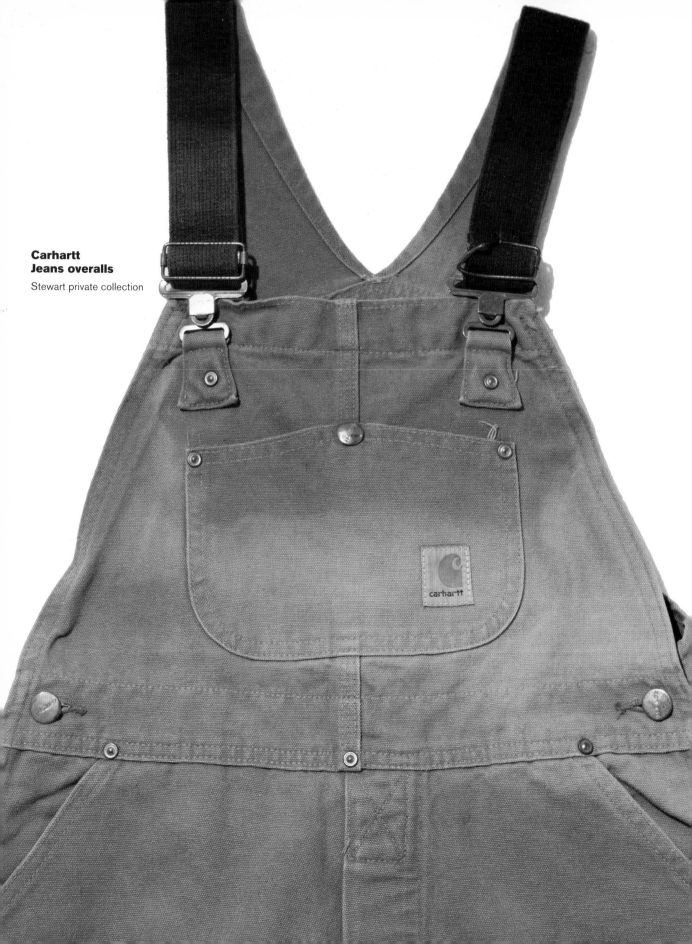

Carhartt
Jeans overalls

Stewart private collection

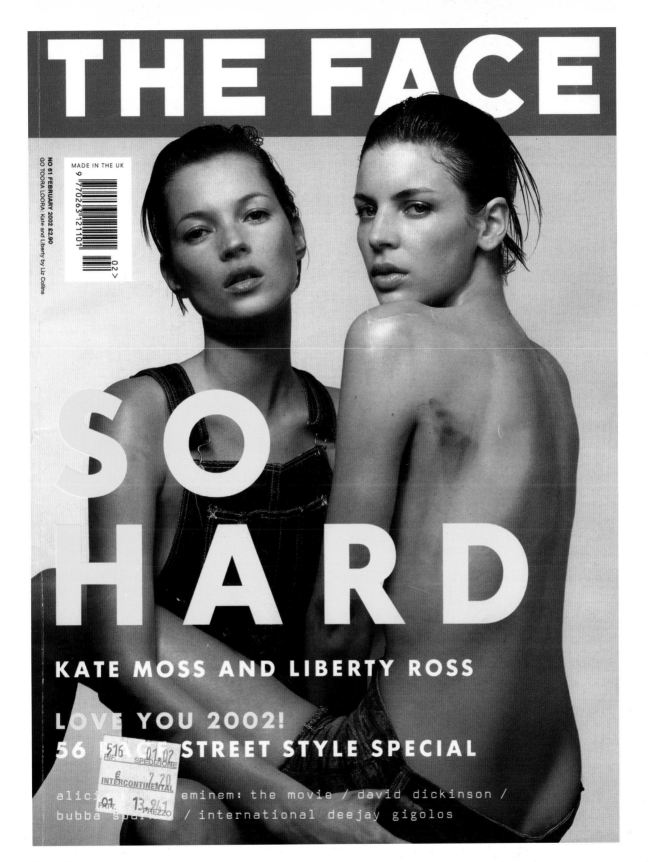

THE FACE

NO 61 FEBRUARY 2002 £2.80
GO TOORA LOORA: Kate and Liberty by Liz Collins

MADE IN THE UK

SO HARD

KATE MOSS AND LIBERTY ROSS

LOVE YOU 2002!
56 PAGE STREET STYLE SPECIAL

alicia keys / eminem: the movie / david dickinson /
bubba sparxxx / international deejay gigolos

Two-Rye-Aye
Photo Liz Collins, styling Heathermary Jackson.
Cover of *The Face*, no. 61, February 2002.

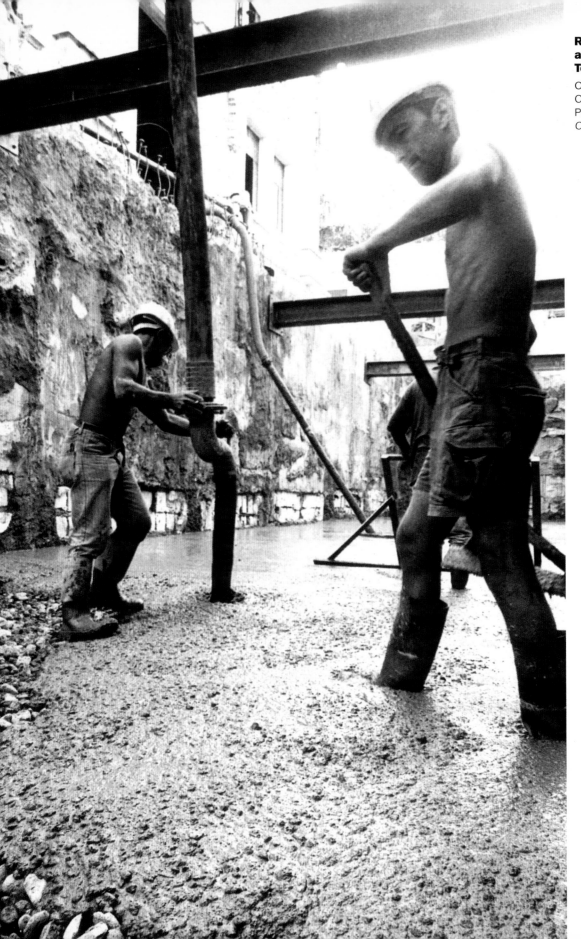

**Restoration
and extension
Teatro Eden**

Client: Fondazione
Cassamarca.
Page from *Dottor Group
Company Profile*, 2008

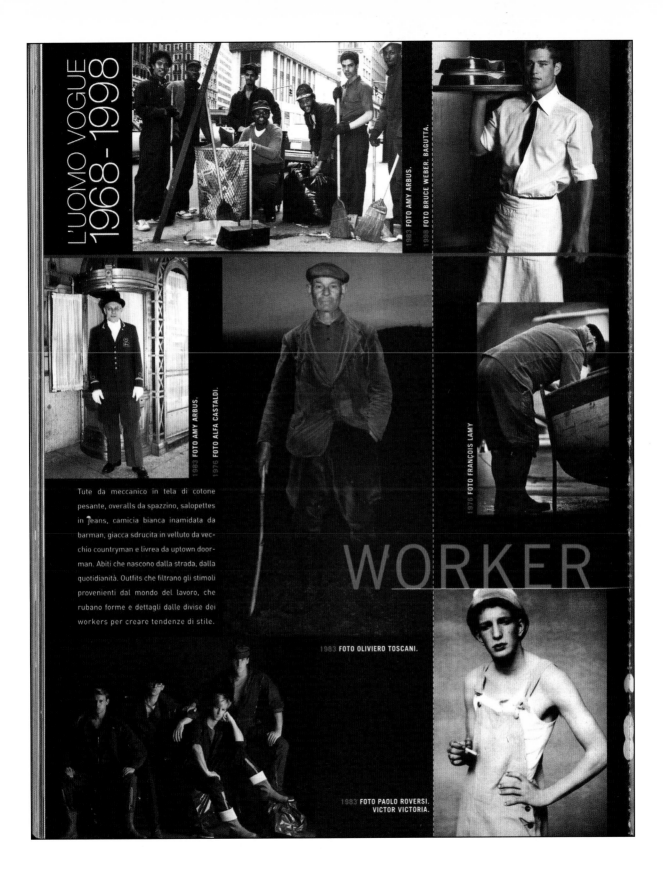

L'UOMO VOGUE
1968-1998

1983 FOTO AMY ARBUS.

1998 FOTO BRUCE WEBER. BAGUTTA.

1983 FOTO AMY ARBUS.

1976 FOTO ALFA CASTALDI.

1976 FOTO FRANÇOIS LAMY

Tute da meccanico in tela di cotone pesante, overalls da spazzino, salopettes in jeans, camicia bianca inamidata da barman, giacca sdrucita in velluto da vecchio countryman e livrea da uptown doorman. Abiti che nascono dalla strada, dalla quotidianità. Outfits che filtrano gli stimoli provenienti dal mondo del lavoro, che rubano forme e dettagli dalle divise dei workers per creare tendenze di stile.

WORKER

1983 FOTO OLIVIERO TOSCANI.

1983 FOTO PAOLO ROVERSI.
VICTOR VICTORIA.

Worker

Photos (from top): Amy Arbus, 1983; Bruce Weber, 1998; Amy Arbus, 1983; Alfa Castaldi, 1976; François Lamy, 1976; Oliviero Toscani, 1983; Paolo Roversi, 1983; text Roberto Rotta. Page from *L'Uomo Vogue*, no. 292, July-August 1998.

Safety shoe
DIADORA

Full grain leather upper, tobacco and pearl
color. Thermoplastic polyurethane sole and
polyurethane foam + film midsole. Aluminum
200 joule toecap.

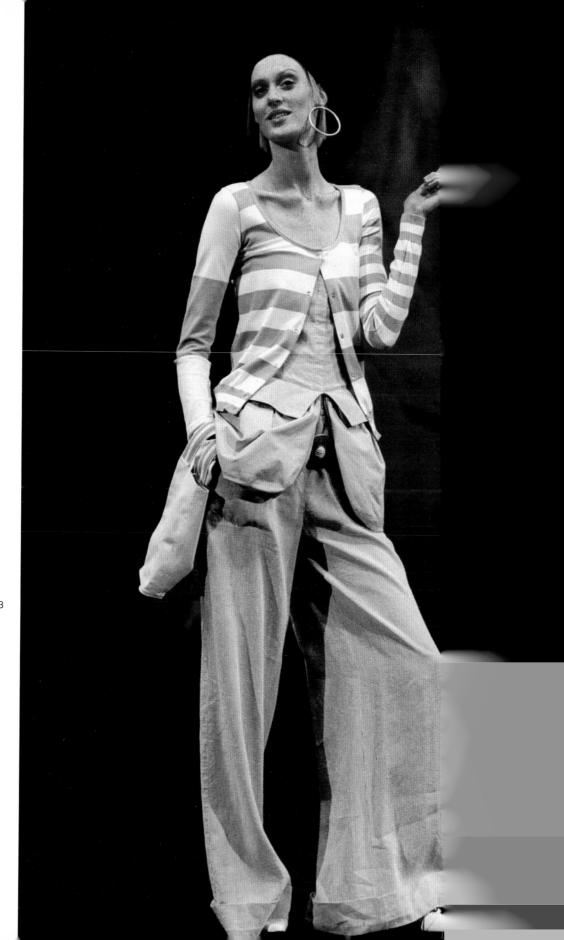

Emporio Armani

Spring-summer show 2003
Courtesy Giorgio Armani

Single-breasted and lined vest
FRAIZZOLI

Contrasting fabrics. Peak lapels, welt pockets, covered buttons and black satin strap on the back.

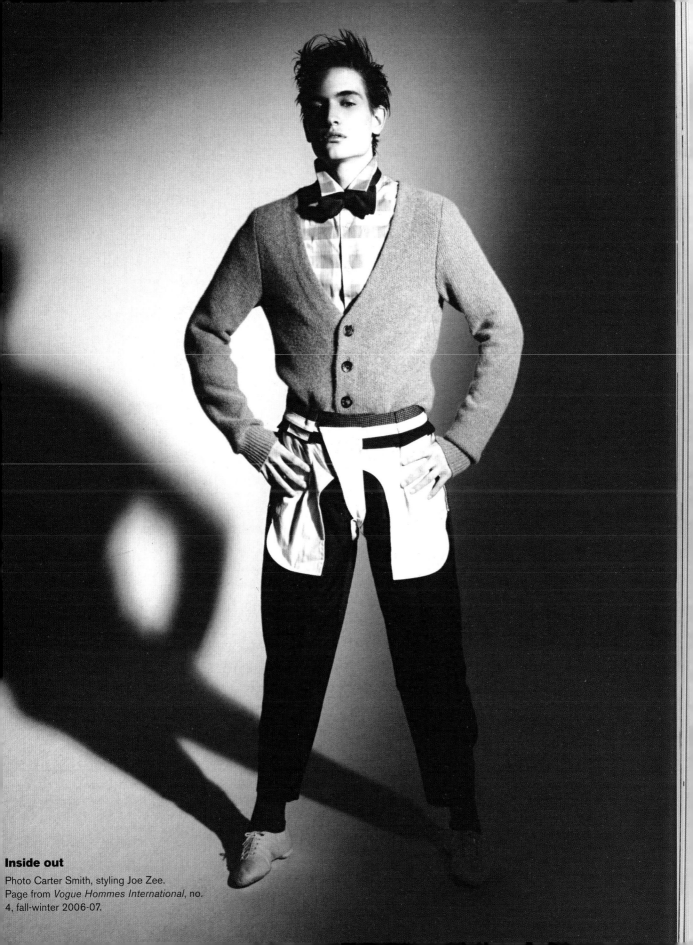

Inside out

Photo Carter Smith, styling Joe Zee.
Page from *Vogue Hommes International*, no.
4, fall-winter 2006-07.

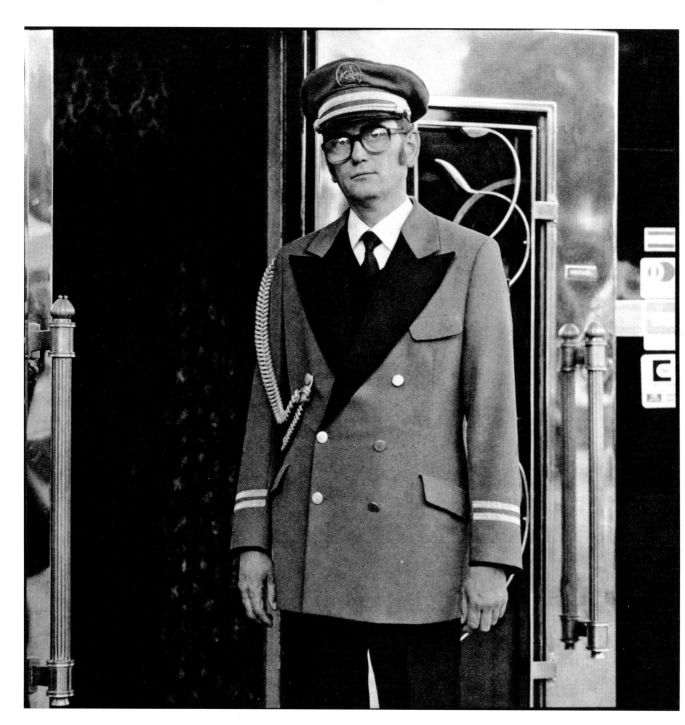

Gerd Linneweber, 39 years old, doorman, August 1985

Photo Jörg Meier, St. Pauli, Hamburg.
Page from Jörg Meier, *Die Würde dieser Menschen*. Nördlingen: Greno, 1987

Unlined vest
FRAIZZOLI

Shawl collar in contrasting color, 60 mm metal lyre
pinned to the breast, detachable gold buttons with lyre.
Woman's version.

Lightweight
CONDOR

Ideal for moderate conditions.
Features blue twill shell and black hook-and-loop
fasteners for easy attachment to cap suspension.

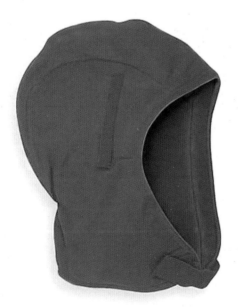

Long Nape
CONDOR

Cotton twill shell liner has an extended nape
that covers worker's neck for added warmth.

The Future Is This Place
at a Different Time

Photo Mark Segal, styling Alister Mackie.
Pages from *Another Magazine*, no. 12,
spring-summer 2007. Cap, Miu Miu.

Bags of bag

Photo Steve Hiett, fashion editor Anna Dello Russo.
Page from *Vogue Italia*, no. 584, April 1999.

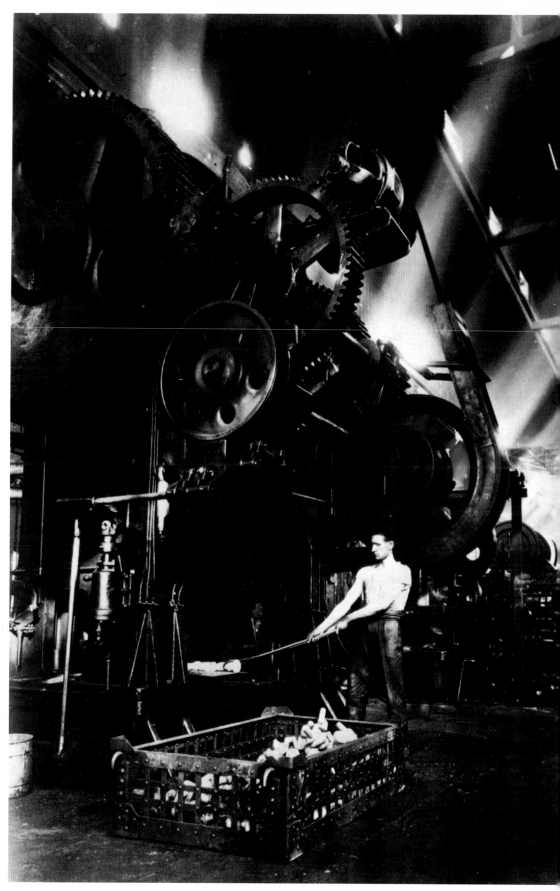

Fiat Lingotto: large press unit

Photo Centro Storico Fiat, Turin, 1925.
Page from Carlo Bertelli and Giulio Bollati, *Storia d'Italia: L'immagine fotografica, 1845-1945*. Turin: Einaudi, 1979, vol. II.

Reusable half mask respirator
MOLDEX

Facepiece:
highly flexible thermoplastic material, maximum comfort and safe seal. Includes gas filter, particulate filter and support for particulate pre-filter.
New filters can simply be slotted in. There is no threading, and no gaskets or others parts are required. Each new filter is fitted with a new inhalation valve.
The thermoplastic seal of the facepiece has a large surface that follows the shape of the face.

Particulate pre-filter
MOLDEX

Optional. The particulate pre-filters can be replaced when they become saturated, extending the lifetime of the respirator.

P2 S R, P3 S R, P3 R D.

Restorer

Dottor Group Company Profile, 2008
Photo Oliviero Toscani

200

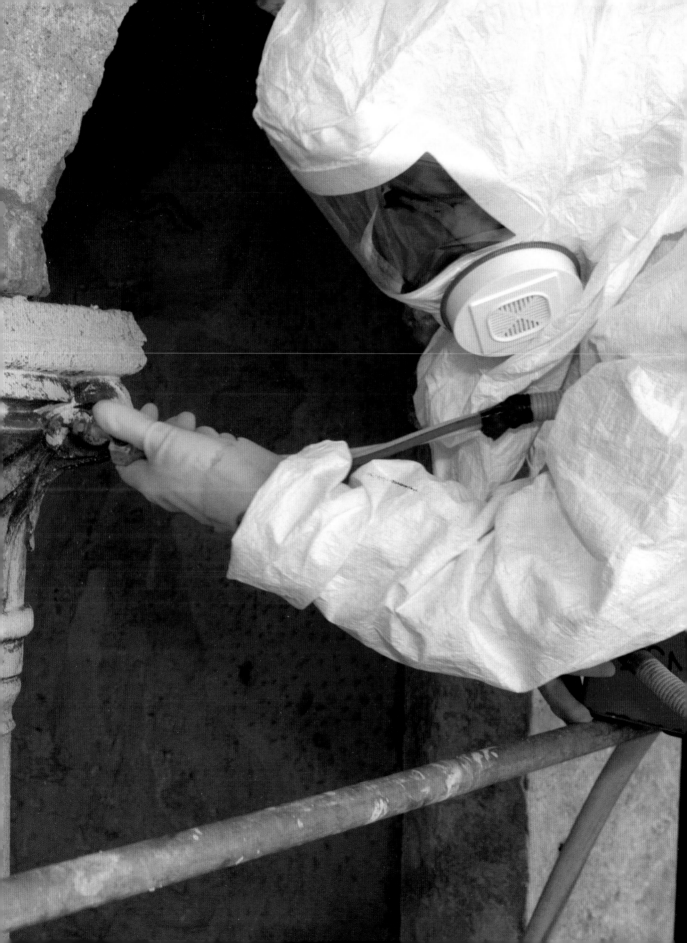

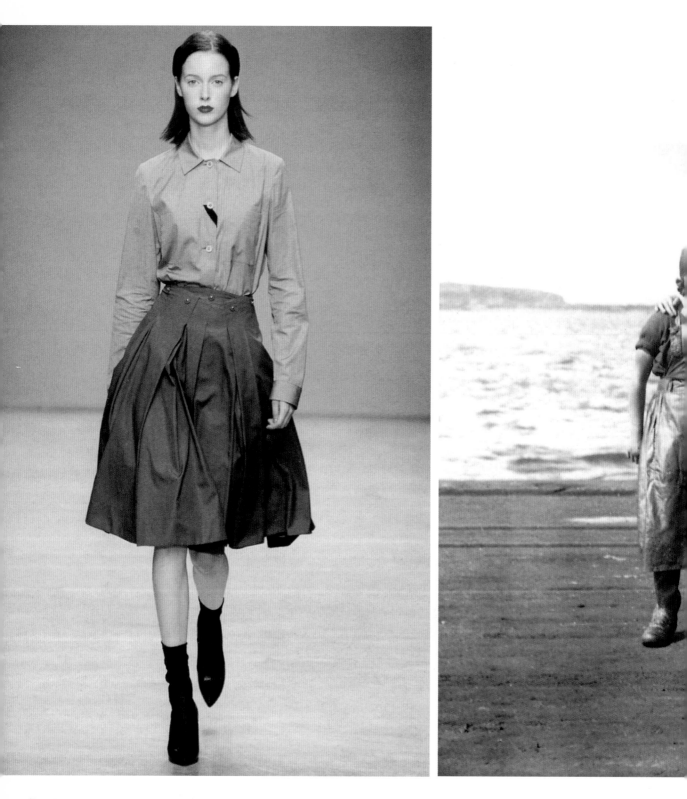

Prada
Spring-summer women's wear show 2001
Courtesy Prada

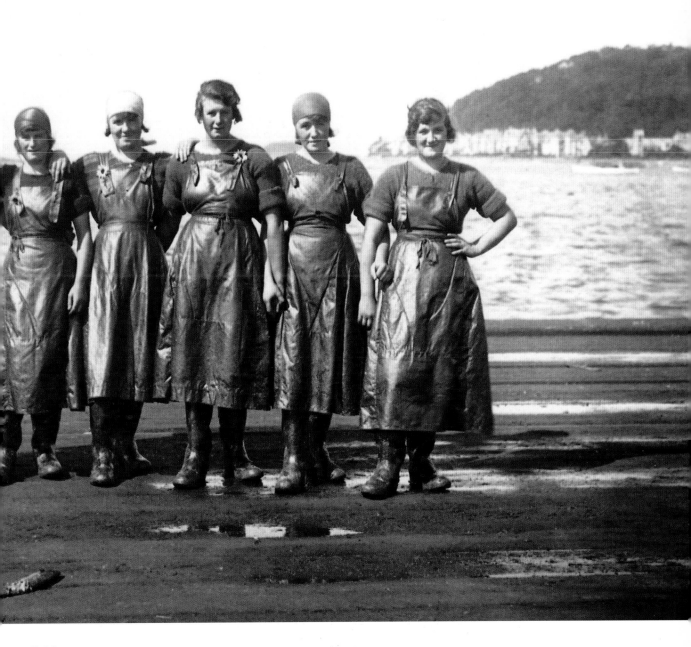

Banffshire

Photo Robert Reid, Scotland, 1928. Page from Jane Livingstone, *Odyssey: l'arte della fotografia al "National Geographic"*, catalogue of the exhibition *Odyssey: the Art of Photography at "National Geographic"* (Corcoran Gallery of Art, Washington D.C., 1988). Florence: Alinari, 1989.

Waste

Photo Steve Pyke, text Timothy Burke.
Pages from *The Face*, no. 79, November 1986.

Protective spectacles
SPERIAN

Lenses with 6 points of curvature;
wide coverage thanks to the lateral, upper
and lower shields built into the frame.

Internal half mask
SPERIAN

Silicone exhalation valve, sound device, secure snap-on system for attachment of the filters.

Drilling for natural gas

Photo Joel Sartore, Rifle, Colorado, 2004
Pages from Ferdinand Protzman, *Tra la gente: i grandi fotografi di National Geographic nel mondo del lavoro.* Vercelli: National Geographic & White Star Society, 2006

Respirator
NORTH SAFETY

Fire-resistant thermoplastic material welding attachment can be flipped up or removed for a wider field of vision when not welding. Clear polycarbonate lens offers 200 degree field of vision and has a specially darkened section on the bottom of the lens.

Respirator
NORTH SAFETY

Respirators protect eyes and face against irritating gases, vapors and flying particles. Scratch-resistant, polycarbonate lens provides a 200 degree field of vision. Available with thermoplastic or hypoallergenic silicone facepiece.

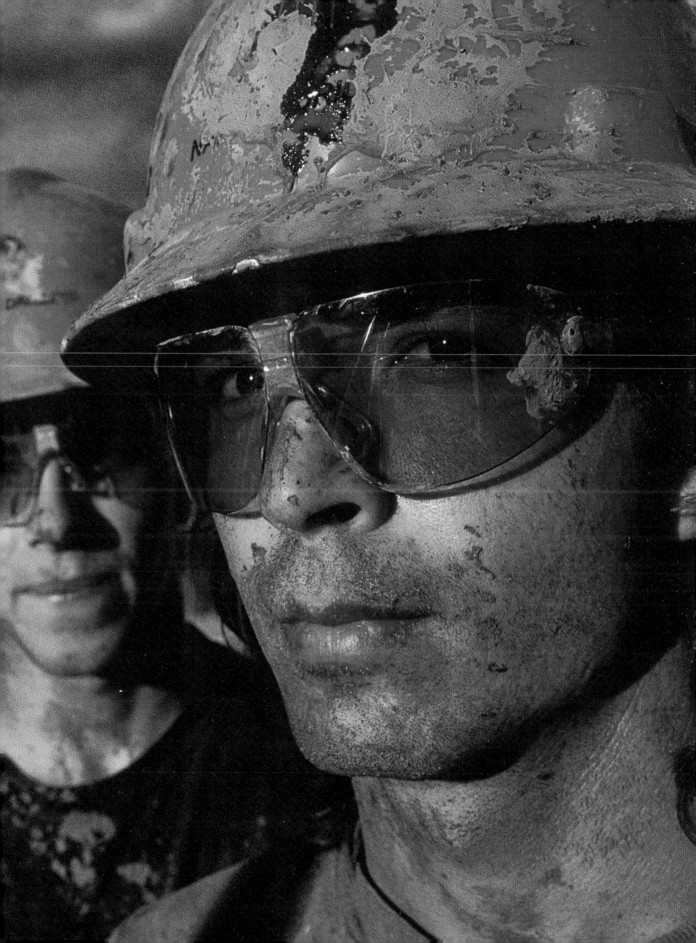

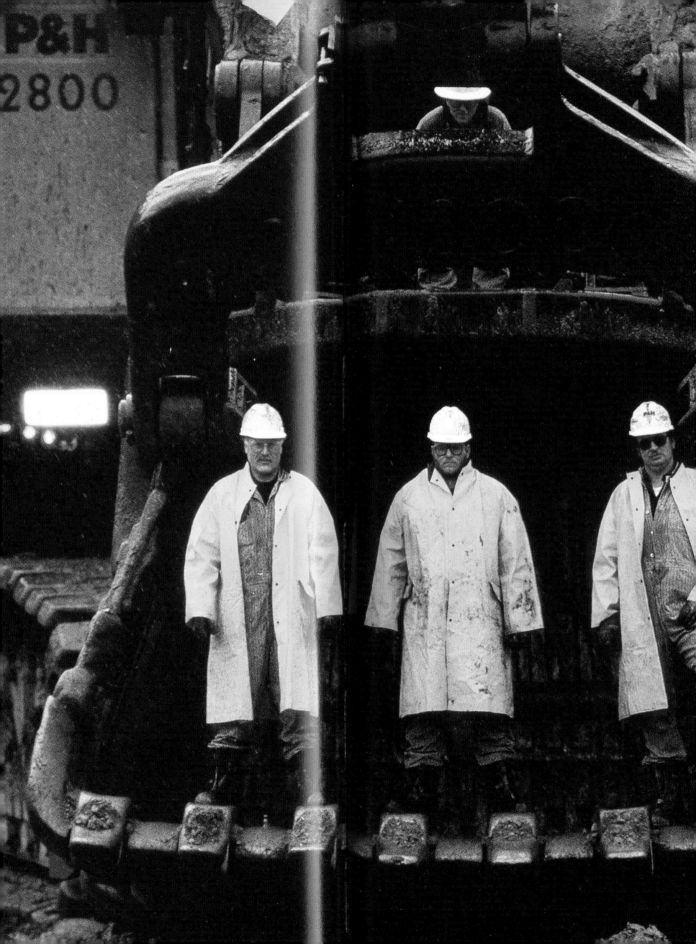

Excavator in Bingham Canyon Copper Mine

Photo Joel Sartore, Salt Lake City, Utah, 1995.
Pages from Ferdinand Protzman, *Tra la gente: i grandi fotografi di National Geographic nel mondo del Lavoro*. Vercelli: National Geographic & White Star Society, 2006

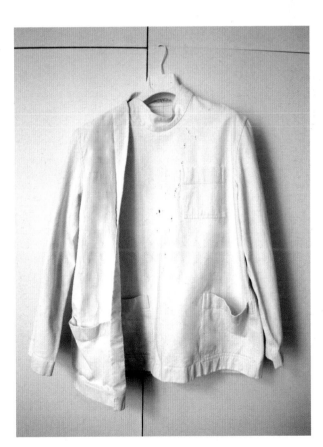

Atelier coat

Adeline André, 1982
Woman's workcoat, in white cotton batavia. Used in the atelier since 1982. Courtesy Adeline André.

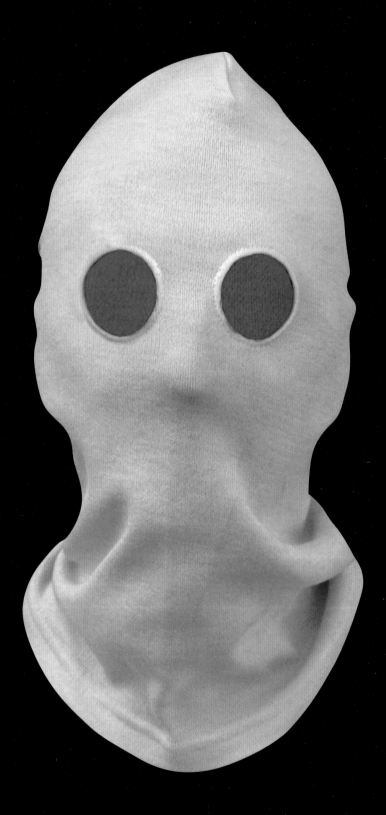

Balaclava
GIORDANI

Nomex® III 300 g balaclava with eyeholes for wear under helmet, universal size.

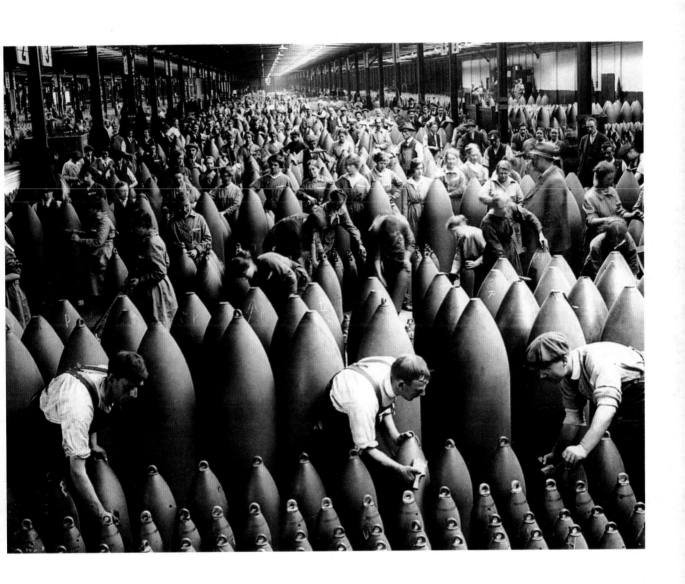

Painting shells in a British military factory

Photo Imperial War Museum, 1916.
Page from Bruce Bernard (ed.), *Century: One Hundred Years of Human Progress, Regression, Suffering and Hope.* London: Phaidon, 1999.

ARC flash kit
SALISBURY

Sewn with flame-retardant Nomex® thread. Meets ASTM F1506 and NFPA 70E standards. All kits come in a large protective storage bag with antifog, antiscratch and antistatic safety glasses that provide 99.9% UV protection and meet ANSI Z87.1, CE EN166 and CSA Z94 standards.

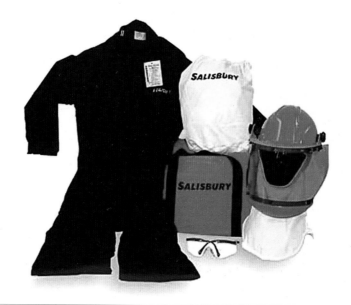

ARC flash kit
SALISBURY

Garments are made from Indura Ultra Soft® material for excellent breathability and comfort. Sewn with flame-retardant Nomex® thread. Meets ASTM F1506 and NFPA 70E standards. All kits come in a large protective storage bag with antifog, antiscratch, and antistatic safety glasses that provide 99.9% UV protection and meet ANSI Z87.1, CE EN166, and CSA Z94 standards.

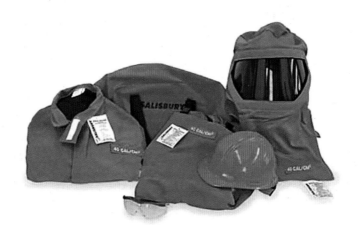

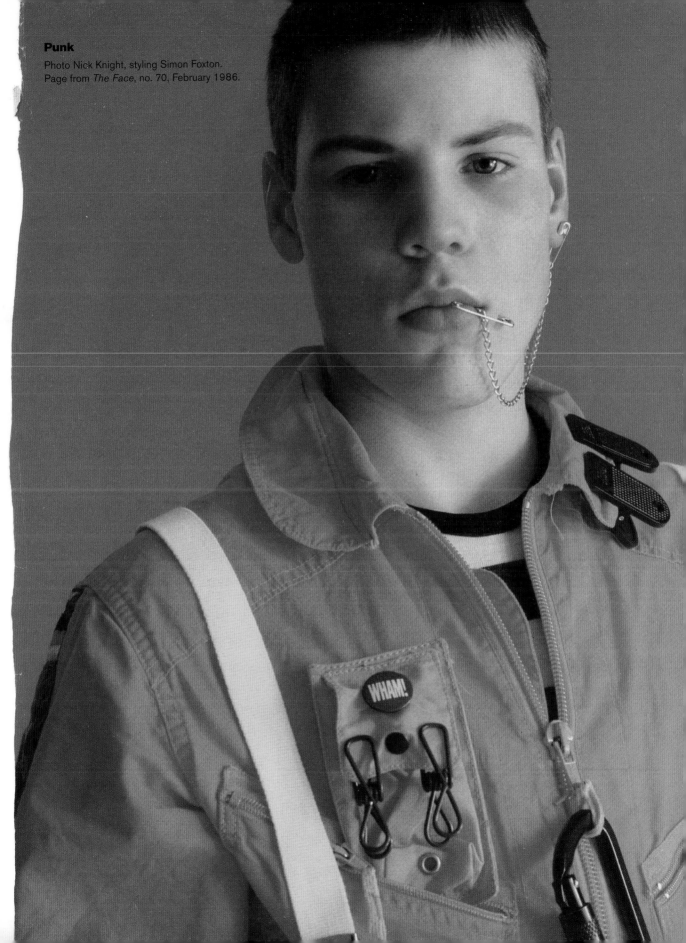

Punk

Photo Nick Knight, styling Simon Foxton.
Page from *The Face*, no. 70, February 1986.

SAFETY HELMET

IS COMPULSORY

Segnaletica Italiana D.L. 493 del 14/08/96 - CEE 92/58 - UNI

Industrial safety helmet
UVEX

Through the maximum utilization of the ventilation surfaces, allowed according to EN 397, an optimal heat exchange is possible. Three variable ventilation openings, with a total surface area of 300 mm², spread over approx. 55 mm² in the forehead area and approx. 245 mm² in the neck area, provide a rapid air current and a pleasant inner climate.

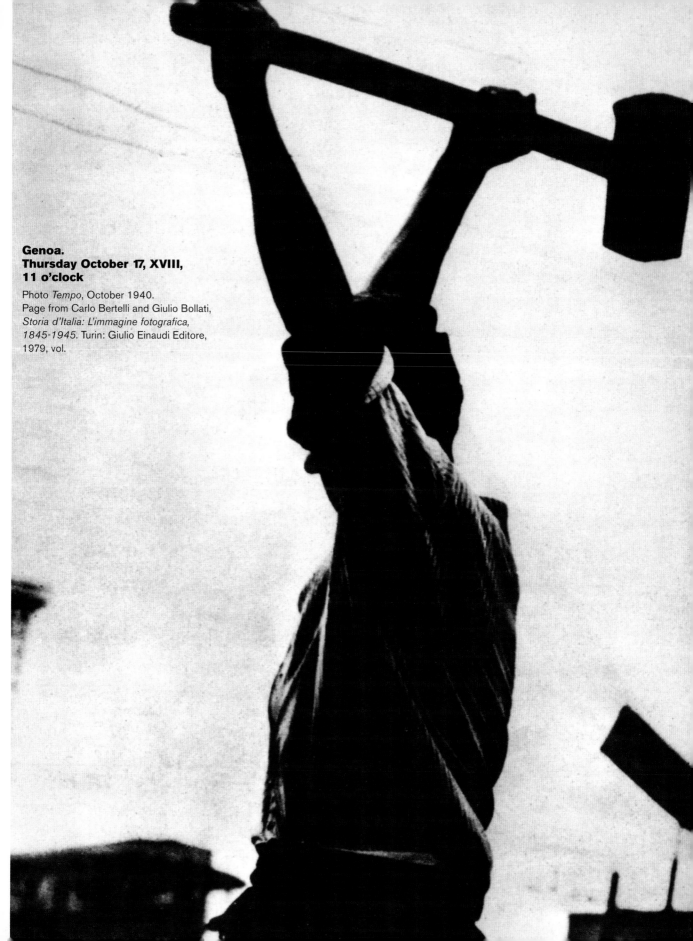

**Genoa.
Thursday October 17, XVIII,
11 o'clock**

Photo *Tempo*, October 1940.
Page from Carlo Bertelli and Giulio Bollati,
*Storia d'Italia: L'immagine fotografica,
1845-1945*. Turin: Giulio Einaudi Editore,
1979, vol.

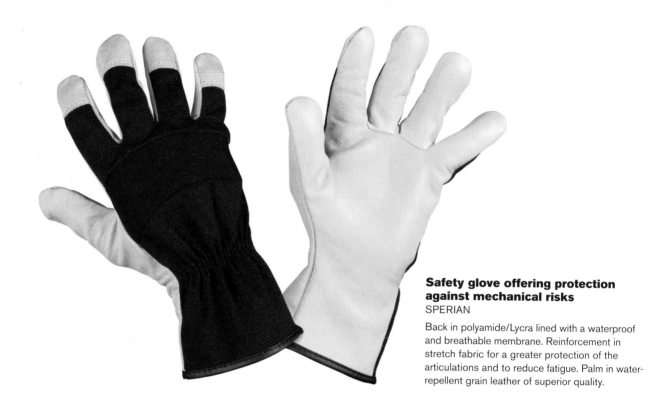

Safety glove offering protection against mechanical risks
SPERIAN

Back in polyamide/Lycra lined with a waterproof and breathable membrane. Reinforcement in stretch fabric for a greater protection of the articulations and to reduce fatigue. Palm in water-repellent grain leather of superior quality.

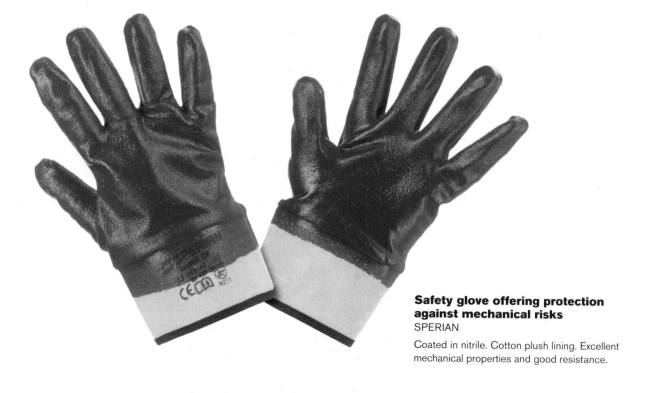

Safety glove offering protection against mechanical risks
SPERIAN

Coated in nitrile. Cotton plush lining. Excellent mechanical properties and good resistance.

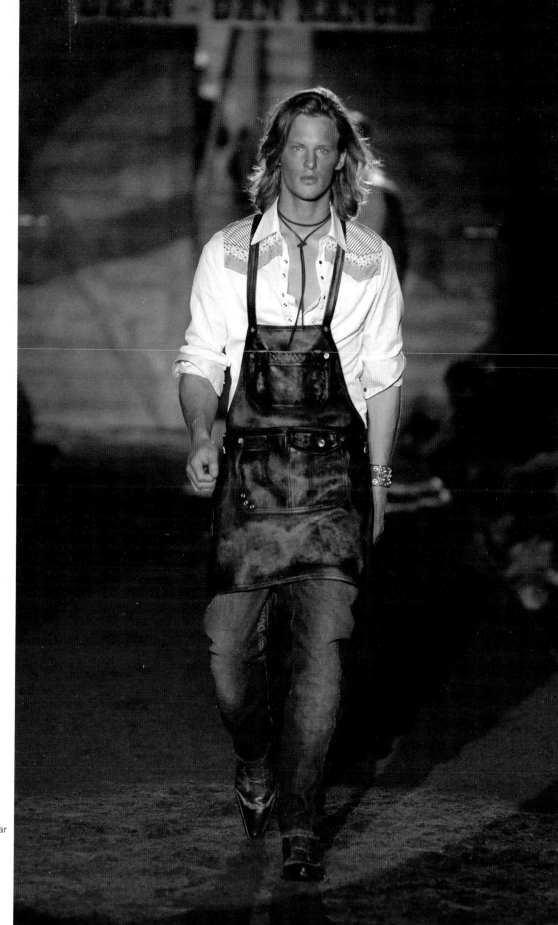

Dsquared²

Spring-summer men's wear
show 2006
Courtesy Dsquared²

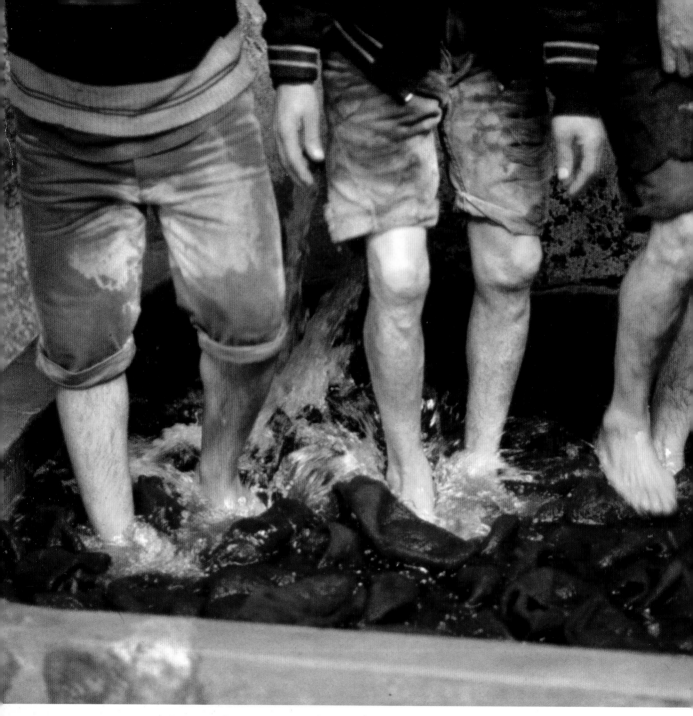

Clothes dyeing in Tunisia

Photo Kurt-Michael Westermann, April 1992
© K.M. Westermann/Corbis

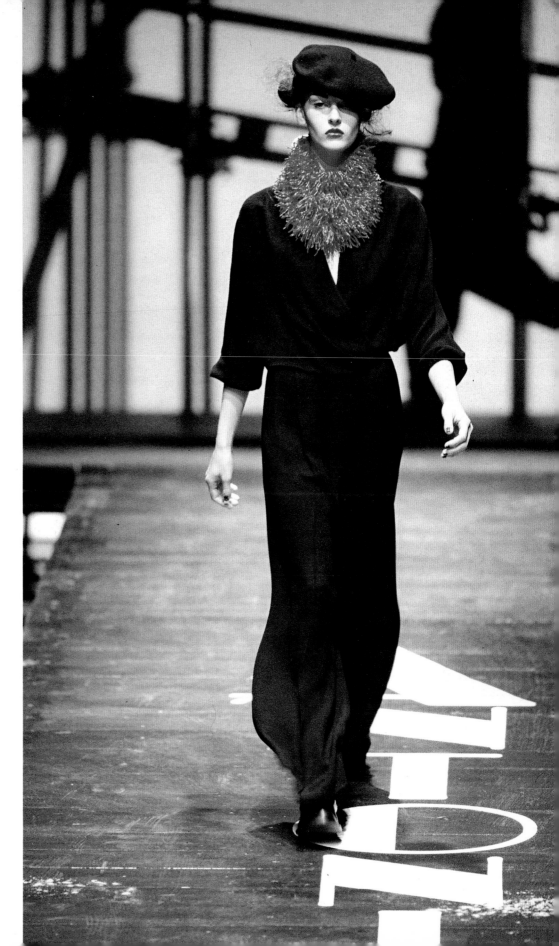

Wolfgang Dwenger, Dentist, 58 years old, November 1984

Photo Jörg Meier, St. Pauli, Hamburg. Page from Jörg Meier, *Die Würde dieser Menschen*. Nördlingen: Greno, 1987.

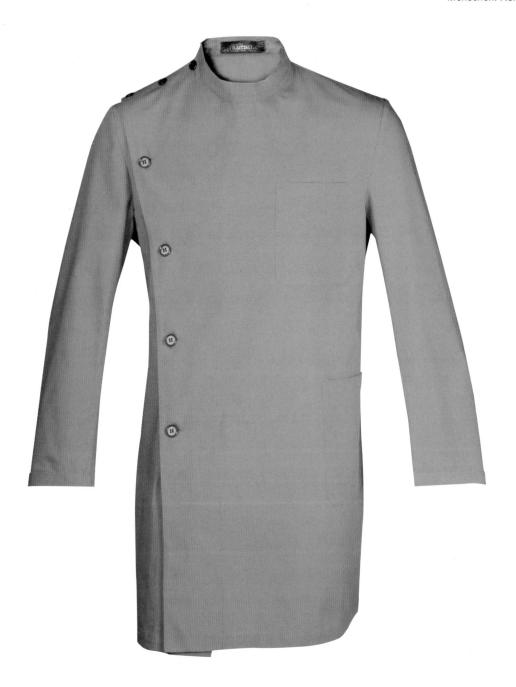

Short lab coat
FRAIZZOLI

Long smooth sleeve. Buttoning on the side. Back with half-belt. Green color. Also available in white.

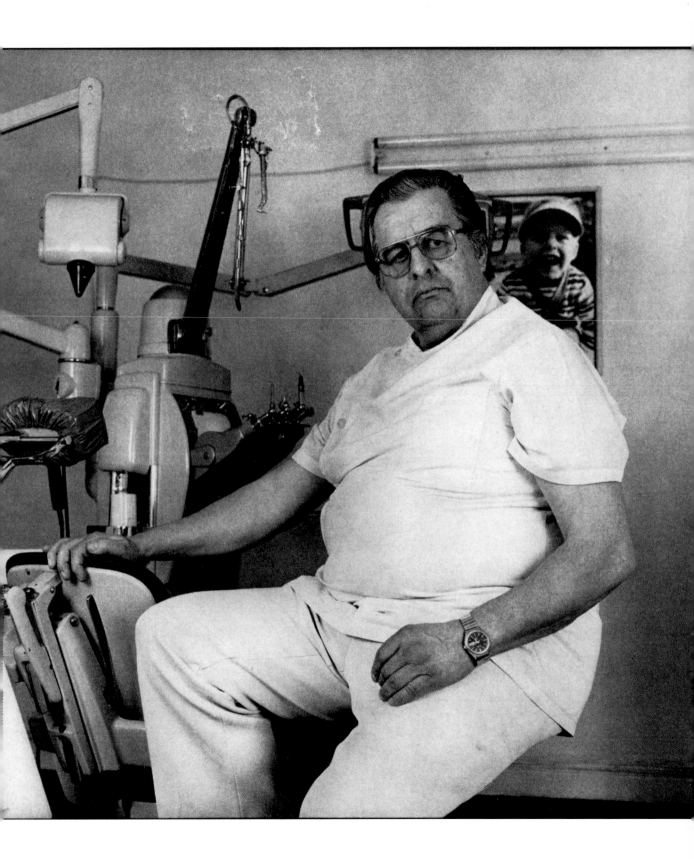

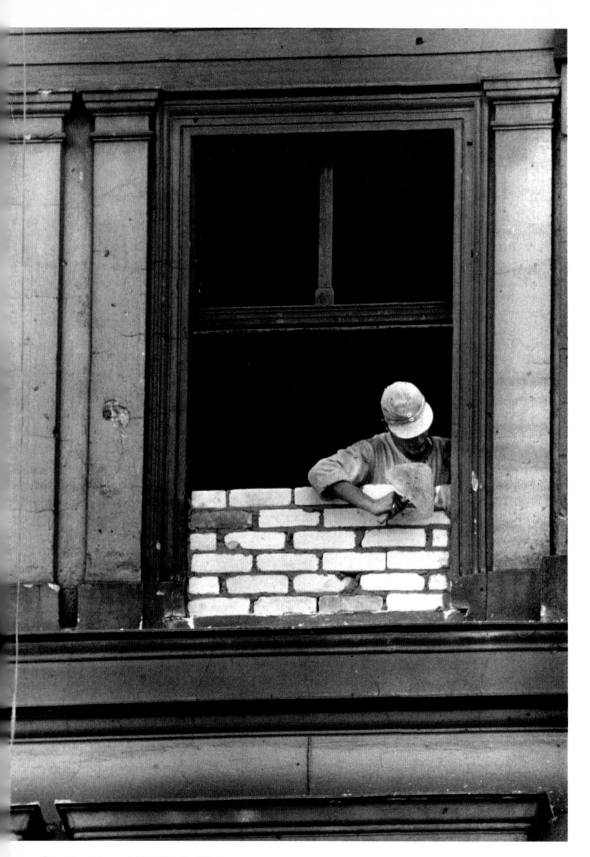

Construction of the Berlin Wall

Photo Burt Glinn, 1961. Page from Bruce Bernard (ed.), *Century: One Hundred Years of Human Progress, Regression, Suffering and Hope*. London: Phaidon, 1999.

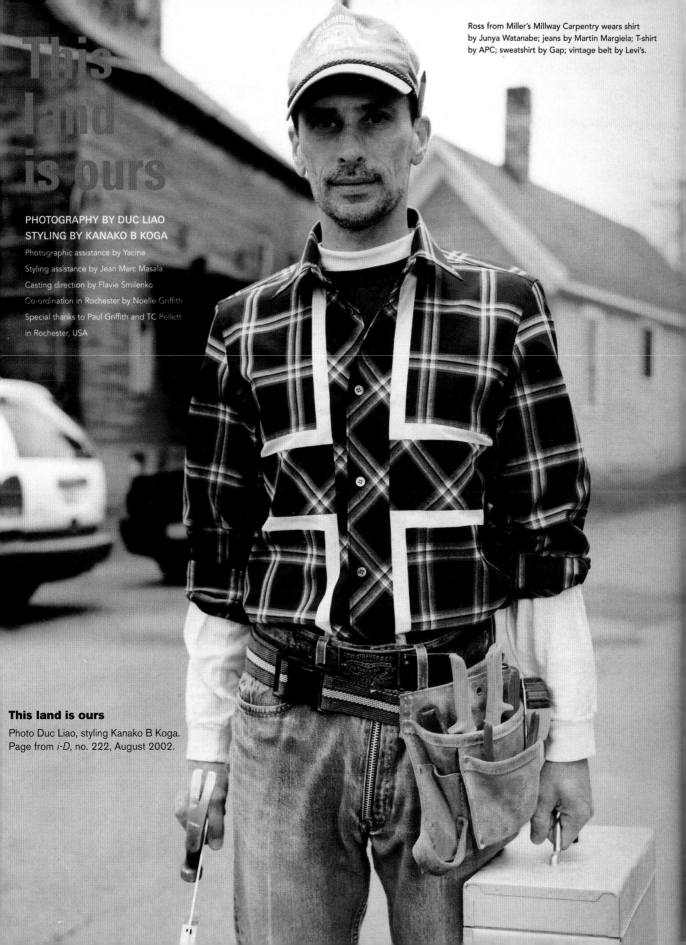

This
land
is ours

Ross from Miller's Millway Carpentry wears shirt
by Junya Watanabe; jeans by Martin Margiela; T-shirt
by APC; sweatshirt by Gap; vintage belt by Levi's.

PHOTOGRAPHY BY DUC LIAO
STYLING BY KANAKO B KOGA

Photographic assistance by Yacine
Styling assistance by Jean Marc Masala
Casting direction by Flavie Smilenko
Co-ordination in Rochester by Noelle Griffith
Special thanks to Paul Griffith and TC Pellett
in Rochester, USA

This land is ours

Photo Duc Liao, styling Kanako B Koga.
Page from *i-D*, no. 222, August 2002.